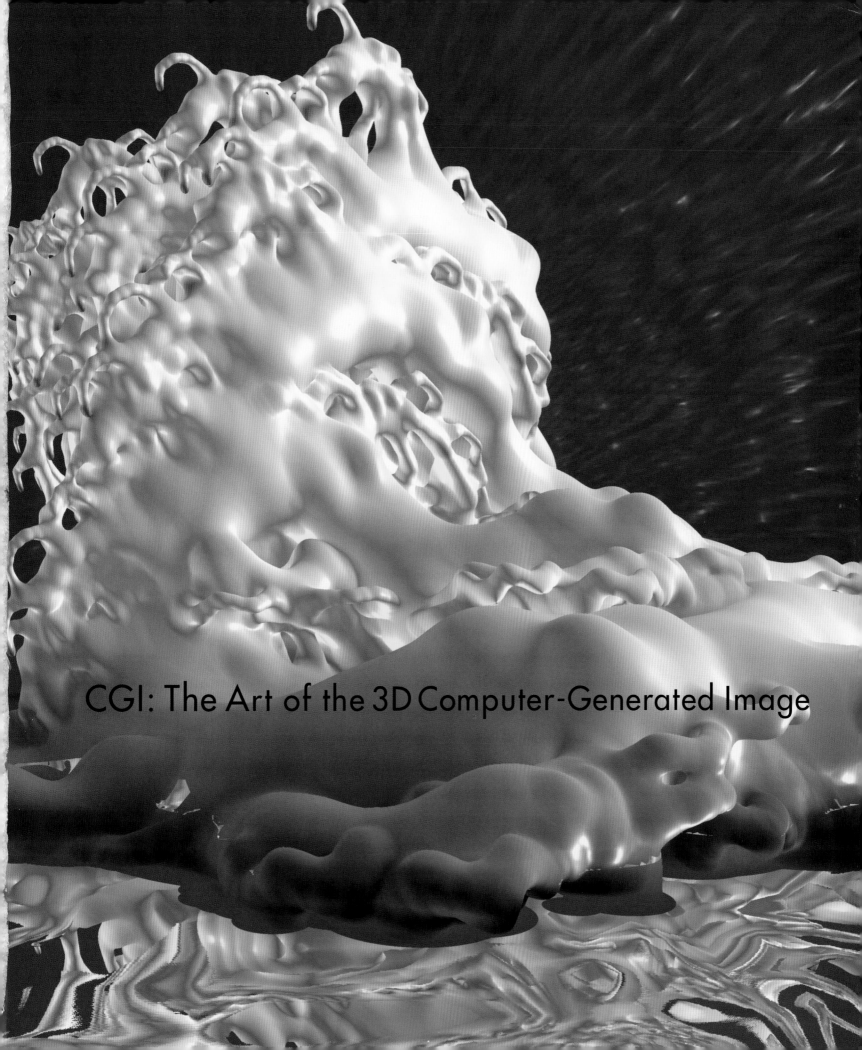

CGI: The Art of the 3D Computer-Generated Image

CGI: The Art of the 3D Computer-Generated Image

Peter Weishar

Foreword by Phil Tippett

Harry N. Abrams, Inc., Publishers

For my son, Nathan

Editor: Sharon AvRutick
Designer: Judy Hudson
Production Manager: Justine Keefe

**Library of Congress
Cataloging-in-Publication Data**
Weishar, Peter.
CGI : the art of the 3D computer-generated image /
by Peter Weishar; foreword by Phil Tippett.
 p. cm.
ISBN 0-8109-4967-9 (hardcover)
1. Arts—Data processing. 2. Computer art.
3. Three-dimensional imaging. I. Title.

NX260.W45 2004
776—dc22

2004009023

Printed and bound in China

10 9 8 7 6 5 4 3 2 1

Harry N. Abrams, Inc.
100 Fifth Avenue
New York, N.Y. 10011
www.abramsbooks.com

Abrams is a subsidiary of

LA MARTINIÈRE
ᴳᴿᴼᵁᴾᴱ

Endpapers: Kenneth Huff, *2002.7* (2002)
Page 1: Yoichiro Kawaguchi, *Pulsy* (2003)
Pages 2–3: Masa Inakage, *Conscious* (2002)
Pages 4–5: From *Wild Weather*, The Moving
Pictures Company. Courtesy of the BBC.
Page 6: Brian Taylor, *Rustboy*, detail
Page 15: Kent Oberheu, *Tentacular Continuum*
(detail)
Pages 16–17: From *Star Wars: Episode I—The
Phantom Menace*. Courtesy Lucasfilm Ltd.
Page 152–153: Eric Heller, *Transport VI*

*All artwork by independent artists is supplied courtesy
of the artists.*

Foreword by Phil Tippett

Perhaps I'm not really the right guy to be writing a foreword on a book extolling the virtues of CGI. I came into the game late, literally dragged, kicking and screaming. My closest friends brand me a curmudgeon and a Luddite, yet somehow the glow (or taint) of proximity to this burgeoning technology has (for better or for worse) dropped me in the middle of an image-making revolution.

My interest in art is historical. My focus is filmmaking but my compulsive/creative roots are in picture making (drawing, painting) and sculpting (clay, wood, plaster, wax, whatever). But I was always fascinated by things mechanically engineered. Tractors and locomotives, cranes and bridges all held the same allure as dinosaurs to my five-year-old mind — they were huge, powerful, and real. I was thrilled to spend time in foundries watching volumes of molten metal being poured, or in machine shops watching the craftsmen powering mills and lathes, churning metal into parts of machines that made machines that made machines. Even if I didn't understand precisely what was happening, the visceral drama of these dangerous processes was inspirational. (Forget that these processes were poisoning the earth and that corporate interests were reaping financial advantages and forsaking the workforce that had devoted and sacrificed its lives to bring it into being.)

So I learned industrial crafts, how to work cameras, and how to design systems to animate inanimate objects. I taught myself to sculpt, make molds, run complicated rubber formulas, use grip equipment and set up lights, construct sets with 2 x 4s and speed-rail, draw storyboards, and schedule my own time and the time of others. In 1977 I got the job of my life, working with a team selected by a thirty-three-year-old filmmaker who'd just had a huge runaway success and was relocating to the San Francisco Bay area near where I was born.

My dreams came true working for George Lucas on the first three *Star Wars* pictures (or are they technically the last three now?). Later I started my own studio, continuing to create visual effects mostly using stop-motion animation techniques in the tradition of Ray Harryhausen. You see, the cool thing about stop-motion animation, prior to the invention of the frame grabber (a video tool allowing stop-motion animators to preview work, check registration, and help determine in-betweens), was that nobody in their right mind could, or would, do it, and those of us who become proficient were treated with a modicum of respect — and suspicion — because we couldn't easily be replaced. I was in pig heaven. Using the analogy of a frog in water being brought to a boil, I was a happy little froggy in a tepid little swamp that was all mine. And then the water got warmer, and warmer, and soon it was a seething cauldron. The digital revolution had hit.

The transition for the boiled frog was very difficult. Yet after a few years, with the support of friends and family, and after some self reinventing, I realized that the brave new world of digital images allowed me to let go of hands-on (honest) work and become a better visual-effects supervisor (I got kicked upstairs) and eventually director of (low-budget) movies using computer graphics images and shot on digital cameras. Who would've thunk it?

I now work with many talented and skilled computer graphic craftspeople and technicians, some the highest caliber of

creative people I've known. The work can yield amazing results. Digital cameras allow us to shoot much more than we could in the past, avoiding the cost of processing film, and produce footage that can be "cloned" directly into easily reproduced duplicates, formatted, and then run through various digital outputs. Color timing now has significantly greater latitude. Editing technology and sound equipment are also far more sophisticated these days, allowing you to see and shape your picture in a matter of weeks instead of months of stabbing in the dark, hoping you've made the right move. Visual effects (used to be called Special Visual Effects) can create just about anything one can imagine. In addition, digital image manipulation allows everyone access to the equivalent of darkrooms without the chemicals. What used to be a huge pain in the ass as a kid — trying to make your own movies — has been revolutionized by various systems so simple even I can use them. All this is wonderful. And yet I have this nagging reticence, an uneasiness partially born of observation and, I admit, also from an Orwellian apocalyptic paranoia that something may not be right.

These feelings, I'm sure, must be residual boiled frog scar tissue. Having come from a very hands-on relationship to work — you proceed from intent and suffer consequences (you got burned, cut, or blown up if things went wrong) — I believe that our new and wonderful tool is in the process of acquiring a "patina of use," as most tools do, as it integrates into an art/craft context. Throughout this process, while we explore its seemingly limitless possibilities, we must always guard against talented folk becoming slaves to its production potential in order to get more work done faster.

CGI has replaced process photography, optical printing, and (almost) table-top animation in the motion-picture industry. What were once considered the black arts or techniques of cinematography and special effects, and available to only a few, are now accessible to a huge new generation of media artists. There is really nothing stopping anyone from creating digital images with the same amount of preparation it would take to paint a picture — except, of course, the vision, dedication, and craftsmanship that separates the few from the masses. As the digital medium grows and artists and contemporary technology fuse — who knows? — maybe one day we will witness a new Renaissance.

And so the little frog has jumped out of the boiling water and into the digital frying pan: AAARRRRGGGGHHHHHH!!!!!!!!!!!

Acknowledgments

There are literally hundreds of people who should be acknowledged for helping to make this book a reality. Foremost, I would like to thank the inspiring artists and talented technicians whose handiwork has graced these pages. Their selfless and massively collaborative efforts make their numbers too great to mention, but their contributions are much appreciated. It is also important to mention Cindy Slattery, who served as the research assistant on this book. Her intelligence, attention to detail, and tireless efforts were a significant factor in its success. I am grateful to my wife, Donna, for her support and for putting up with me while I worked on yet another book. Thank you to Eric Himmel, Sharon AvRutick, Judy Hudson, Samantha Topol, and the team at Harry N. Abrams, Inc., for their insights and contributions, and just for being a pleasure to work with.

Not everyone employed by a studio is a production artist. It was my pleasure to work with many resourceful professionals in public relations, licensing, marketing, production, administration, and many other integral areas of the film, game, video, and special-effects industries. These people helped secure permissions, compile images, and supply and check copy, and they skillfully dealt with the countless legal, organizational, and logistical issues with obtaining work from major studios and artists. Some of them (in alphabetical order) are: Margaret Ademic, Steve Argula, Helen Arnold, Suzie Arons, Jim Bloom, Maud Bonassi, Jérôme Boulbès, Chris Brandkamp, Bob Brandon, Sarah Bruce, Steph Bruning, Stephanie Bryan, Scot Byrd, Rita Cahill, Nicholas Callaway, Joanna Capitano, Hannah Clarke, Thom Cordner, Helene Cornell, Cathy Cultra, Andy Davies-Coward, Jon Davison, Roy Elvove, Melissa Gauthier, Margarita Harder, Melissa Hendrick, Chris Holm, Rob Ingall, David Irving, Jennifer Jones, Virginia King, Susan Klein, Marcin Kobylcki, Howard Kolins, Amy Krider, Yayoi Krieg, Roni Lubliner, Larry McCallister, Christopher Meledandri, Tina Mills, Lisa Muldowney, Francisco Navarro, Martin Parker, Brian Patrick, Miles Perkins, Katherine Perry, Lori Petrini, Amanda Powell, Andy Power, Nancy Rhodes, Amanda Roth, Jerry Schmitz, Jenny Shaheen, Matt Shaw, Andrea E. Siegel, Todd Sokolove, Jacky Spigel, Suzy Starke, Debbie Taylor, Melissa Taylor, Marie Trudeau, Sherry Wallace, George Wang, Linda Zazza, Donna Zelazny, and Robin Zlatin. Many others contributed to this volume, and I apologize for being unable to mention each one here.

It is important to acknowledge the film and television studios, networks, publishers, and other rights holders who have graciously allowed their images to be shown on these pages. They are: AOL Time Warner, BBC, Blizzard Entertainment, Blockbuster, Inc., Callaway Editions, Inc., Charlex, Cyan Worlds, Inc., DC Comics, Dimension Films, DreamWorks SKG, Fathom Studios, the Future is Wild, Lucasfilm Ltd., Microsoft Corp., Miramax, New Line Cinema, Oddworld Inhabitants, Paramount Parks Inc., Pixar, Radio City Entertainment, The Sci Fi Channel, Sierra, Six Flags Theme Parks — Movie World Madrid and Australia, Sony Pictures Television, Stainless Steel Studios, Stan Lee Media, 20th Century Fox, Universal Interactive, Universal Studios, Inc., and The Walt Disney Company.

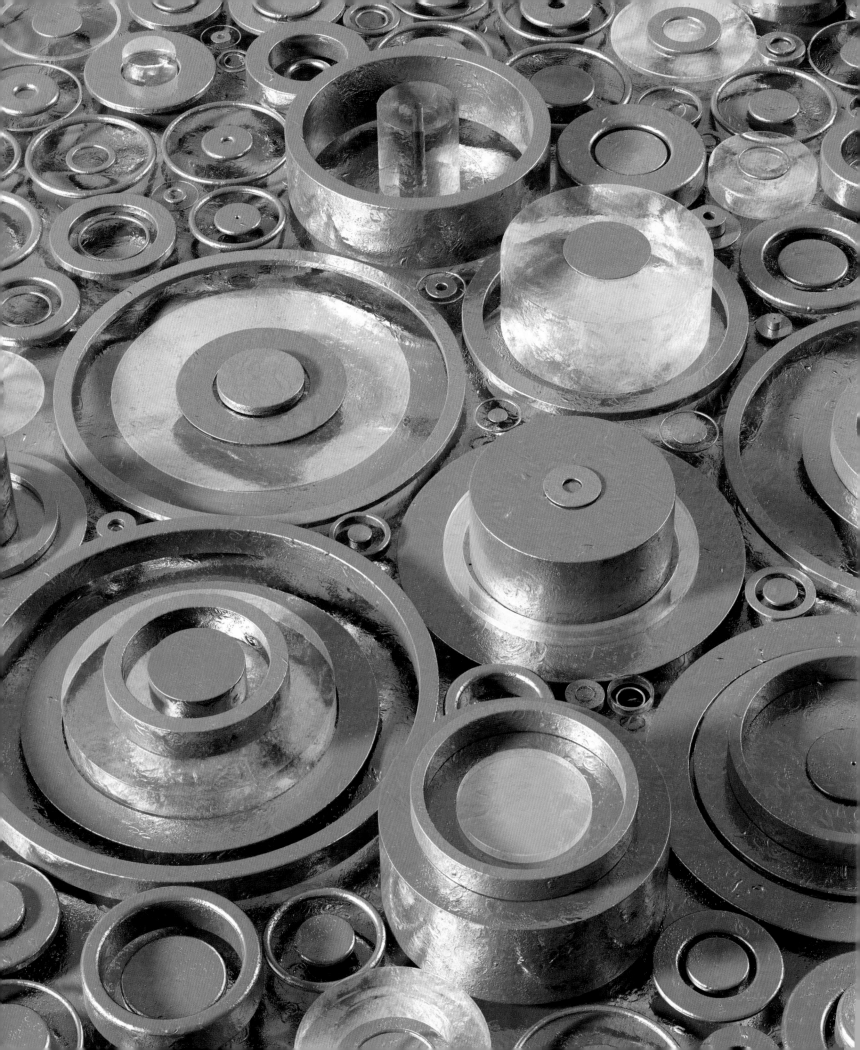

Introduction

Until recently, to many people the phrase "computer artist" was an oxymoron. High-end computers were commonly viewed as overly complex, soulless machines whose power could be harnessed only by geeks in horn-rimmed glasses and lab jackets. Artists, on the other hand, were often portrayed as prima donnas with little understanding of practical or technical issues. The neat little stereotypes of left-brain/scientist and right-brain/artist allowed no room for a creative person with technical acumen or a programmer with the soul of an artist. But of course such people do exist, as they always have.

Throughout history, many great artists have also been architects and inventors. It has long been accepted that the artists who mastered architectural design, metal casting, the formulation of pigments, and the construction of complex and (in some cases) monumental structures had disciplined minds and exceptional technical abilities. Today, these are exactly the individuals who gravitate toward computer art.

When they were created, many great works of Western art — from the Parthenon to the paintings in the Vatican — were looked upon as the product of divine inspiration and intervention. In a parallel, today many of the images produced by computer artists are somehow perceived as magically produced, albeit not by divine beings, but by technology. In fact, there's no magic to it at all. Like all true artwork, these stunning images are the product of talent, training, vision, hard work, and exceptional technical and artistic skill.

In the hands of a trained artist, the computer can become a tool for expressing artistic vision, every bit as much as a paintbrush or chisel. One must recognize that the creation of successful art does not lie solely in the moment of inspiration, but also in the painstaking attention to detail and the millions of crucial decisions along the path to the realization of the finished piece. Just as a master painter conveys his or her unique vision through the application of color, the direction and length of brushstrokes, and the inclusion or omission of detail, the computer artist manipulates the myriad of variables in the software to create compelling images.

But perhaps because of the tool's high cost and the massive amount of effort it takes to master it, to some naysayers computer artists are more craftspeople than artists. Or perhaps critics feel that because the computer calculates much of the intricate detail in CGI, the end product is more of a result of a software feature than of artistic skill. But think of orchestra conductors. While they do not play every instrument or produce a single sound in a symphony, they are still master musicians. To the uninitiated, it looks like all they do is wave a wand in the air while the orchestra magically plays beautiful music. Computer art looks just as easy. Just a few well-placed keystrokes, and *poof!* photo-real images appear on the screen. But as Mickey Mouse discovered in *The Sorcerer's Apprentice*, there is more to it than just waving that wand around.

An even more telling comparison would be between the computer artist and a filmmaker. As most people who have held a video camera know, it is a simple matter to point the camera and press a button to record a family function. Yet we recognize that there is a world of difference between a home video and an accomplished feature film. Filmmakers deal with a complex array of lighting, cinematography, staging, story, and editing issues to produce their artwork. Setting up and using the equipment necessary for producing

Kenneth Huff, *2002.4* **(detail), 2002.**

a feature film takes a small army of experienced artists and technicians. The same is true for the spectacular computer-generated special effects for features.

This is not to say that every computer artist is also a master programmer and technician. Nor is every programmer in the field an accomplished artist. Yet it is safe to say that a successful computer artist must possess a good degree of technical acumen and an effective programmer in the field must have a clear understanding of the needs of an artist.

Artwork created on the computer is commonly referred to as "CGI," or computer-generated image. In its broadest sense, CGI (often abbreviated to "CG") can be defined as any image that is created with the use of a computer processor. It is therefore remarkably pervasive — the genre includes printed matter from billboards to matchbook covers, and everything in between. Modern building design, television and film production, package design, medical imaging, and textile design are equally dependent on computers. At this moment you are probably surrounded by dozens of objects designed on the computer, all of which were initially conceived and visualized as a computer-generated image. Clearly, with such a broad and ubiquitous subject it is necessary to narrow the focus.

3D Computer-Generated Images

Indeed, when many professionals in the field use the term CGI, they are referring exclusively to 3D images — and this is the focus of this book. Such images can be created in two ways. A common method is to use software that sculpts an image inside the computer by creating a kind of wire-mesh sculpture that is then "skinned," or covered, much like papier-mâché is layered over a chicken-wire form.

The skinned 3D model is then "painted" with mathematically created patterns, photographs, or other scanned images. The artist then adds lights, backgrounds, color, and movement.

Much of the work in this book, however, was created through another method: the visualization of fractal algorithms — mathematical formulas that describe a kind of contained chaos where tiny particles seem to float in a random manner — which are used to create effects like clouds, fire, and water. The artists who work with fractal images are in effect sculpting virtual clouds by writing code or adjusting the numerical values of the attributes inside the software to set parameters that control the movement of the three-dimensional effect. Put aside the image of sculptors with chisel and stone; fireworks designers provide a better parallel. If they do their job right, they create beautiful, sparkling shapes and flowers, a magnificent combination of order and chaos. But if one calculation is off or a variable such as weather intrudes, the result is more like a random explosion than art.

Most feature film CGI special effects use some combination of fractal imagery and sculpted 3D objects. Sculpted objects are generally better for creating accurate models where the artist is concerned with exact proportions (such as lead characters). Fractal imagery is often used to provide incredible detail and random, natural-looking effects such as leaves, grass, or sand that would be exceedingly difficult to model individually.

In this book we will look at the following areas of CGI art: film and television animation and special effects, computer games, and fine art as they are created in studios and by independent artists.

Film and Television

Many CGI artists in the film industry work on special effects for live-action films, which often have multimillion dollar budgets and relatively tight deadlines. Therefore, CGI for film tends to be a collaborative effort in which highly trained specialists send a series of shots through the production pipeline. The artists are usually divided into teams: One group will do the modeling (the building of the objects and sets inside the computer), another will complete the set up (rigging the character so it will move properly when animated, i.e., setting it up so that it will bend at the knee rather than the shin), and others will work on texture, animation, lighting, and rendering. When CG artists "render" a scene they generate a frame, or a 2D picture of the CG elements. The last step is compositing (blending CG elements and backgrounds to create a final single image). In film, CG elements are often composited with live-action actors, props, and sets. This kind of CG work generally requires the highest degree of realism. Special-effects houses often try to outdo each other in technical achievement, with awed audiences becoming the beneficiaries.

Not all film industry CGI artists work on special effects. The fully animated CGI feature, a relatively new phenomenon, has become a favorite of movie audiences. Since the 1995 Disney/Pixar release of *Toy Story*, more than a dozen 3D computer-animated full-length features have been released. While film companies creating animated features use production pipelines similar to those at special-effects houses, many CG artists prefer to work on animated features due to a greater freedom of expression, greater control, and longer production cycles.

CGI artists working in television have different challenges than their colleagues in film. They are often faced with tighter budgets and production schedules. Television images do not need to be as highly detailed as film because a typical broadcast-quality image is less than one-eighth the resolution of 35 millimeter film. The audience is generally a bit less demanding, perhaps because they perceive TV as a "free" medium. But this does not mean that TV work is second best. On the contrary, it has given rise to some wonderful scientific visualization. Extinct creatures, ruined cities, and astronomical marvels have all been brought to life through television CGI. In addition, big-budget television commercials have often pushed the boundaries of CGI special effects with technical achievements that are on par with some of the most spectacular feature films.

Computer Games

Keith Richards of the Rolling Stones once commented that rock and roll is nothing more than a few basic chords — it's how the artist combines them that makes all the difference. Like rock-and-roll musicians, or haiku poets, computer-game artists work in a genre that is often defined by its limitations. In a real-time game — in which the player interacts with the environment seamlessly — the artist must be concerned with keeping the computer models as simple as possible and showing only the amount of detail that will not slow down play. The average gamer is primarily concerned with responsiveness, not with the detail of the environment. In other words, no one wants to get his or her virtual head blown off while waiting for the picture to load. With the increasing power of home computers and console games, this has

become less of an issue, but the amount of detail allowed in a real-time game is still significantly less than in a feature film. It's amazing, though, that the graphics for the 2003 computer game Tron 2.0 are significantly more detailed than the 1982 feature film on which it is based. At the same time, the game images, generated "on the fly" (allowing the player to see infinite views of the characters and environments) are created on equipment costing less than one-thousandth the price of the hardware used to generate images for the film.

Computer games usually include "cut scenes" or "cinematics," short, filmlike animations that tell a story and give the player a view of the fully realized characters and sets. Traditionally a cut scene is generated as a sequence of still pictures that are then saved as a finished video. This is known as a pre-rendered animation, in that all the frames are completely finished, just like a live-action video. Because all of the calculation is done beforehand, cut scenes provide the artists with the opportunity to let loose and render with all the detail of a feature film. As the computer and console gaming industry shifts to real-time games almost exclusively, cut scenes are presented as real-time graphics. For real-time graphics the computer calculates all of the light, texture, and shapes to draw the image instantly as the player views the game. Real-time graphics take up less disk space and can allow the player to move freely around the environment. These "in-game"–type graphics are high enough quality that they can be used to tell a story as well as be used inside the game.

Fine Art

As the field of CGI has grown, so has the number of individuals who have chosen to pursue a career as CG fine artists. Various factors, including the proliferation of high-quality digital printers, the reduction of hardware and software costs, the growth of the CGI industry, and the increase of public acceptance have helped the field grow exponentially in the last few years. Many independent artists have skills so refined that they are able to experiment, play, and express themselves with a computer as easily as a painter moves a brush across canvas. They have seen that they do not need to be part of a production studio to produce great CG art.

A number of these artists have followed the paradigm created by printmakers and photographers by producing high-resolution prints for sale. They lavish the same vast amounts of care and craftsmanship on making archival quality, oversized computer printouts as other artists do on making photographic or lithographic prints. Unfortunately, attracting buyers at appropriate levels has been an uphill battle. Unlike a photographic negative or a print plate, a digital file will not deteriorate. Therefore high-quality prints can be created at any future point, which some collectors feel reduces their value. Recognizing this, most CGI artists limit print runs and are very protective of their original files.

Other Areas of CGI Art

Many CGI artists choose to work in the 2D realm. Their work is, in many cases, no less technically difficult or visually stunning than that of their 3D counterparts. Popular programs such as Photoshop have enabled thousands of artists to realize their vision in ways unimaginable just a few short years ago. In

fact, most 3D artists will bring their work into such programs to refine details or composite various elements. However, the inclusion of entirely 2D CGI work would have broadened the scope of this book to the point where it would not do justice to either aspect of the field. This is why the images you will see on the following pages were created entirely or in large part in a 3D program.

CGI is used widely in industrial design and architecture, in creating technical illustrations and industrial renderings that are often quite compelling in their detail and artistry. While such work is worthy of art books and galleries, traditionally it is viewed apart, just as hand-drawn renderings have been. This book does not include industrial design images. (We do, however, include a lighting study of a structure that was never built.)

CGI in the 21st Century

This book is the result of a diligent, informed, and concerted effort to compile some of the best 3D CGI work available. The work shown on these pages has been culled from thousands of images by hundreds of artists. Each piece included is the product of extraordinary talent and skill. But in no way is this a complete overview of the work done in the industry today. There are many wonderful CGI artists who, unfortunately, we could not represent in this book. Difficulty in obtaining permissions precluded us from using work from some outstanding studios, such as Rhythm & Hues and ESC. In some cases, such as with Sony Imageworks and Kleiser-Walczak, similar permissions issues prevented us from showing a more complete view of the technical and artistic range of the studio. Even with twice the page count and

resources it would be arrogant to claim a volume of this nature is complete. Instead, *CGI: The Art of the 3D Computer-Generated Image* serves as a broad sample. I hope it will be an inspiration to a wide range of artists and enthusiasts who will grow to appreciate this truly amazing field.

A few years ago I had the pleasure of interviewing some of the pioneers of the CGI industry, individuals who were working full time in the medium while it was still a curiosity. I asked them if at that time they had envisioned that CGI would eventually become a major industry and an integral part in an overwhelming majority of feature films. They all had the same basic response: "Of course. I just didn't think it would take so long." While the average person involved in a technical field thought of the future as the next, faster processor or snappy new software, these visionaries saw the big picture. They knew that computer-generated imagery would become an important and popular art form and like the great artists of the past, they helped guide the field to eventually realize their vision.

Mention the European Renaissance, Cubism, Abstract Impressionism, or any other major art movement and art history students can name the artists and thinkers who consciously helped shape it, both intellectually and by example. The same will be true for CGI. It has not become what it is out of happenstance or merely as the result of increased computing speed coupled with better software. It is a new way of making art, conceived and brought to life by brilliant and dedicated individuals who one day will be recognized alongside the other great artists who have helped shape our culture.

Filmmaking, photography, printing, architecture, and design have already been transformed by the digital image. In the twenty-first century, as CGI becomes a dominant art form, it will become a ubiquitous part of our lives not only for entertainment but for information, communication, and education as well. This book is a tribute to the artists, programmers, technicians, producers, and visionaries who have unlocked virtual wonders and shown us a world beyond imagination.

A note to the reader:
Many books that purport to cover the art of CGI are mostly either compilations of sketches or technical manuals. While there is nothing wrong with how-to books on CGI (I've written a couple myself), they are not art books. This book presents finished CGI artworks, that is, fully rendered 3D images (in some cases composited with photographic elements) as the artists intended them to be seen.

Kent Oberheu, *Tentacular Continuum* (detail).
See page 207.

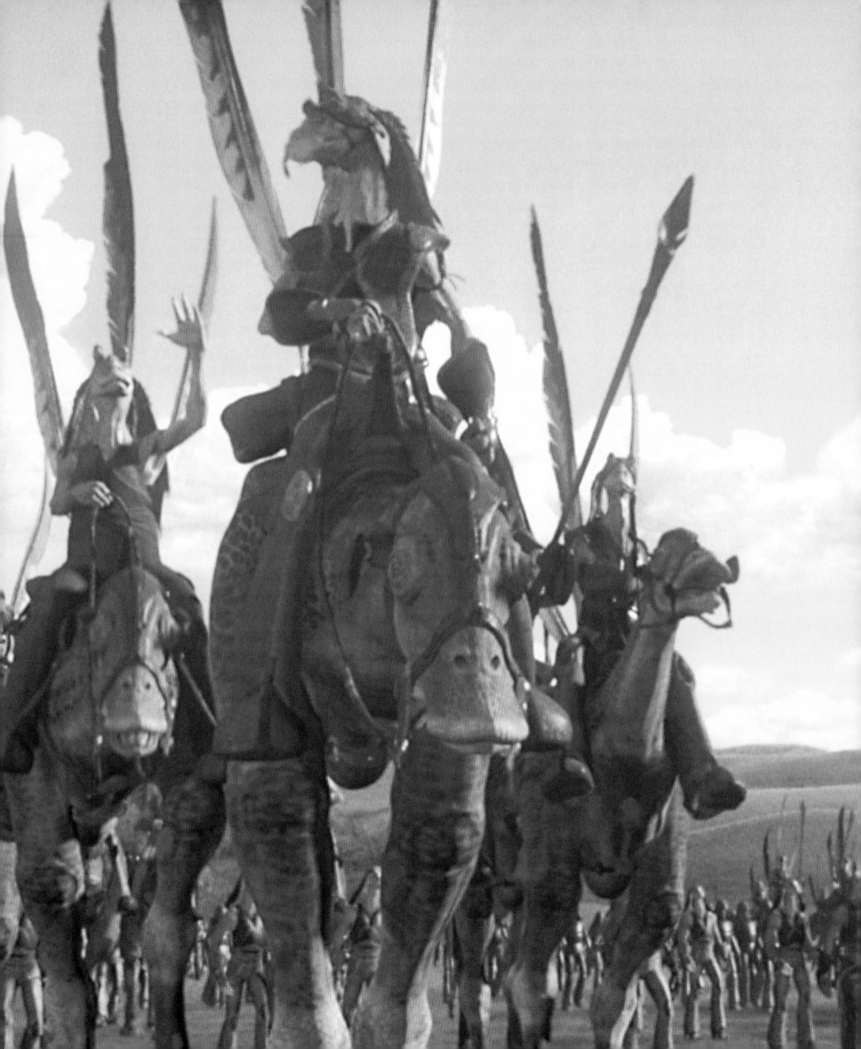

Studios

Blizzard Entertainment

Blizzard has been one of the most popular and well-respected makers of computer games since 1994. With blockbuster hits including the Warcraft®, Diablo®, and StarCraft® series, the company has enjoyed back-to-back number-one selling games, as well as consecutive Game of the Year awards. The company's online game service, Battle.net®, is the largest in the world, with millions of active users. The Irvine, California–based company employs more than 150 designers, producers, programmers, artists, and sound engineers in its development group, whose dedication, enthusiasm, and craft are evident in Blizzard's immensely playable games and high-quality graphics.

All of these images are from the 2002 hit computer game "Warcraft III: Reign of Chaos." These shots are from cinematics, small movies that play inside the game to help move the plot forward. Here, as in many cases, the cinematics were pre-rendered, not created with "on-the-fly" rendering. A pre-rendered image can use a great deal of time and processing power to display realistic lighting and detail. Courtesy Blizzard Entertainment.

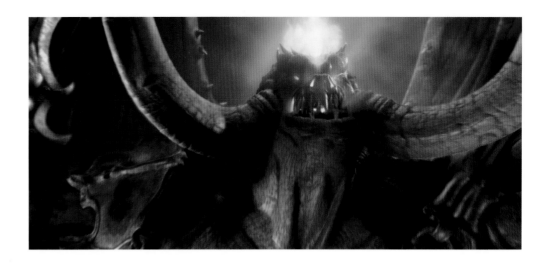

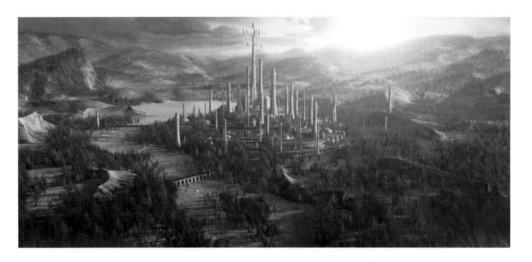

Blue Sky Studios

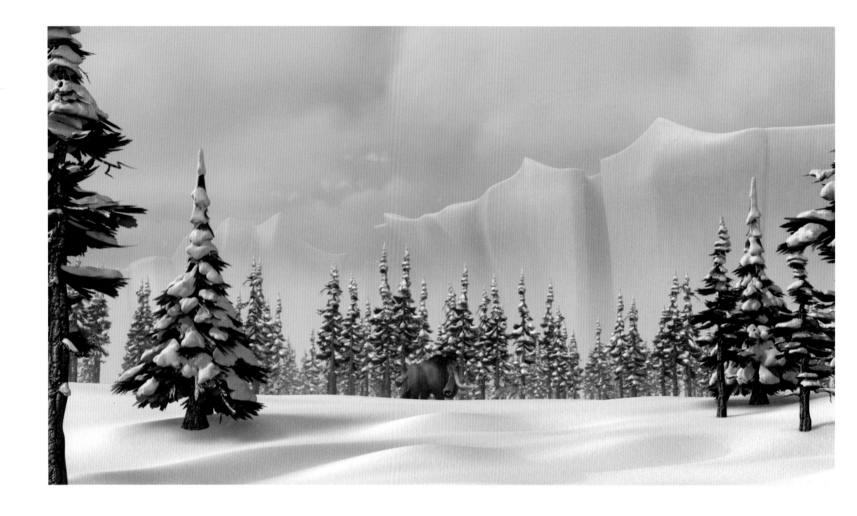

In 1987 Eugene Troubetzkoy, Carl Ludwig, Chris Wedge, Alison Brown, Michael Ferraro, and David Brown had a crazy idea about forming their own computer animation and special effects company. They named their endeavor Blue Sky Studios in recognition of their "out there" ideas. Armed with a couple of computers, a kitchen table, and no corporate backing, they set out on a journey that led them to an Academy Award for their short film *Bunny* (1999) and the smash-hit CGI animated feature *Ice Age* (2001). Of course, now their ideas don't seem so crazy anymore. Along the way, Blue Sky worked on many award-winning television commercials and feature films and developed one of the most sophisticated and accurate rendering software packages in the industry. In 1999 20th Century Fox bought the studio and Blue Sky became an integral part of 20th Century Fox Animation. Blue Sky has now grown to 190 dedicated individuals. Its next feature film, *Robots*, will be released in 2005. All images courtesy of Blue Sky Studios and Twentieth Century Fox Film Corporation.

In many ways *Ice Age* is a kind of a buddy/road movie with a plot that unfolds over the course of a long migratory trek. The artists at Blue Sky Studios built large-scale sets composited from 2D and 3D elements to set the stage for the story. Although there were many technical hurdles, the images gain their overall impact not from adherence to photo-realistic detail, but from their striking compositions, dramatic color palettes, and believable lighting. © 2004 Twentieth Century Fox Film Corporation. All rights reserved.

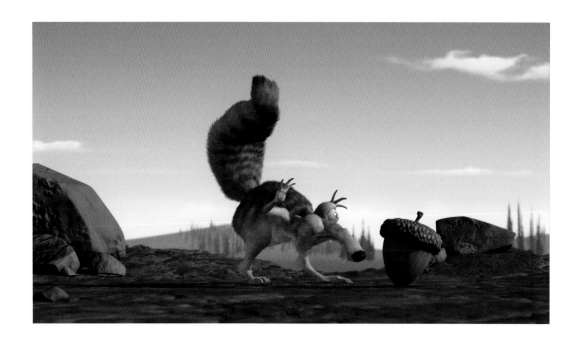

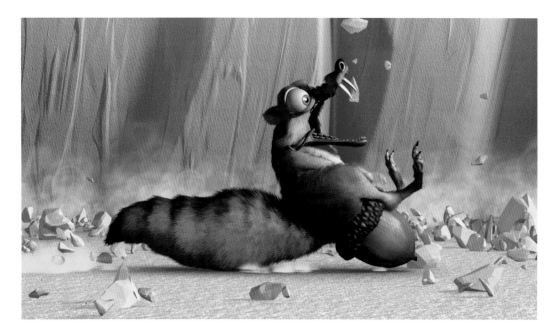

For the smash hit, Academy Award–nominated feature film *Ice Age*, Blue Sky Studios created a creature called the Scrat. This skittish little saber-toothed squirrel is on a fanatical and frustrating quest for acorns. While the Scrat does not have a speaking part, director Chris Wedge voices its variety of yelps, twerps, and screeches. The Scrat is a tour de force of animation with the expressiveness and brilliant timing reminiscent of a classic Warner Bros. cartoon. © 2004 Twentieth Century Fox Film Corporation. All rights reserved.

Overleaf: The four main characters of *Ice Age*, all of whom were designed by Peter De Seve, are (left to right): Roshan (known as "Pinky" to his traveling companions), Sid the sloth, Manny the mammoth, and Diego the saber-toothed tiger. Their fur is comprised of layers of thousands of transparent two-dimensional planes called cards with pictures of fur on them. When used in large numbers, cards can create the illusion of thick fur, bushy leaves, and grass-filled meadows. © 2004 Twentieth Century Fox Film Corporation. All rights reserved.

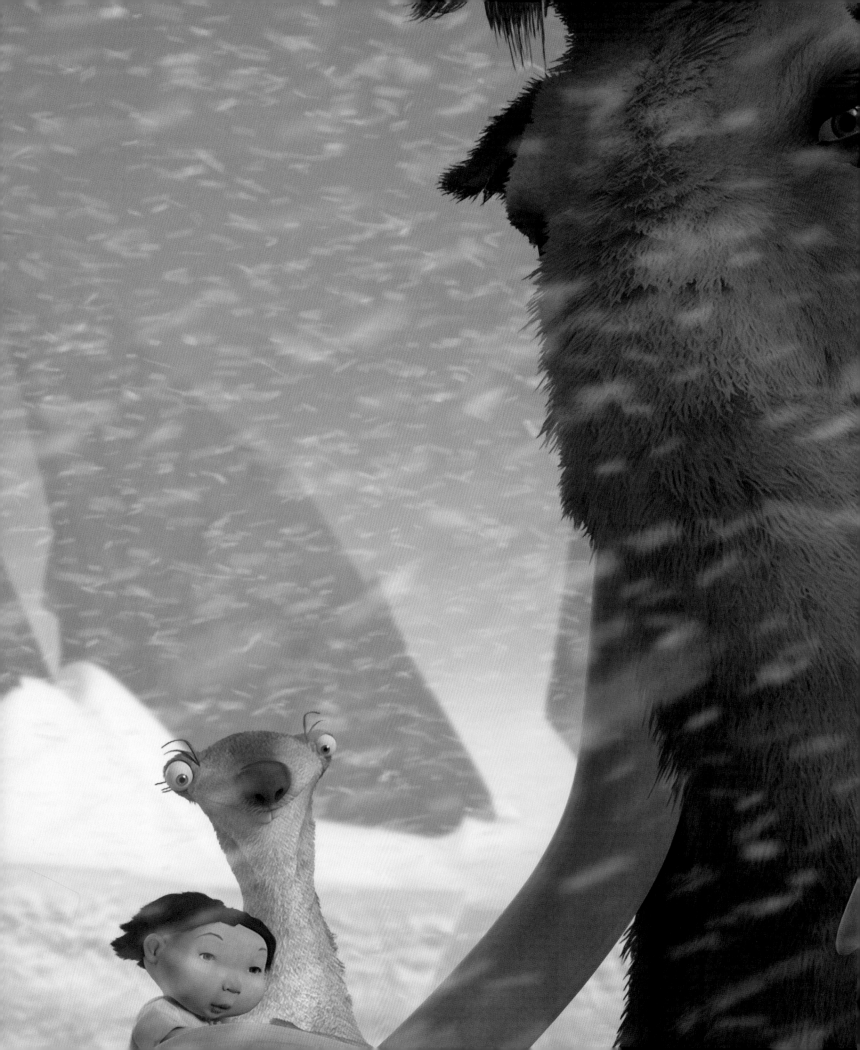

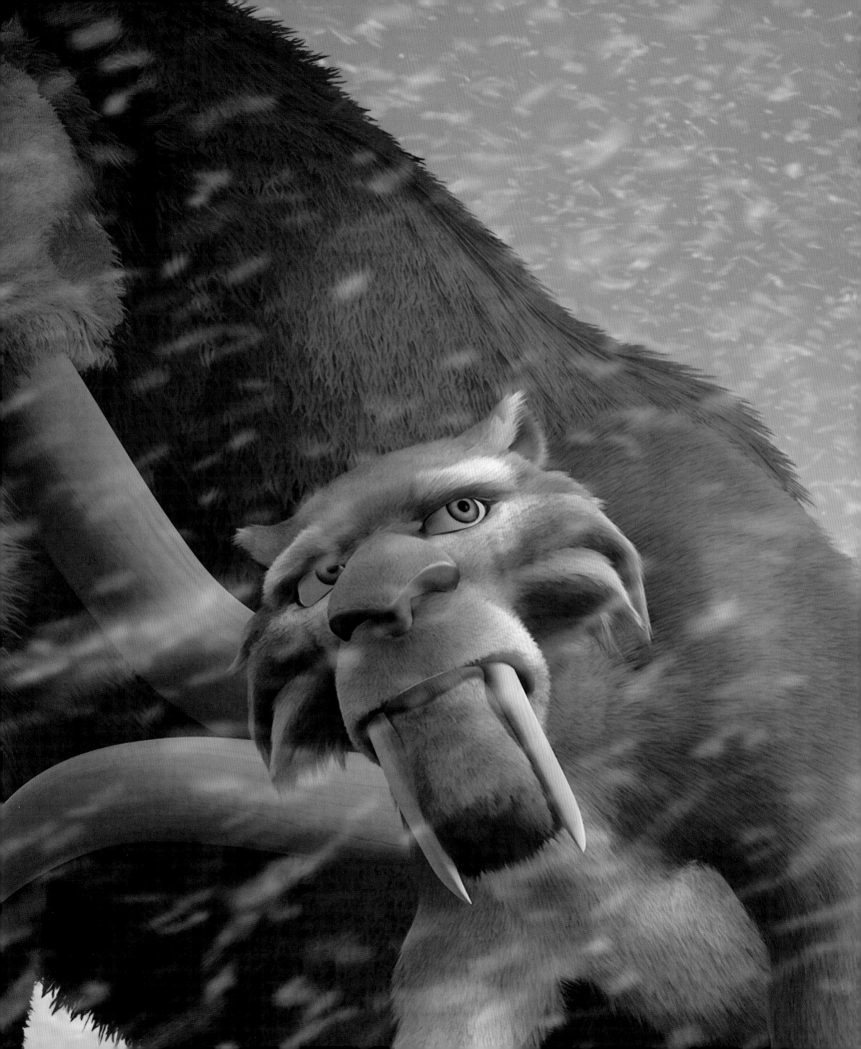

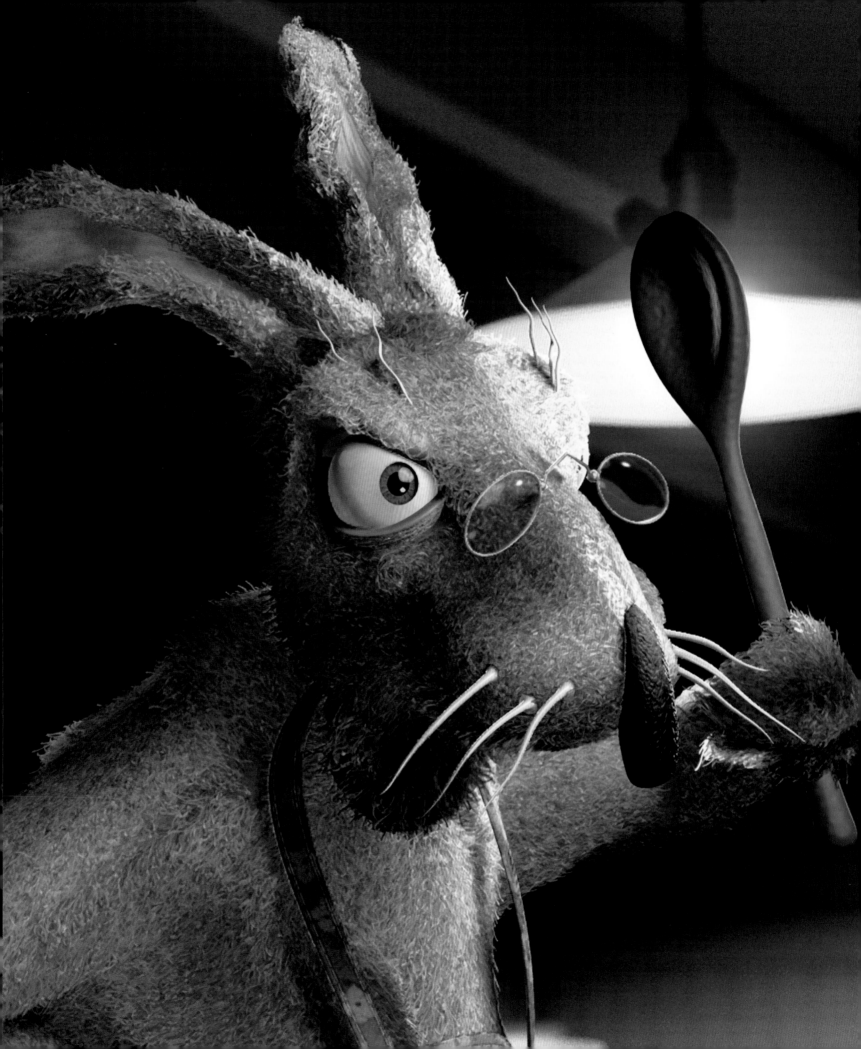

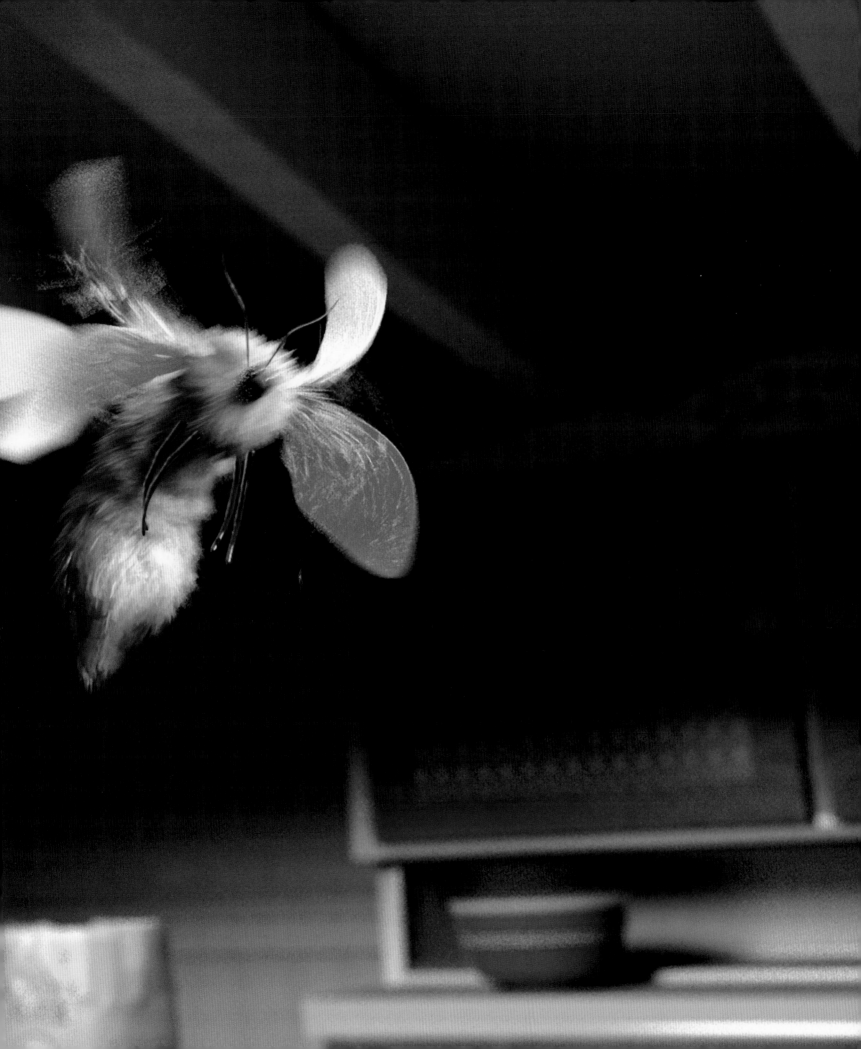

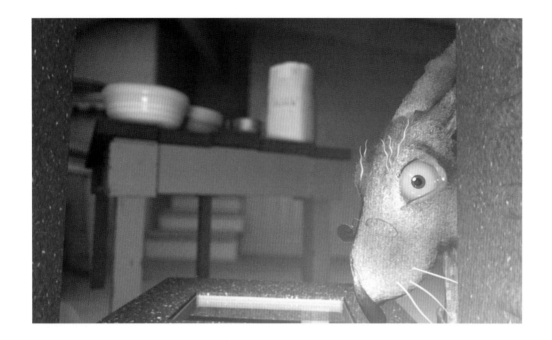

This and previous page: Blue Sky Studios' short film *Bunny* is the poignant story of a widowed rabbit who bakes a carrot cake while being taunted by a persistent moth. Her fur was created with the same kind of card system used in *Ice Age*. For the backgrounds Blue Sky used a sophisticated rendering method known as radiosity, which generates shockingly real images by mimicking the way light bounces off and is absorbed by surfaces. © 2004 Twentieth Century Fox Film Corporation. All rights reserved.

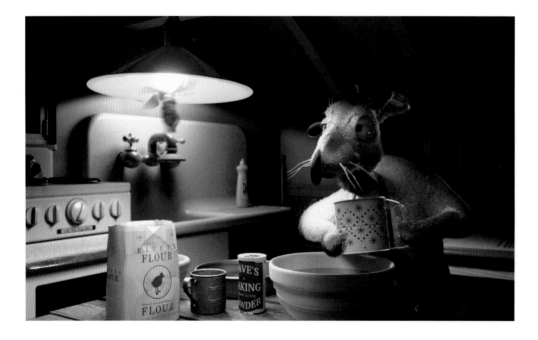

Blur Studio

The Venice, California, Blur Studio was founded in 1995. The company has produced numerous projects spanning a wide range of media — large-format films, commercials, concept art, feature effects, ride films, and video game cinematics. Notable recent projects include the *SpongeBob SquarePants* 3D stereoscopic ride film, *Stargate SG-I Attraction*, *The Rise of Nations* cinematic, Shania Twain's "I'm Gonna Getcha Good" music video, photo-real effects for *Bulletproof Monk*, and a Spiderman action-figure spot. Also under the Blur banner is a broadcast design division dedicated to creating motion graphics for television and film. Its clients include ABC, NBC, CBS, WB, and E! Entertainment.

Blur Studio specializes in creating dramatic animations for real-time games and amusement park ride films. They are blurring the line between the graphics we see on the computers and rides and in big-screen theatrical release.

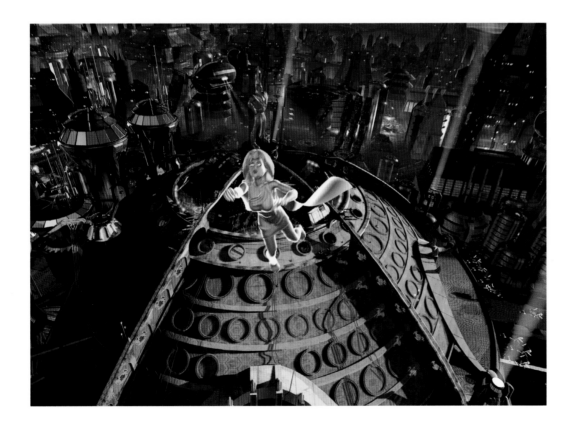

7th Portal ride film. Paramount Parks Inc./Stan Lee Media. Blur Studio, Inc./ Six Flags Theme Parks — Movie World Madrid and Australia/ AOL Time Warner/DC Comics

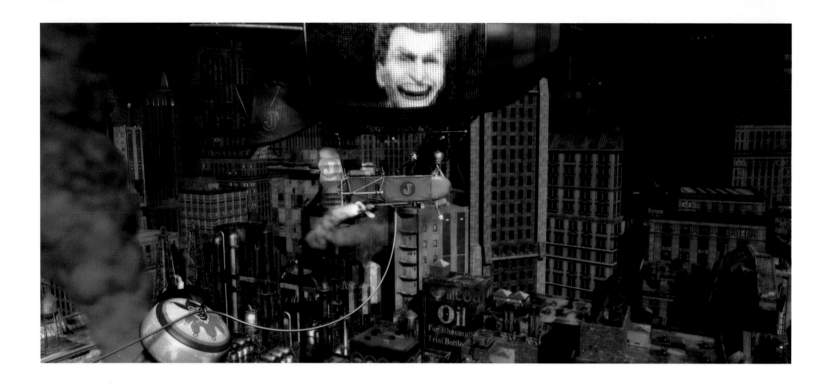

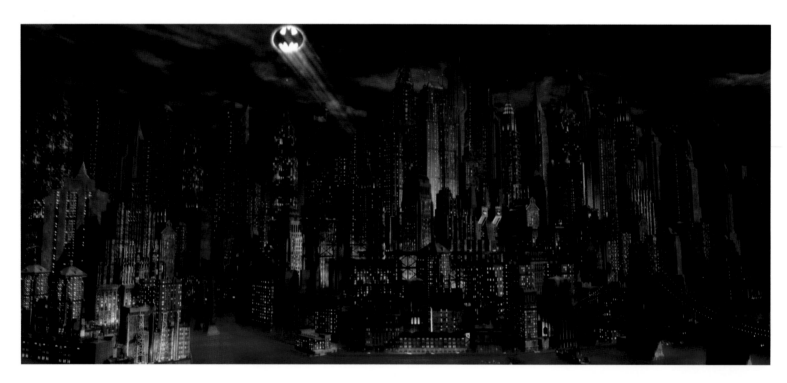

These images were generated for a Batman-themed ride film. These virtual reality location-based rides, with their twisting and turning cars synched to spectacular on-screen visuals, are the direct descendant of military and commercial flight simulators. Blur Studio, Inc./ Six Flags Theme Parks — Movie World Madrid and Australia /AOL Time Warner/ DC Comics

These two images are from video game cut scenes, linear short movies that tell a back-story to a game. Cut scenes often give the artist a chance to add the detail and intricate animation and special effects that cannot be achieved while the game is playing. "Empire Earth" game: Blur Studio, Inc./Sierra/Stainless Steel Studios. "Fellowship" game: Blur Studio, Inc./ Universal Interactive

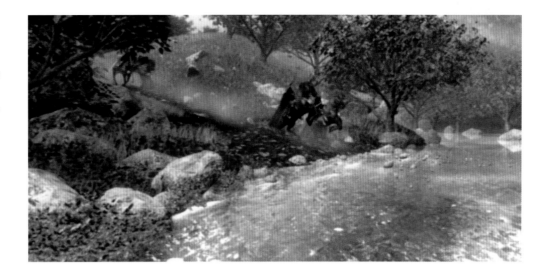

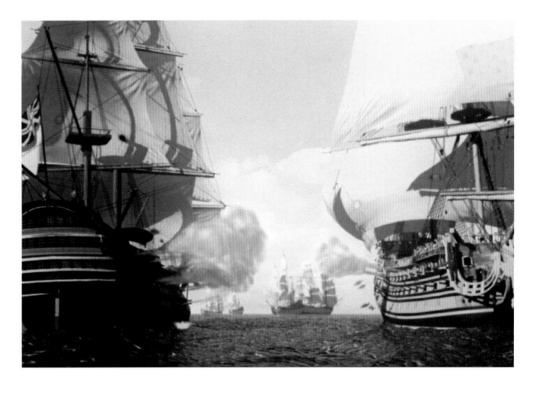

Star Trek ride film. Blur Studio, Inc./Viacom/Paramount Parks, Inc.

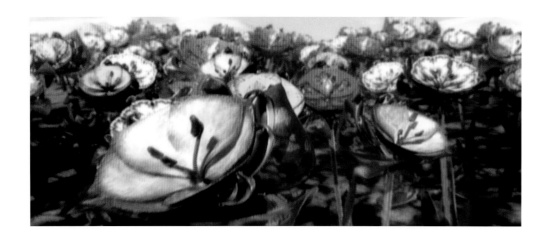

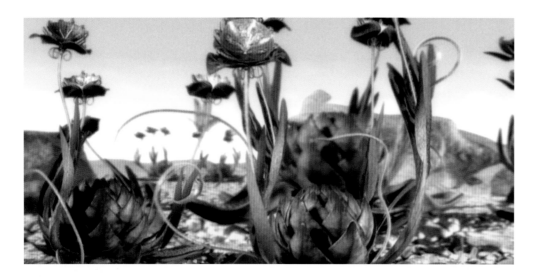

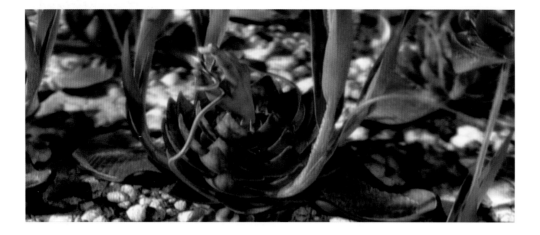

These stills are from very short pieces
known in the television industry as bumpers.
In this spot for the Sci Fi Channel, which
lasts less than ten seconds, Blur animated
some pleasant yet alien-looking plants with
surprisingly vicious carnivorous tendencies.
Blur Studio, Inc./Sci Fi Channel

Charlex

Charlex was founded in New York City in the late 1970s as a tape production house. It became known for its bold and innovative use of digital technologies (rather than the slower, more costly optical methods) to produce high-end graphics and effects. The 1988 feature film *Tapeheads* portrays those early, irreverent days of the company, with John Cusack starring as Alex Weil, one of the founders and the current executive creative director. Now a full-service production house with sixty-eight employees and a sixteen-person 3D computer animation department, Charlex has an impressive list of more than 100 industry awards and many Fortune 500 clients.

Charlex made ragweed and pollen come to life for the McCann-Erickson TV and print campaign for Allegra. The image was composited with a live-action plate, so the artists had to pay special attention to lighting to achieve a seamless effect. © 2003 Aventis Pharmaceuticals, Inc.

The television commercial "Taxi Dance" was produced for BBDO for their client Cingular Wireless. In the piece taxis wheel about, sans drivers, in a well-choreographed dance. All of the photo-realistic elements and movements were generated in the computer. Courtesy Cingular Wireless.

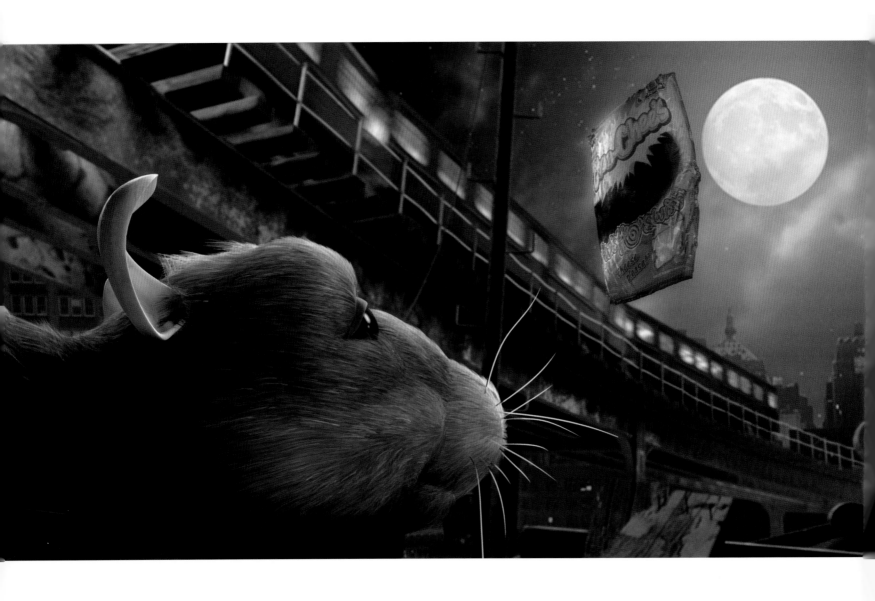

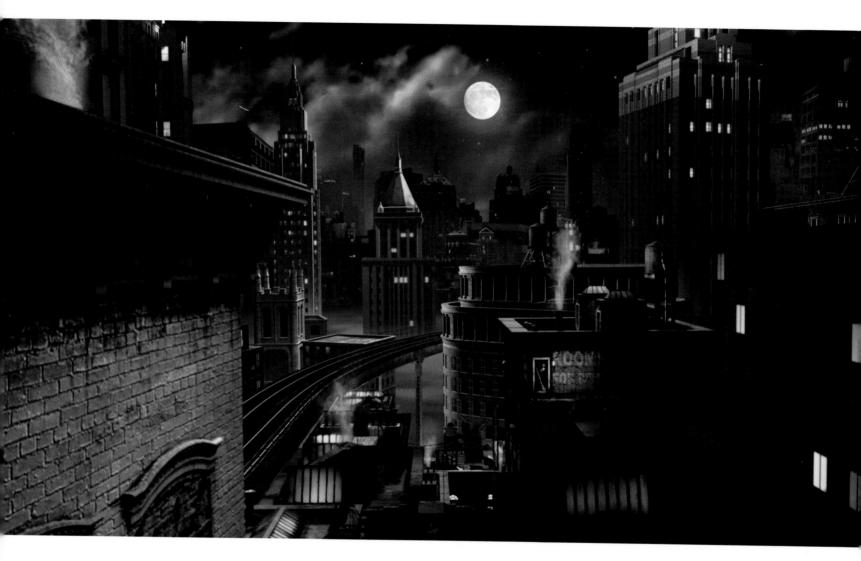

In these stills from Charlex's short film *Labratz* we can see how the skilled use of painterly backgrounds and carefully crafted composition with an almost monochromatic color palette creates a foreboding yet intriguing stage for the rodent protagonist.

Cyan Worlds

In 1987, brothers Rand and Robyn Miller formed a new media company, Cyan, on the outskirts of Spokane, Washington. Their initial foray into the entertainment industry was *The Manhole*, the first-ever entertainment CD-ROM. In 1991 Cyan began work on "Myst," a project that would expand the world of computer entertainment. With its complex backstory and stunning artwork, "Myst" set the standard for CD-ROM games, and with its sequel, "Riven," is among the best-selling computer games in history, having sold more than twelve million units worldwide. Cyan Worlds' latest project is a multiplayer boxed and online game entitled "Uru," which expands upon the foundational storyline of the D'ni with the promise of virtually endless environments and real-time interaction with other players in their quest to rebuild the vast subterranean city of D'ni.

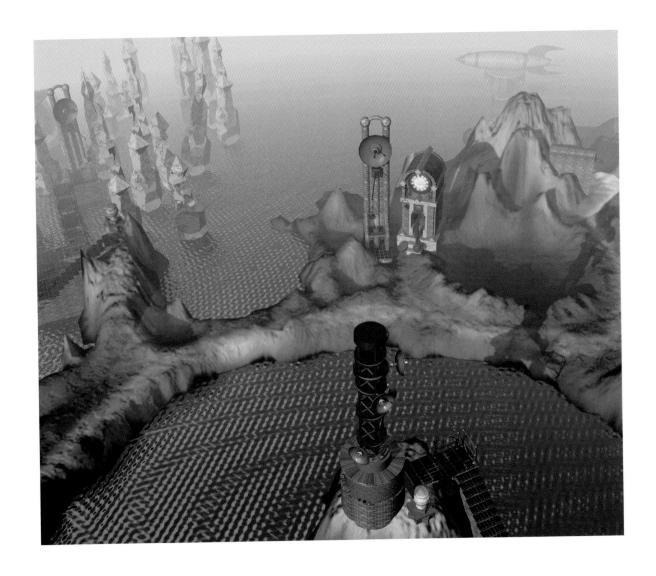

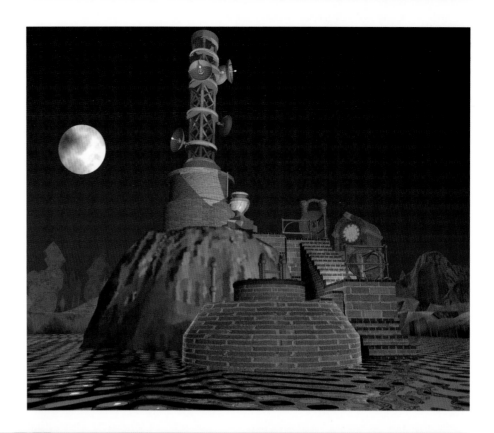

The lush and unusual world of "Myst" changed the way both players and artists viewed video games. Cyan proved that games could be compelling, mature, nonviolent, and downright gorgeous. These images are overviews from the Channelwood and Selenitic ages of "Myst."

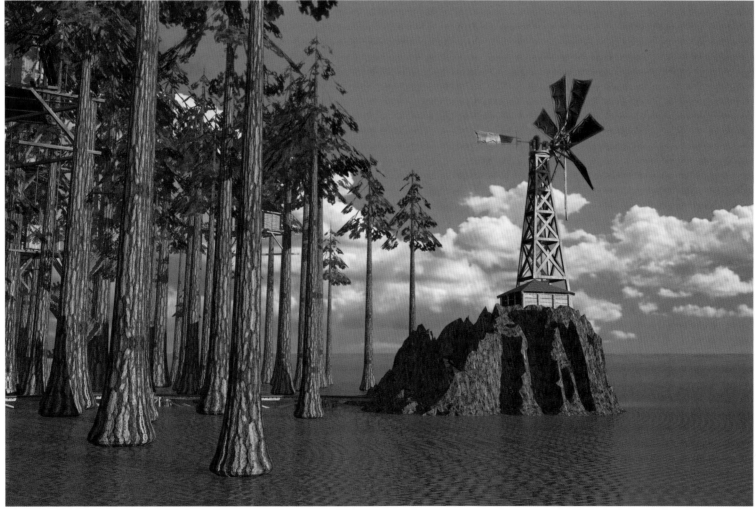

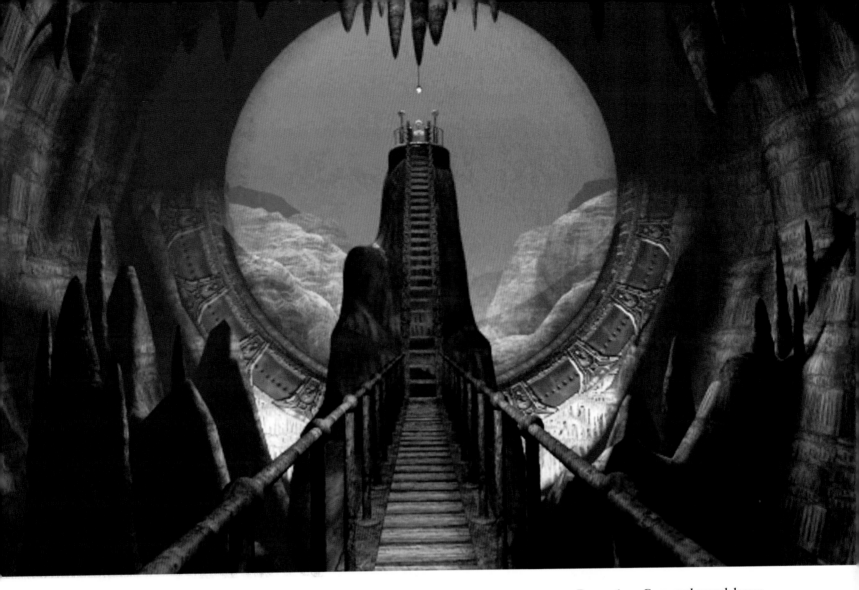

Pages 36–42: Cyan used a much larger production crew, all-new computers, and high-end software for "Riven," the sequel to "Myst." The game play and concepts were similar, as single players made their way through eerily empty worlds, but the increased software, hardware, and manpower capabilities helped Cyan make rich, photo-real environments that matched even the most elaborate Hollywood productions in lush detail. In spite of the artistic and financial success of "Riven" and "Myst," publishers and the gaming community have all but abandoned the puzzle-game genre; this may be due to the myriad of less successful copycat games. Such image-based games are still produced for young children, but they lack the sophistication and depth that Cyan pioneered.

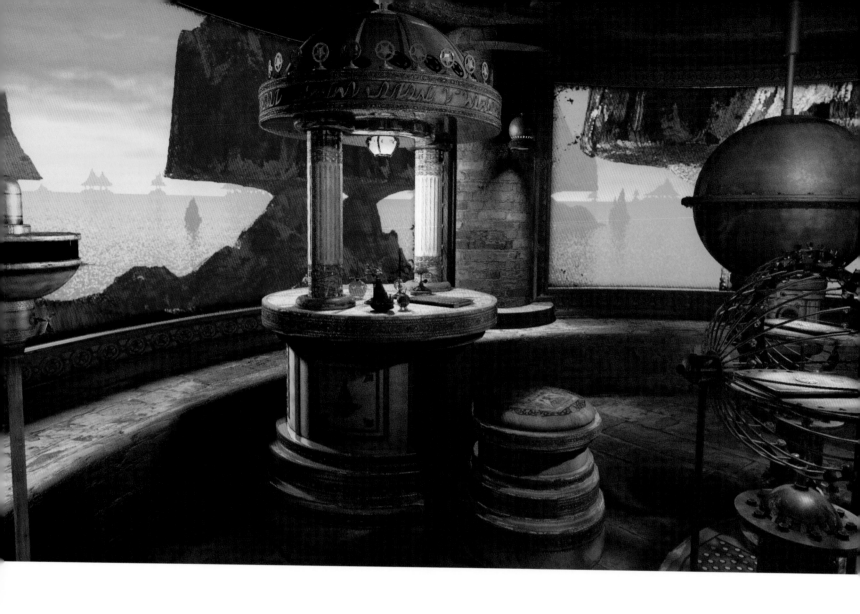

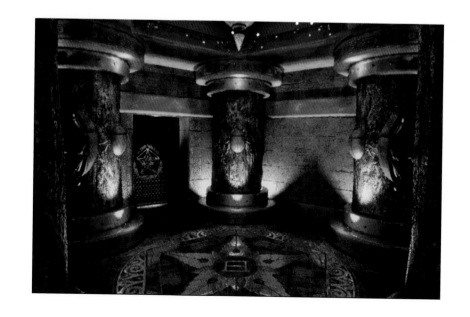

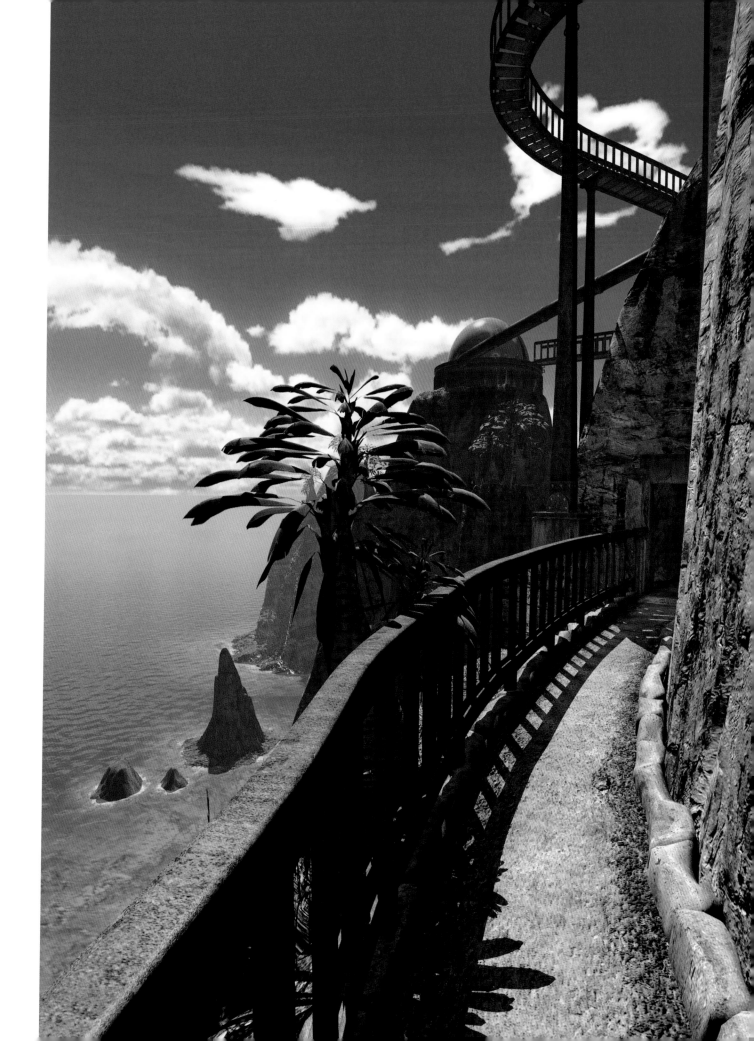

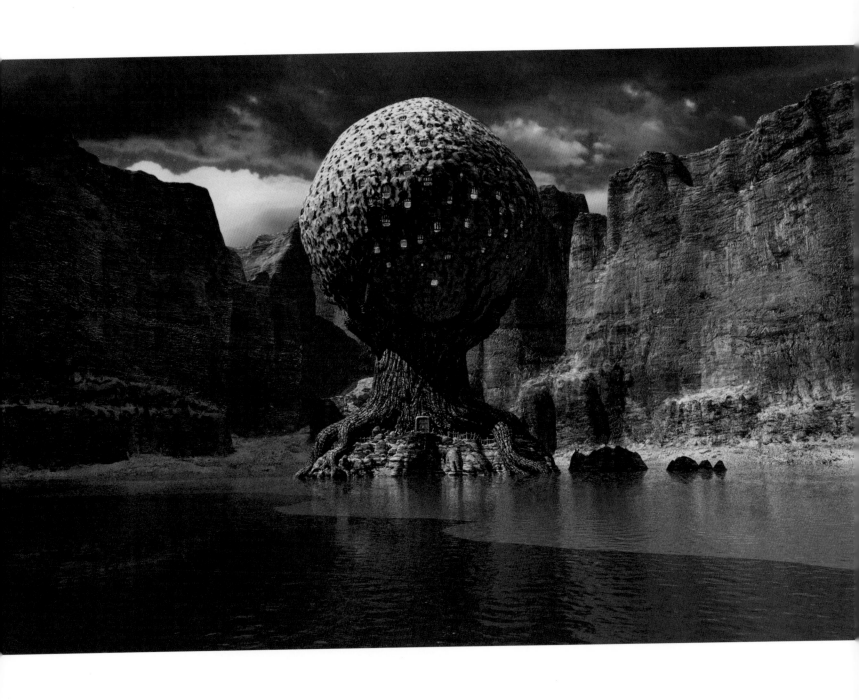

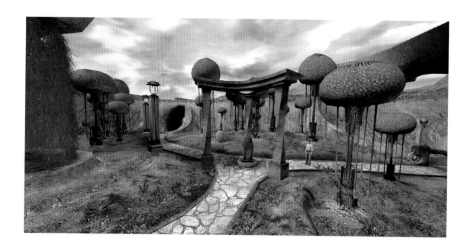

Cyan Worlds is famous for its stunning renders of magical environments built by a mysterious race named the D'ni. Their imaginative games take players through a serious of "ages" composed of abandoned fantastic structures and surreal landscapes. In a radical departure, Cyan developed "Uru," a massive multiplayer online game (MMOG) in which thousands of players can interact with each other rather than exploring alone. These "Uru" images were rendered in real time, allowing players to move freely through the world while the computer instantly renders every new view. With the advances in computer technology, the quality and detail of these images rival that of "Myst," in which each image took hours to render.

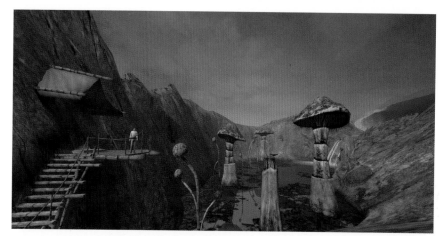

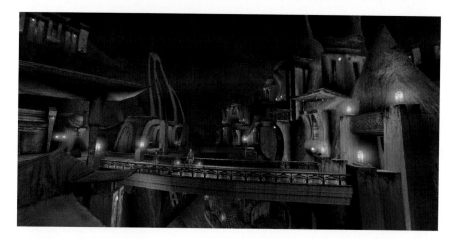

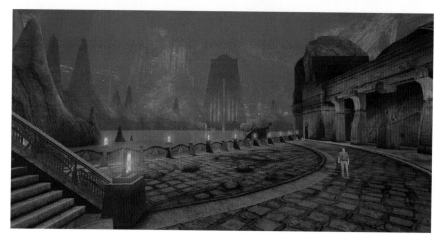

Digital Domain

In 1993, Stan Winston (four-time Academy Award winner, known for his stop-motion creature animation), visionary filmmaker James Cameron (best known for his use and understanding of spectacular visual effects), and Scott Ross (who had been instrumental in the implementation of digital production at Lucasfilm, where he had risen to the level of senior vice president in charge of ILM) founded what was to become one of the world's most prestigious and successful special effects studios, Digital Domain. Its success and rapid expansion were remarkable even by CGI industry standards. By 2003 the studio employed more than 500 and had produced special effects for films such as *True Lies, Interview with the Vampire, Apollo 13,* Cameron's *Titanic* (1997 Oscar winner for Visual Effects), *The Fifth Element, What Dreams May Come, Fight Club, X-Men, Red Planet, How the Grinch Stole Christmas, The Time Machine, The Lord of the Rings: The Fellowship of the Ring,* and *XXX.*

In the 2000 film *How the Grinch Stole Christmas,* directed by Ron Howard, the foreground of the Whoville set was shot in a studio. It was extended with the addition of CG models, terrain, and backgrounds. CG characters liven up the shot as they pass seamlessly from the real to virtual worlds. Courtesy Universal Studios Licensing LLP © 2000 Luni Productions GmbH + Co. KG.

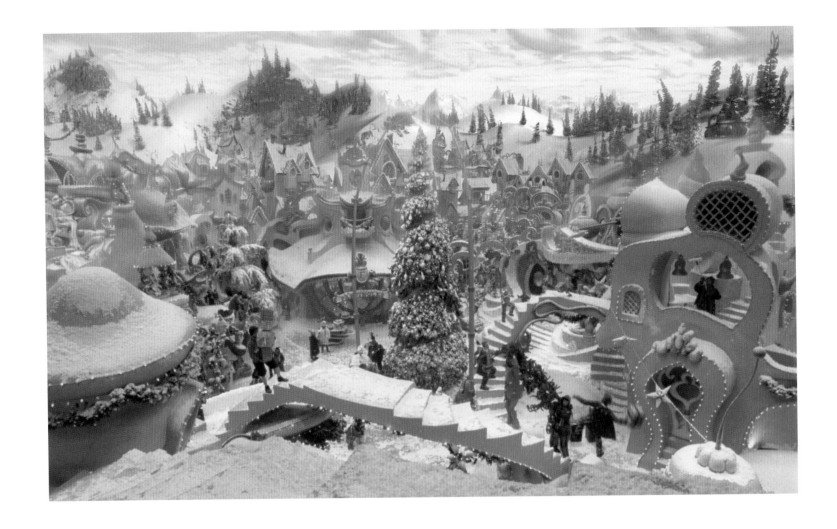

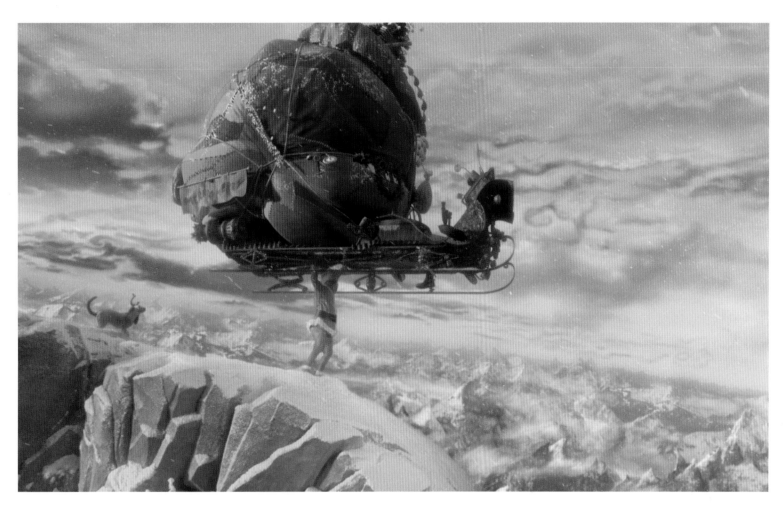

For *How the Grinch Stole Christmas*, shots of Jim Carrey in the studio, holding a lightweight plank in the air, were composited with a CG sleigh and a complete CG wintry background. Courtesy Universal Studios Licensing LLP © 2000 Luni Productions GmbH + Co. KG.

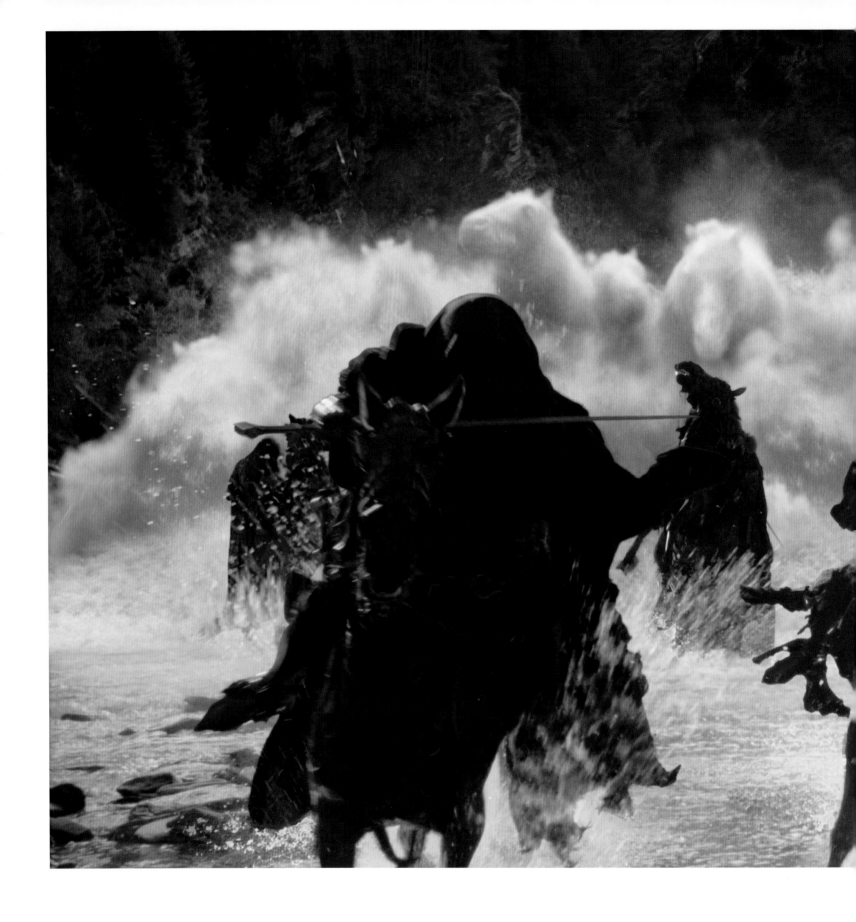

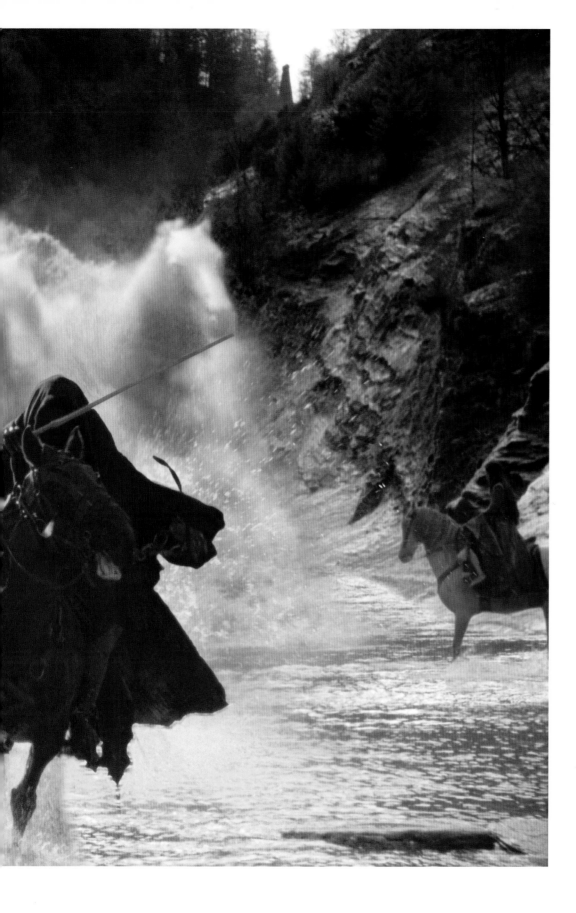

To create the water horse effect for *The Lord of the Rings: The Fellowship of the Ring* (2001), a torrent of CG water subtly morphs into a stampede of CG water horses, which were composited into the background plate of the riverbed. CG Ringwraiths on horse-back were also added to the shot. Courtesy New Line Cinema.

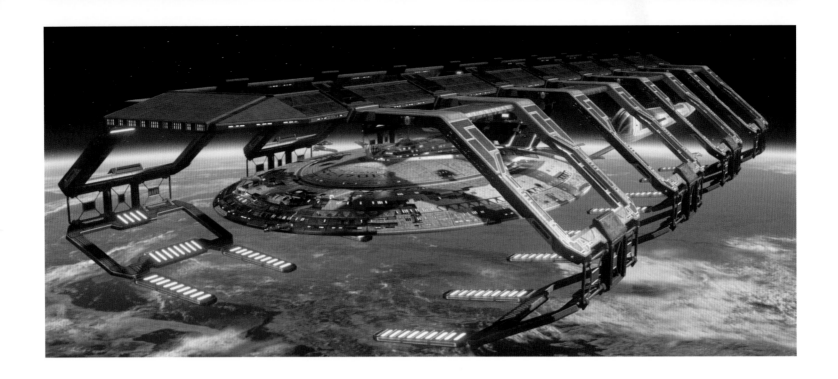

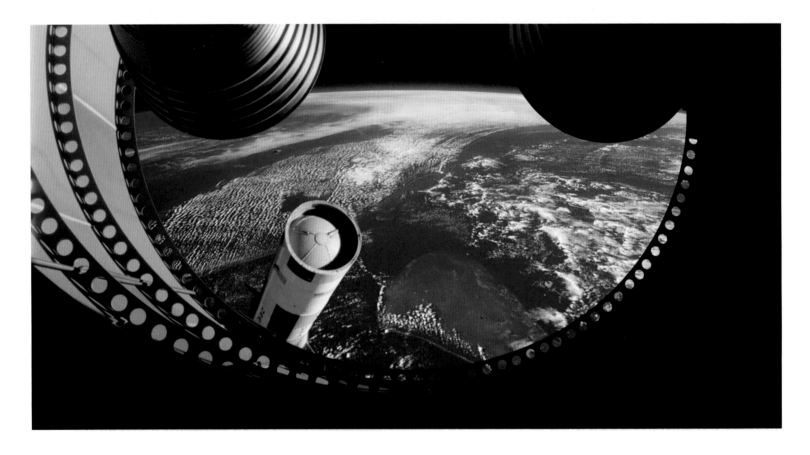

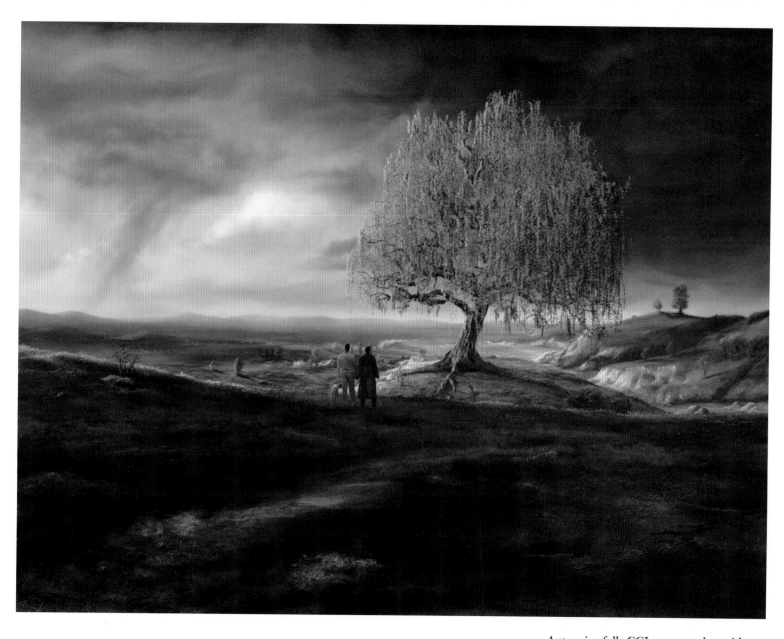

A stunning fully CGI tree, complete with surface textures and foliage, bloomed, swayed in the breeze, and cast its leaves into the wind for the 1998 feature film *What Dreams May Come*. Courtesy Universal Studios Licensing LLP © 1998 Interscope Communications, Inc.

Opposite top: A fully digital *Enterprise* is under repair in a digital space dock. Background views of the Earth were derived from large-resolution NASA images with CG clouds added.

Opposite bottom: Live-action and digital images come together for the rocket stage separation in Ron Howard's *Apollo 13*. © 1995 Universal City Studios, Inc.

Double Negative

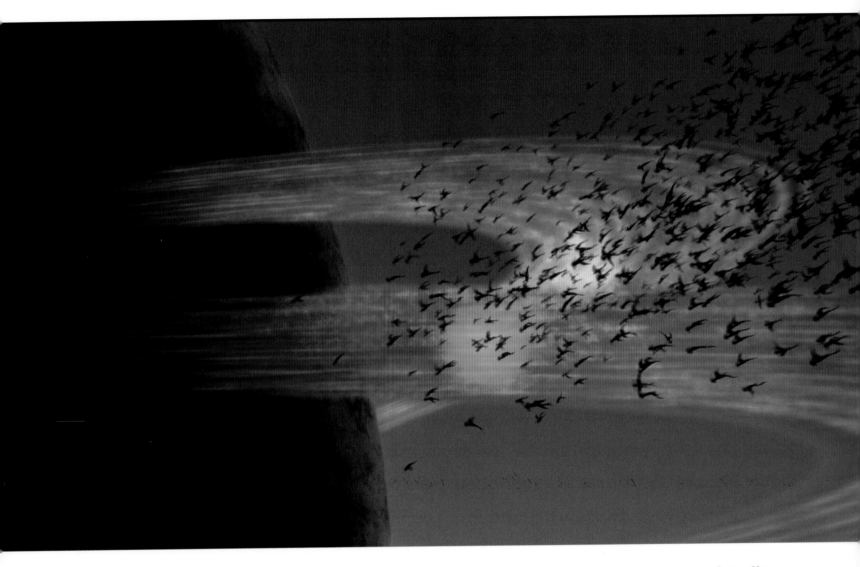

Since its founding in 1998, Double Negative has firmly established itself as a leading player in visual effects production worldwide. Credits to date include *Enemy at the Gates*, for which it was recognized at SIGGRAPH 2001, *The Hours*, *Johnny English*, *Die Another Day*, *Captain Corelli's Mandolin*, *Bridget Jones's Diary*, *Pitch Black*, *The League of Extraordinary Gentlemen*, *Tomb Raider II*, and *Cold Mountain*. Double Negative concentrates on the creation of visual effects that work seamlessly within live-action films. *The Independent* pointed out that Double Negative's effects are "so special that you barely notice them."

In the 2000 horror/science-fiction film *Pitch Black*, swarms of winged alien predators fill the night sky thanks to custom artificial-intelligence flocking software developed by Double Negative. A matte painting of the ringed planet was supplied by Magic Camera Company. Courtesy Universal Studios Licensing LLP © 2000 Universal City Studios Productions, Inc.

With a gremlinlike aversion to bright light, the all-CGI monsters of *Pitch Black* hunt only in the inky darkness. Here, an alien emerges from the shadows as it stalks its prey. A full-size sculpture was made, which was then scanned into the computer. The data was used to create the highly detailed digital creature. Courtesy Universal Studios © 2000 Universal City Studios Productions, Inc.

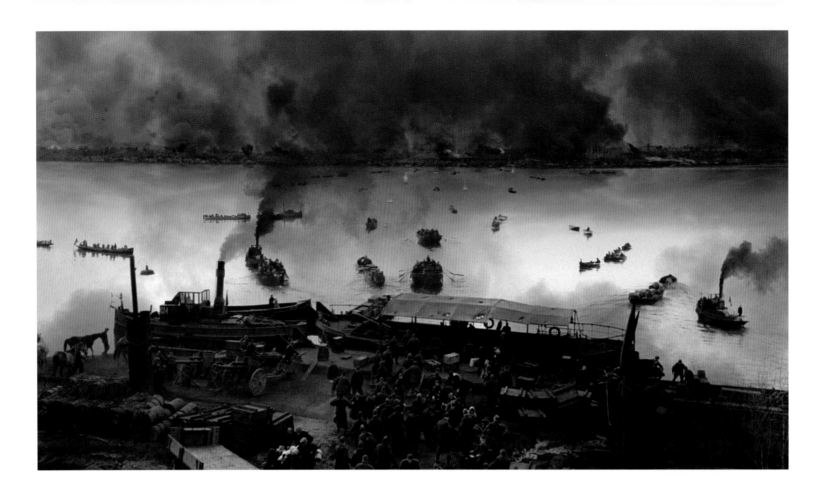

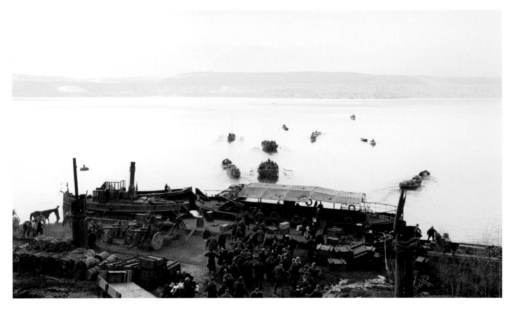

For the 2001 feature *Enemy at the Gates* directed by Jean-Jacques Annaud, Double Negative added CG smoke and destruction to change an unassuming river crossing into the hell that was the Siege of Stalingrad. These before-and-after shots show the extent of digital color correction as well as the seamless integration of virtual and real elements. A sweeping take from a camera crane was shot on location beside a flooded quarry in Germany, standing in for the River Volga in Russia. Double Negative match-moved the shot (a CG artist matched the movement of the real camera with that of a virtual camera, making the addition of digital objects possible) and then added a highly detailed matte painting of the burning city of Stalingrad to the far shore. Isolated elements of boats in the water, explosions, and smoke plumes were shot on location and then added into the composite, using the matchmove data to place them accurately. Finally swarming fighters and dive-bombers were created in CG and added to the far distance to complete the scene of chaos and destruction. Courtesy Paramount Pictures.

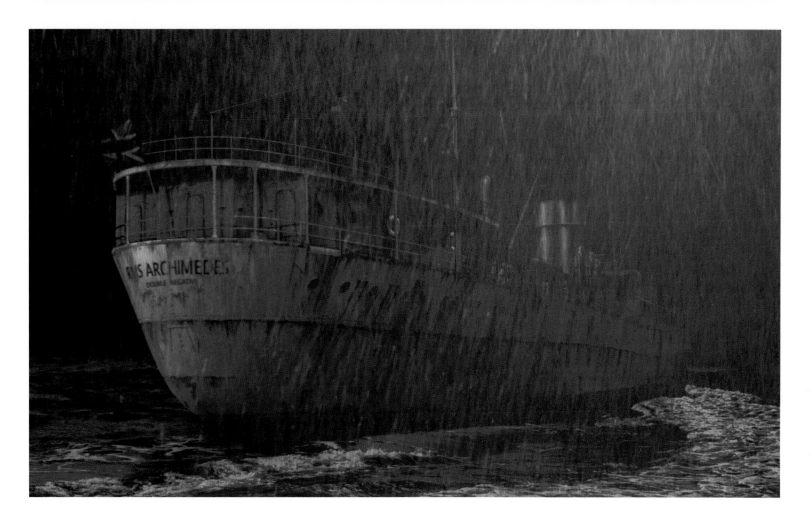

Double Negative created the CG boats and submarines ominously making their way through the icy-cold Atlantic in the 2002 horror film *Below*. They shot live-action water elements at the London docks, using a tugboat to create surging wake patterns. The plate was matchmoved and a CG ship was composited along with rain elements that were shot against a black screen. Courtesy Miramax Films.

Fathom Studios

Atlanta-based Fathom Studios has been creating award-winning computer animation for more than a decade. A division of the interactive agency Macquarium Intelligent Communications, the studio focuses on developing original content for television, film, and the Internet through passion and creativity. Fathom is currently in production on a fantasy adventure film, *Delgo*, the first independently produced computer-animated feature in the U.S. The film is contains all CG sets and fully animated characters.

This is a scene of the Lockni village from the feature film *Delgo*. Note how the colors of the structures are desaturated in the distance, an effect that mimics atmospheric perspective and gives the illusion of depth. Courtesy of Fathom Studios, Macquarium Intelligent Communications.

A crowded bazaar is a challenge to animators and modelers alike. Courtesy of Fathom Studios, Macquarium Intelligent Communications.

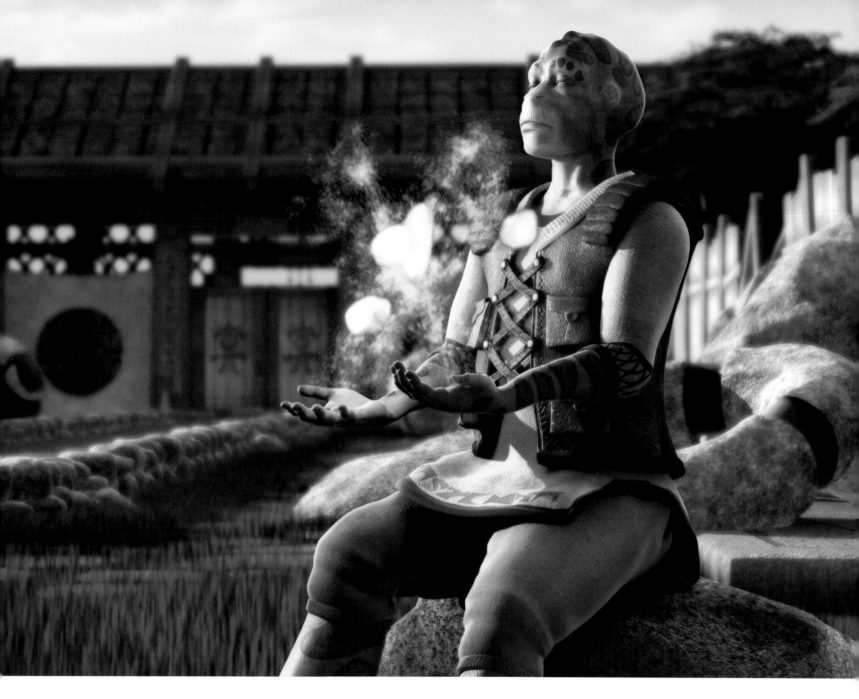

Like a magical Zen master, the character Marley can manipulate the physical world through meditation. Courtesy of Fathom Studios, Macquarium Intelligent Communications.

422 South

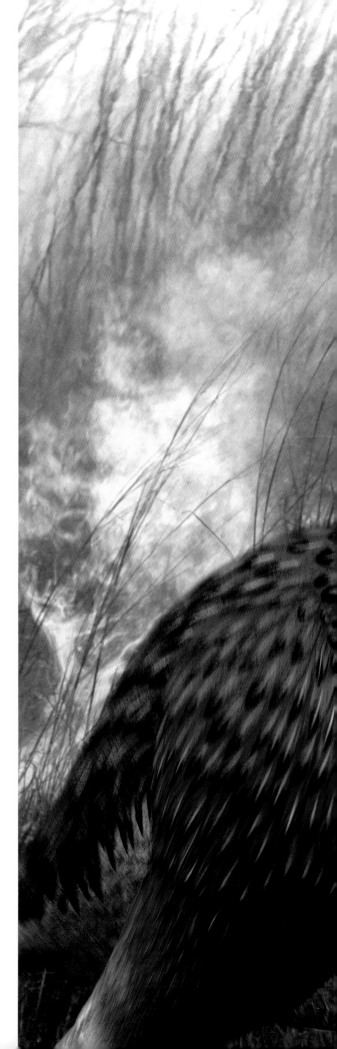

422 South is one of the most respected specialist providers of design and CGI to broadcast television producers. Founded in 1988, and now part of the Barcud Derwen media group, the company is based in a converted Victorian church in Bristol, England, with a smaller satellite operation in central London. The company employs approximately twenty-five full-time staff members. Their award-winning work can be seen on major UK TV channels, as well as in Europe and in the United States on National Geographic TV and Discovery Channel, among other channels.

Carakillers are flightless birds from five million years in the future. They use the frequent grassland fires to their advantage, hunting along the fireline and snatching prey from the advancing flames. These and the other creatures here are from the television series *The Future Is Wild*.

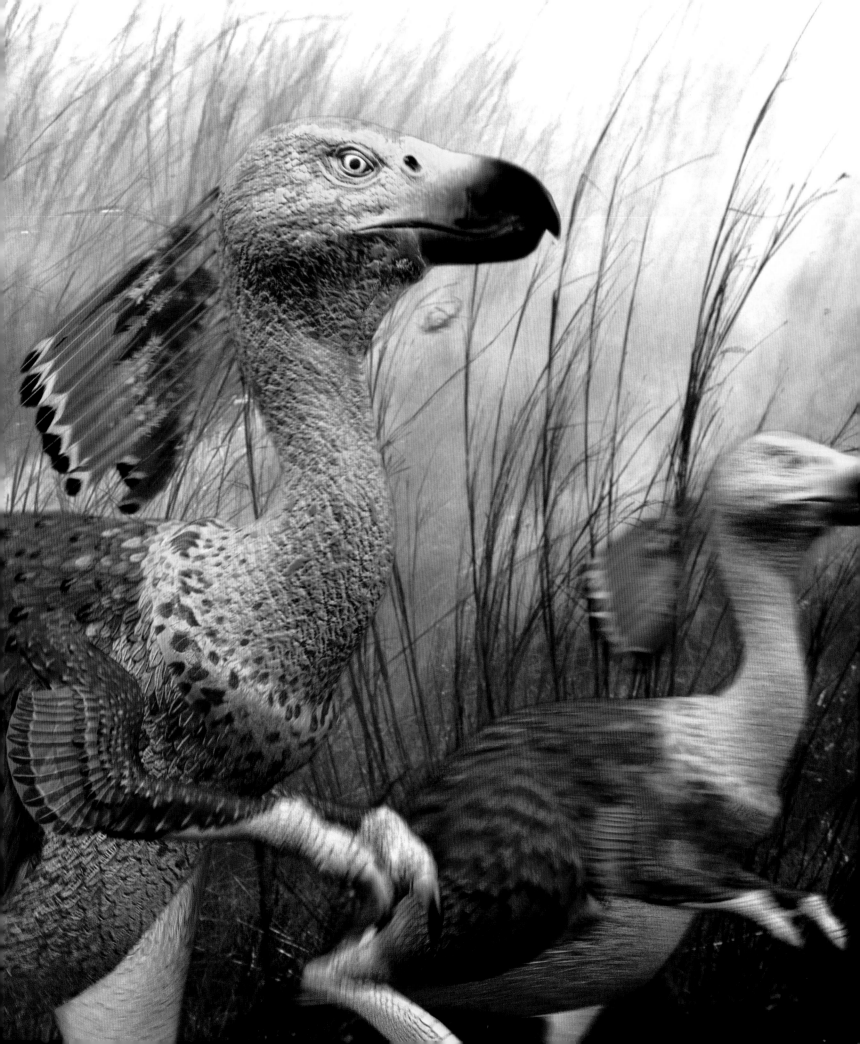

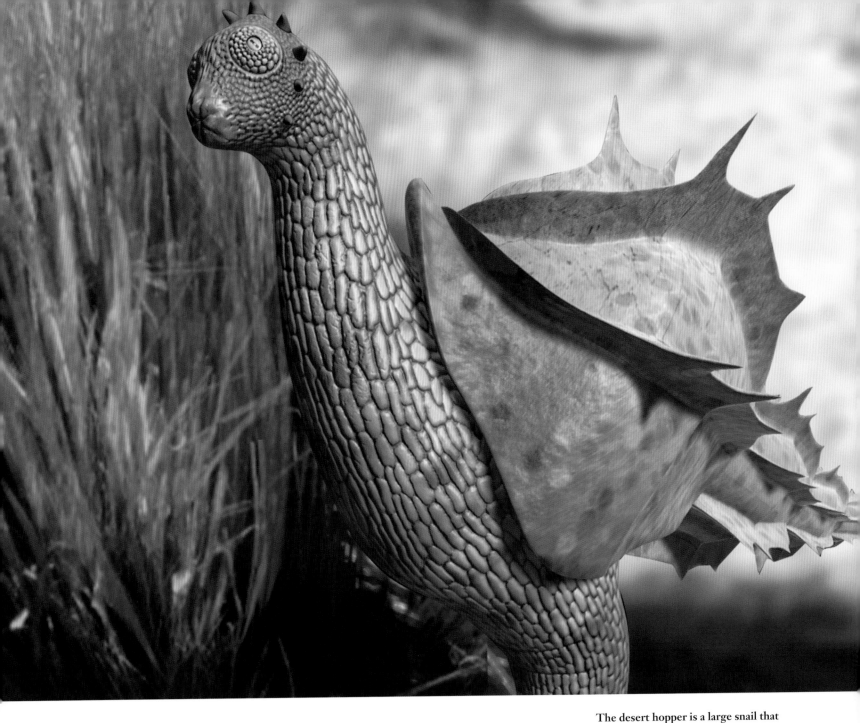

The desert hopper is a large snail that hops around on its muscular foot 200 million years in the future. This creature can eat the toughest plants of the Rainshadow Desert, finding nutrition in the most unpalatable-looking growth.

The Future is Wild Limited is an independent media production and rights management company. It has successfully created a unique and innovative thirteen-part television series *The Future is Wild*, combining art, scientific rigor, and education in an original, entertaining, and informative manner.

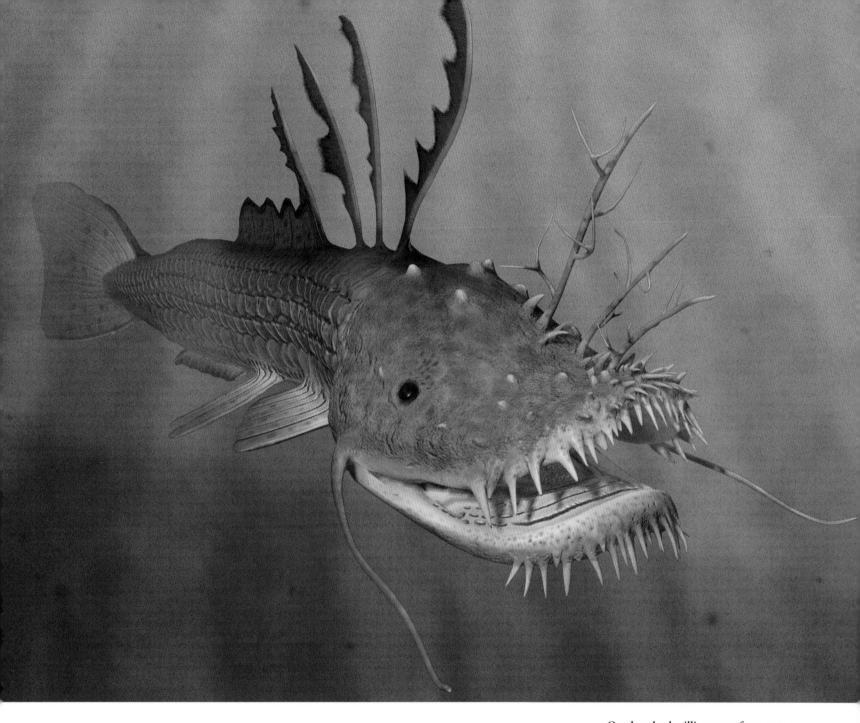

One hundred million years from now a lurkfish lies in wait, its amazing camouflage making it almost invisible. When it finally pounces, the lurkfish subdues its prey with a huge electrical charge.

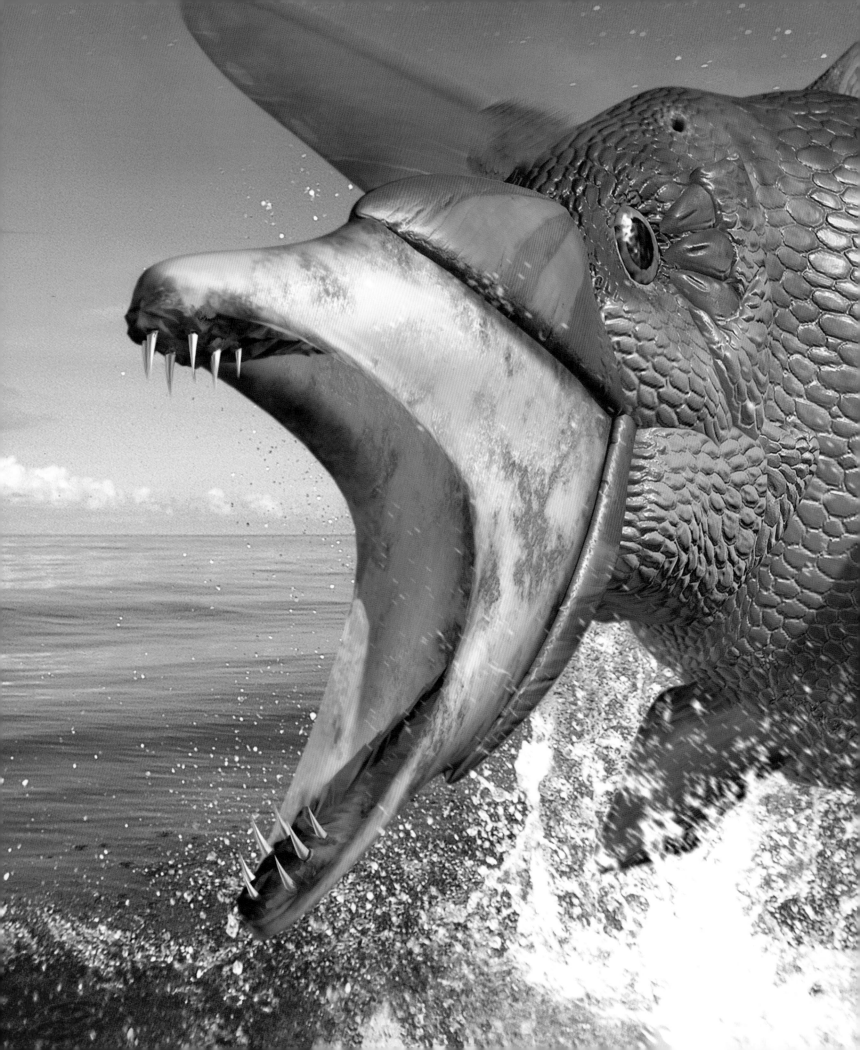

Two hundred million years in the future, these ocean fish fill the niches left by the extinction of birds and take to the air in true flight. They have sharp teeth on powerful protrusile jaws that snap out to pluck prey from the waves.

Framestore CFC

Framestore CFC was formed in December 2001 through the union of two of the most creative and dynamic companies in the industry: FrameStore and The Computer Film Company (CFC). The company is now the largest visual effects and computer animation company in Europe, with more than thirty years of combined experience in digital film and video technology. The company has won numerous international awards including two Technical Academy Awards from the Academy of Motion Picture Arts and Sciences, and ten Primetime Emmy Awards. Framestore is located in London, England, with a satellite office in New York City.

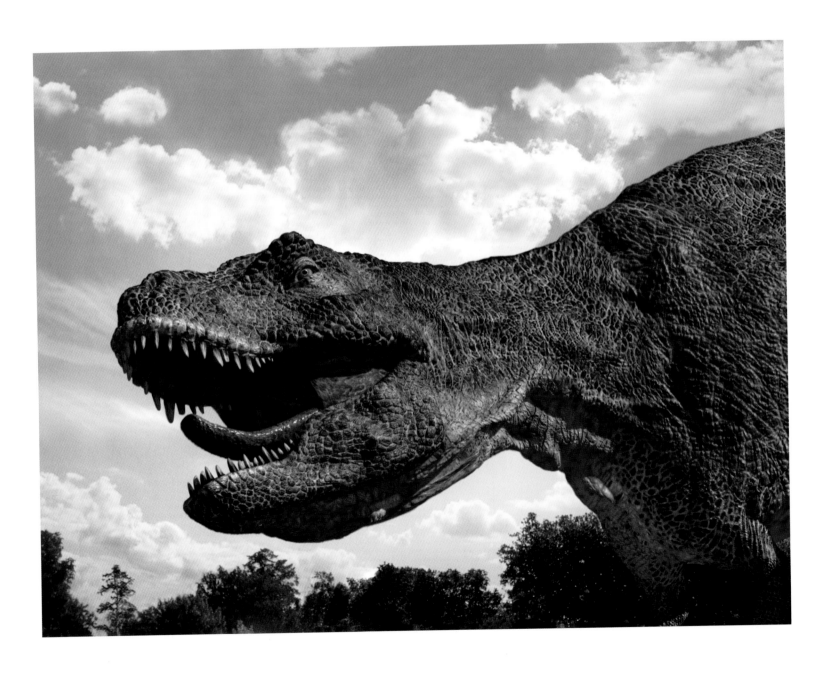

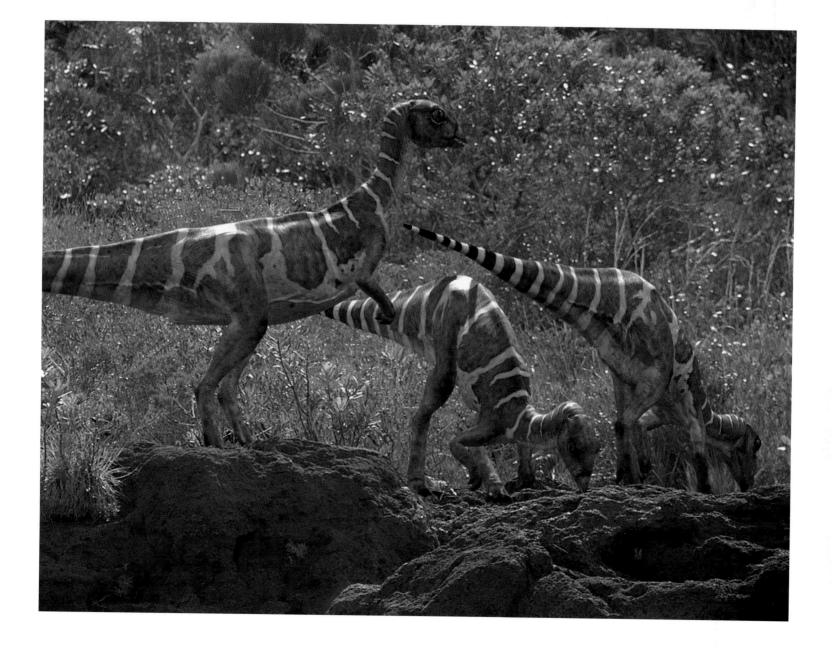

Walking with Dinosaurs, a major CG anima-
tion series for BBC Science, was produced
in collaboration with Framestore CFC as
part of the BBC's flagship science program.
The series consisted of six thirty-minute
documentaries covering the natural history
of the Triassic, Jurassic, and Cretaceous
eras. Framestore CFC re-created the animals
of that world, including the Opthalmasaur
(overleaf), *T. rex* (opposite), and

Hypsilophodon (above), and showed what it
would have been like to walk (and swim)
among them. The design and movement of
the dinosaurs was based on information from
paleontology experts on both sides of the
Atlantic, and the resulting footage — nearly
two and a half hours of photo-realistic CG
animation — represents two years' work by a
dedicated team of CG professionals. ©BBC
1999 Courtesy of the BBC.

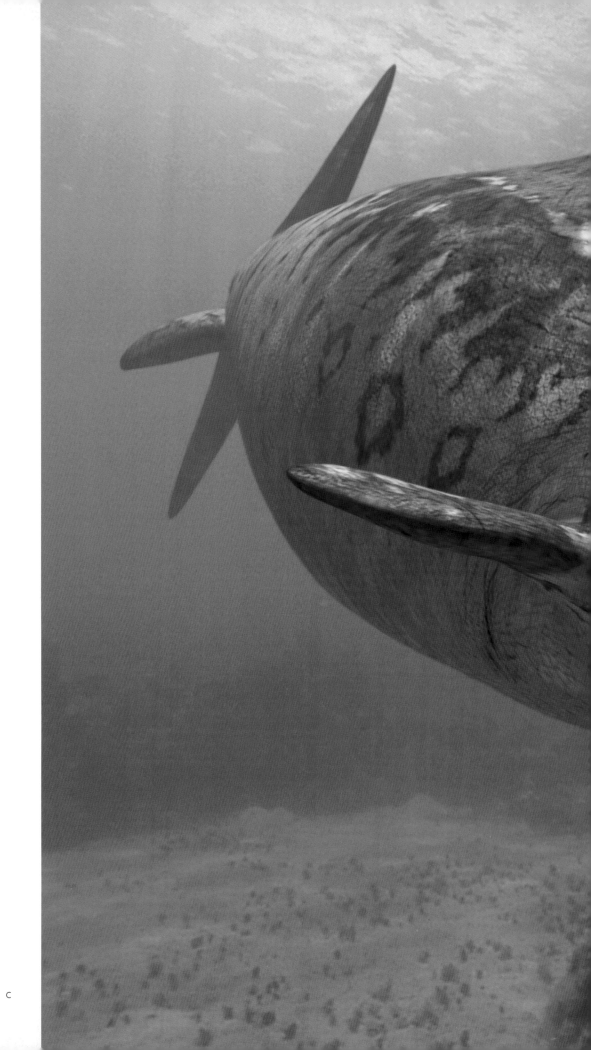

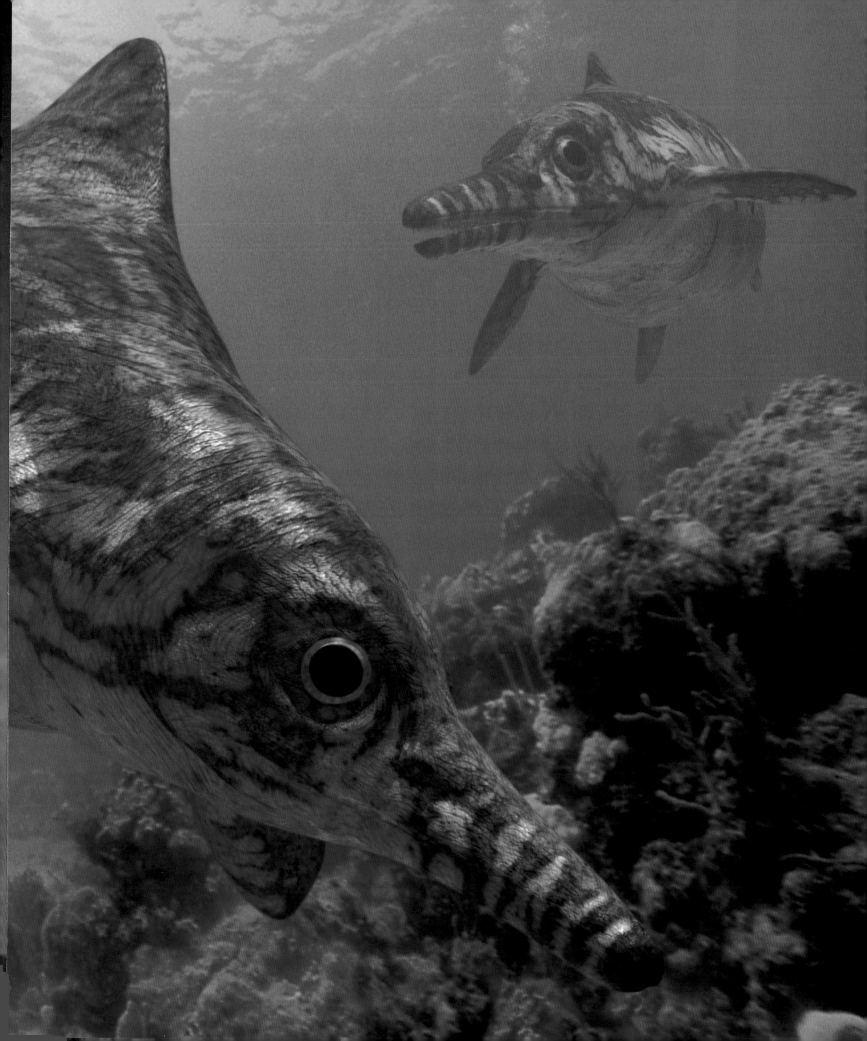

Framestore had the task of creating believable dinosaurs that read books, wear clothing, and do domestic chores for Hallmark's popular miniseries *Dinotopia*, the story of a secret world where dinosaurs and humans live together in harmony. Their all-digital creatures were composited with live-action people and real sets to make these convincing images. *Dinotopia* incorporates a staggering total of 1,800 visual-effects shots, more than two-thirds of which contain computer-generated elements created by a team of 130 CG and compositing artists. Courtesy Hallmark Entertainment.

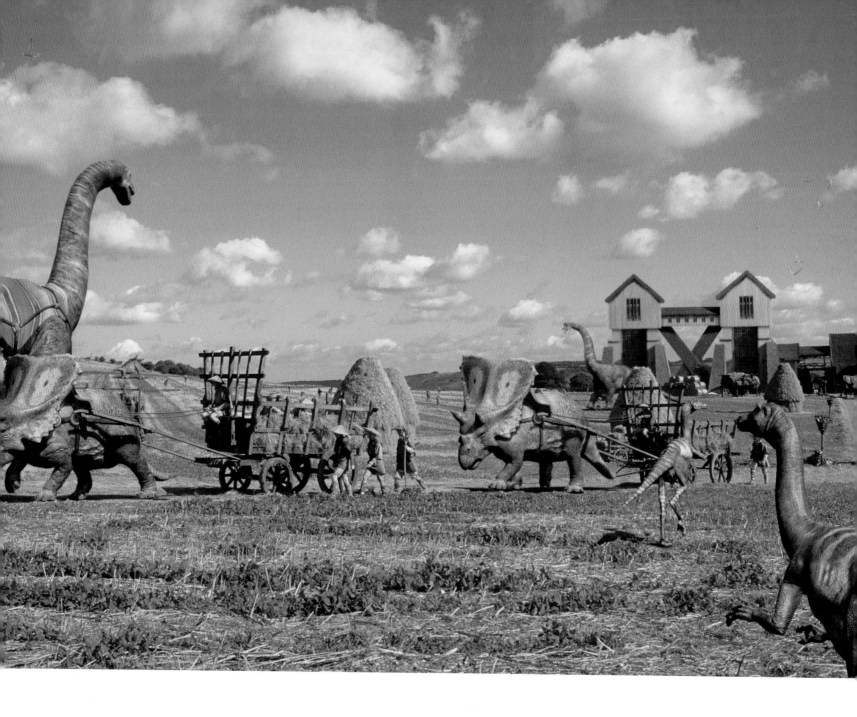

Industrial Light & Magic

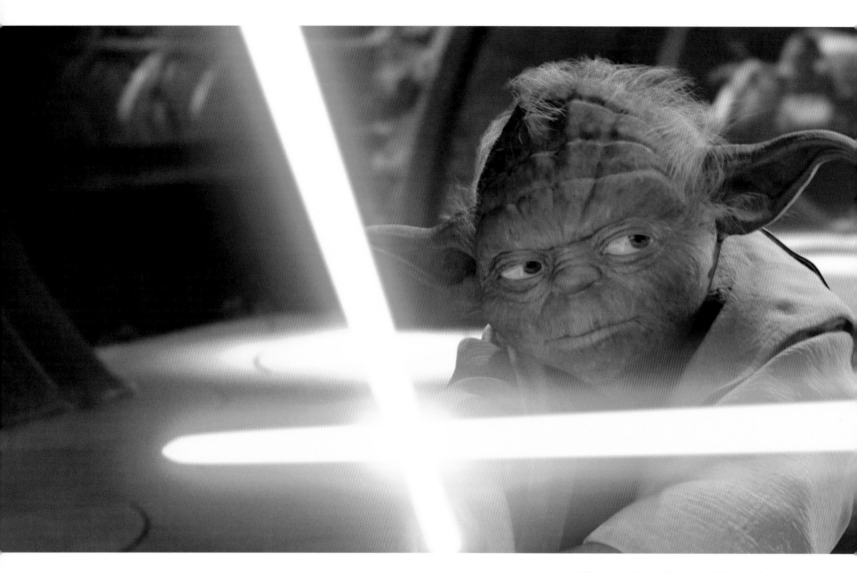

The venerable Jedi master Yoda had always been played by a relatively sedentary puppet until his digital stunt double was called to arms for a light-saber duel with the evil Count Dooku in *Star Wars: Episode II — Attack of the Clones.* The all-CGI Yoda delighted audiences by leaping and twirling about the screen while accurately maintaining the dignified yet scruffy appearance of his original. All Star Wars images (pp 16–17, 72–80): Courtesy of Lucasfilm Ltd. Star Wars © Lucasfilm Ltd. & TM. All rights reserved. Used under authorization. Unauthorized duplication is a violation of applicable law.

It is hard to imagine the history of computer animation and special effects without Industrial Light & Magic (ILM), which George Lucas founded in 1975 as part of Lucasfilm Ltd. In 1977 ILM produced the special effects for *Star Wars*, which forever changed expectations for blockbuster visual effects, and followed up with even more astounding work: the attack of the Imperial Walkers in *The Empire Strikes Back* (1980) is often regarded as the pinnacle of photo-real stop-motion effects.

While the ILM model shop and creature shop continue to be among the best in the world, the studio has also become a leader in digital effects and animation. In 1982 ILM delivered the first all-CGI feature film effect for *Star Trek: The Wrath of Khan*, and in 1993 it changed the world of filmmaking with its seamless photo-realistic dinosaurs for *Jurassic Park*. They proved that CGI characters could look as good as physical models while moving in a more realistic manner.

ILM's reputation has attracted some of the most talented individuals in the film, animation, and computer industries. Their influence is profound; in fact, many of the founders and key personnel from other famous production houses in this book are ILM alumni. ILM, however, is much more than a training ground. With more than 1,200 employees, it is one of the world's largest and most prolific production houses, with an unwaveringly high standard of quality that has earned it fourteen Academy Awards for Best Visual Effects and sixteen Academy Awards for Scientific and Technical Achievement.

To create the illusion of Jedi knights speeding through the crowded city on their flying machines, ILM added motion blur to the digital elements in this shot. When real objects move very fast, the 24-frame-per-second film camera captures a streaked image. A CGI render would show the same fast-moving object in perfect focus. The CG artists will add the blur and even the look of film graininess in order to generate a final image that the audience will accept as photo-real. © Lucasfilm Ltd. & TM. All Rights Reserved. Digital work by Industrial Light & Magic.

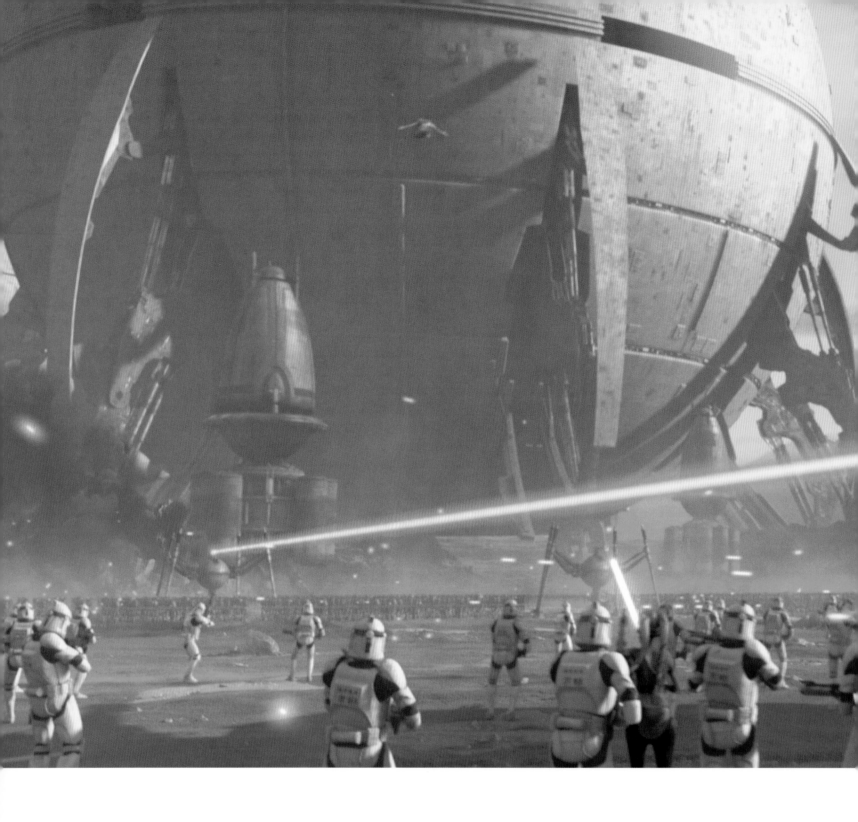

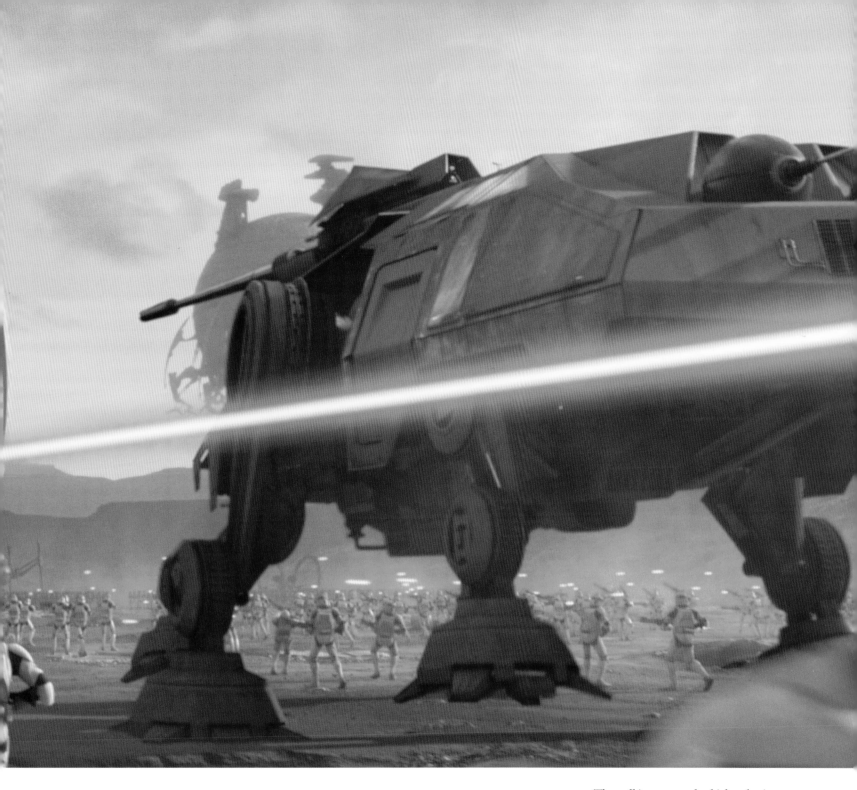

The walking armored vehicles, darting beams of light, spherical spaceships, and swarms of white-clad storm troopers are all icons of the *Star Wars* saga. However, *Star Wars: Episode II — Attack of the Clones* sported all-digital effects for this shot, not stop-motion models composited with live actors. Courtesy Lucasfilm Ltd.

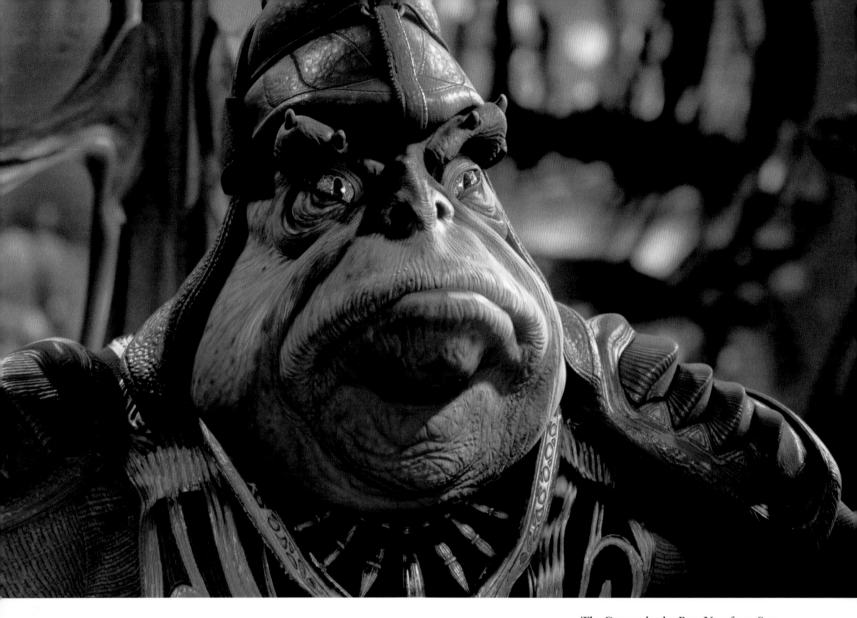

The Gungan leader Boss Nass from *Star Wars: Episode I — The Phantom Menace* was an animation and modeling tour de force with his floppy jowls and flowing garments. Even though creating this character was a difficult technical challenge, the end result was a performance and look far superior to a puppet or an actor with a rubber mask. Courtesy Lucasfilm Ltd.

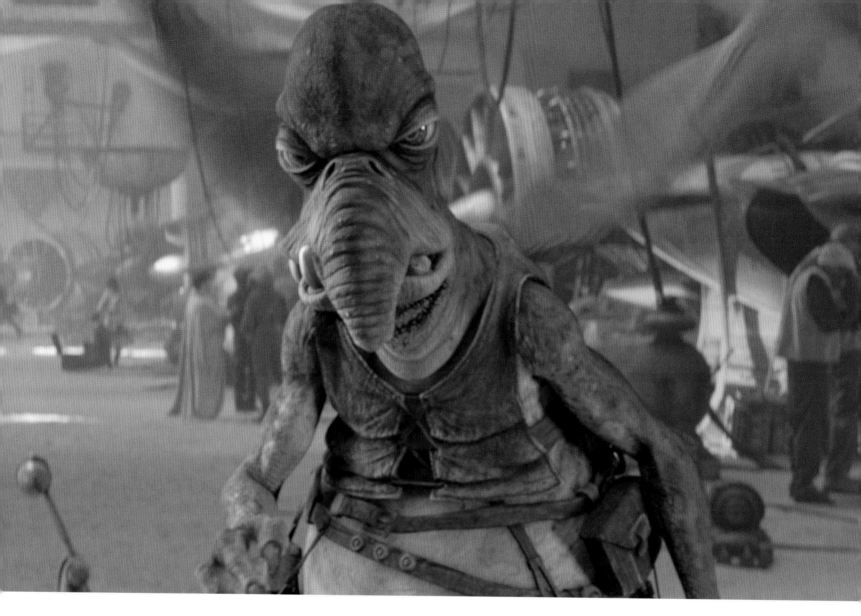

Like a bumblebee (only much less attractive), the alien Watto manages to buzz through *Star Wars: Episode I* on improbably small wings. The character was exceedingly difficult to animate because his every move seemed to break the laws of physics. Courtesy Lucasfilm Ltd.

A digital monster worse than any computer virus does not fare too well against Anakin Skywalker in gladiator-like combat. Courtesy Lucasfilm Ltd.

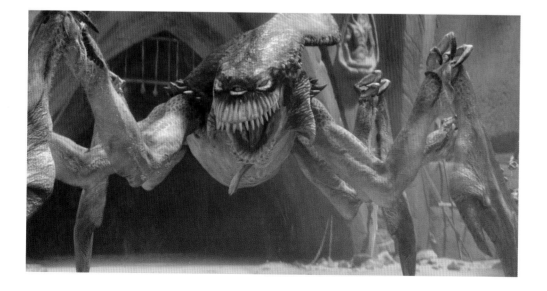

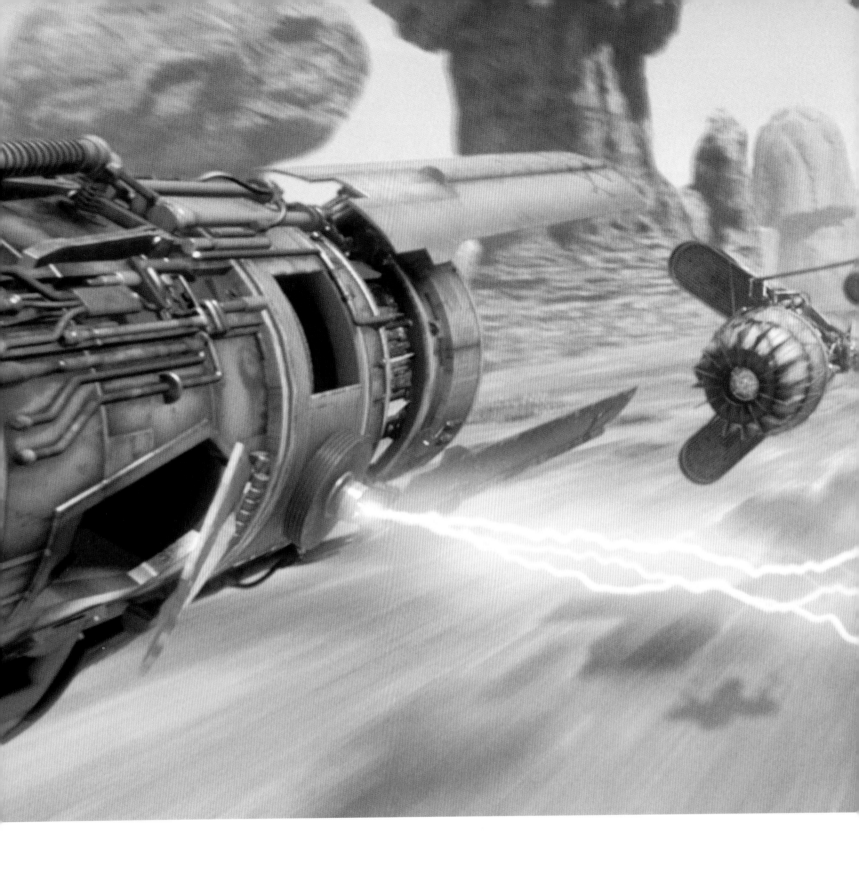

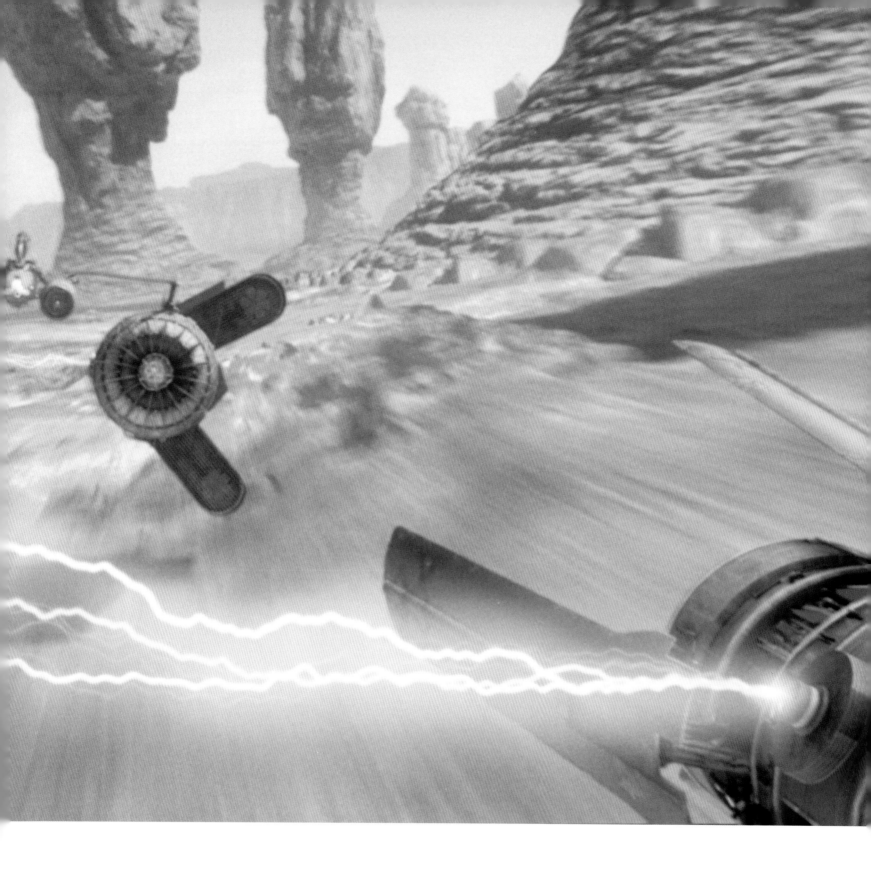

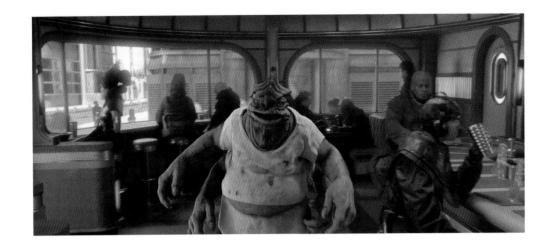

It seems that a long time ago in a galaxy far, far away they had diners just like ours. However, their cooks sported a distinctly green visage and extra arms, and their patrons looked even more alien than anything we might see at the all-night diner. To achieve this otherworldly greasy spoon, ILM added a mix of all-digital and real actors on a real set with an animated background plate. The foreground character is all digital, down to the grease stains on his T-shirt. Courtesy Lucasfilm Ltd.

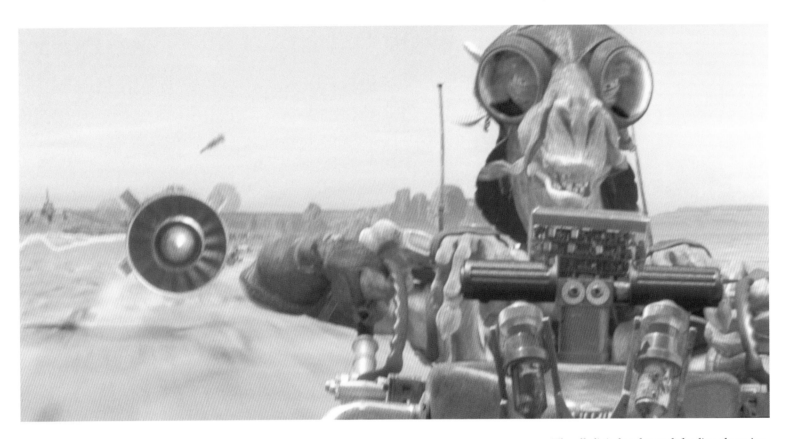

The all-digital pod race defending champion Sebula is an alien who walks on his hands, steers with his feet, and can't resist an opportunity to literally knock off his competitors. He is only one of the hundreds of digital and real elements that comprised the climactic pod race from *Star Wars: Episode I*. The backgrounds for the pod race (previous spread) were complex composites involving hundreds of shots from the American Southwest, along with dozens of digital matte paintings. Courtesy Lucasfilm Ltd.

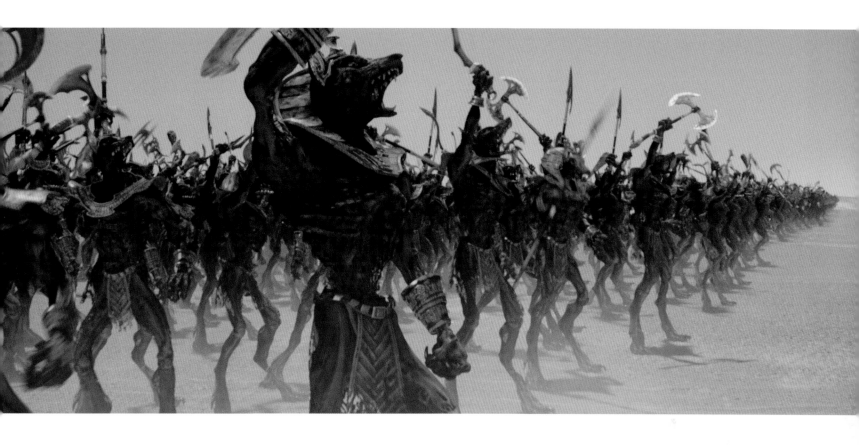

The characters in the army of the dead from the *The Mummy Returns* (2001) in various points of view, from a tight single close-up to a broad vista of thousands of warriors in a massive battle scene. CG artists take into account how and where their models will be seen and vary the complexity of the image depending on how close it is, how well it will be seen, or even how long it will be on camera. The level of detail (LOD) is adjusted accordingly to save computing, modeling, and animation time. Courtesy of Universal Studios Licensing LLP. © 2001 Universal City Studios.

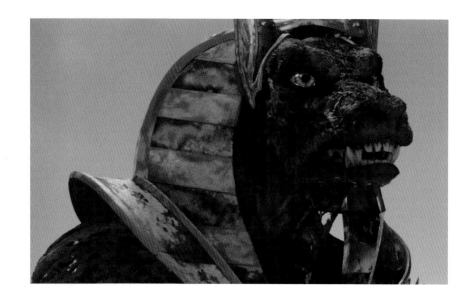

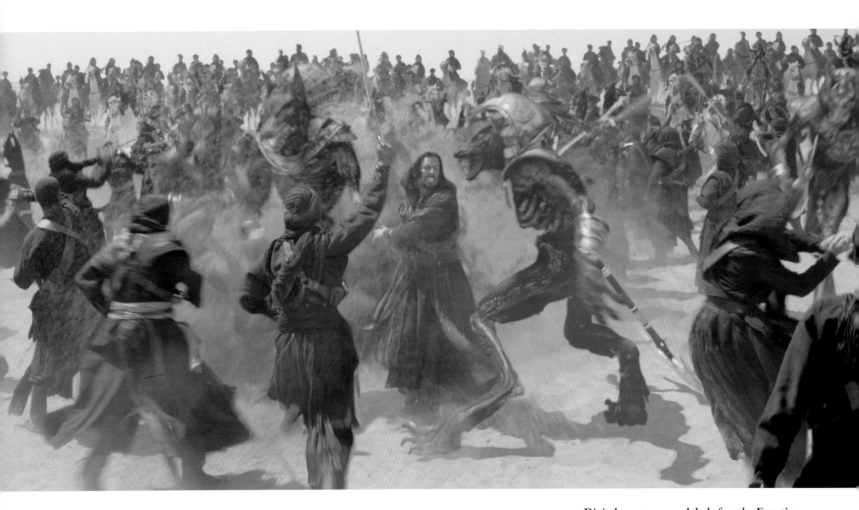

Digital creatures modeled after the Egyptian god Anubis mix it up with their live-action nemesis in *The Mummy Returns*. The scene was originally filmed with a smaller group of actors battling real blue-clad stuntmen. 2D artists removed the stuntmen from the plate and the 3D animators replaced them with the army of the dead. The image was then composited with other plates to add both CG and live-action extras to fill out the frame. Courtesy of Universal Studios Licensing LLP. © 2001 Universal City Studios.

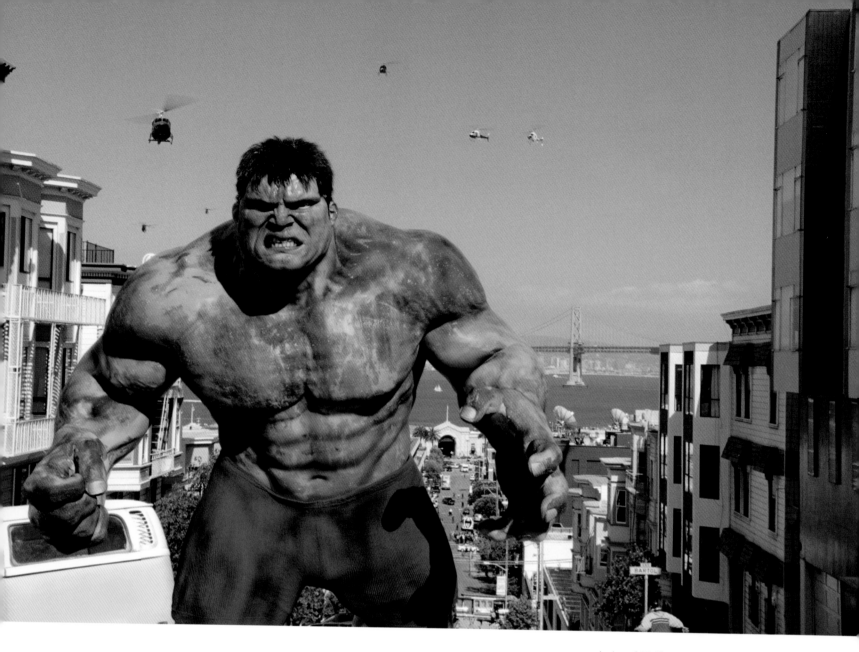

A virtual Hulk stomps through a very real plate of San Francisco while fighting CGI tanks and helicopters in Ang Lee's *The Incredible Hulk* (2003). The artists match the light, shadow, hue, and saturation of the live-action and CG plates to create the illusion that the character is part of the scene. Courtesy Universal Studios Licensing LLP. © 2003 Universal Pictures.

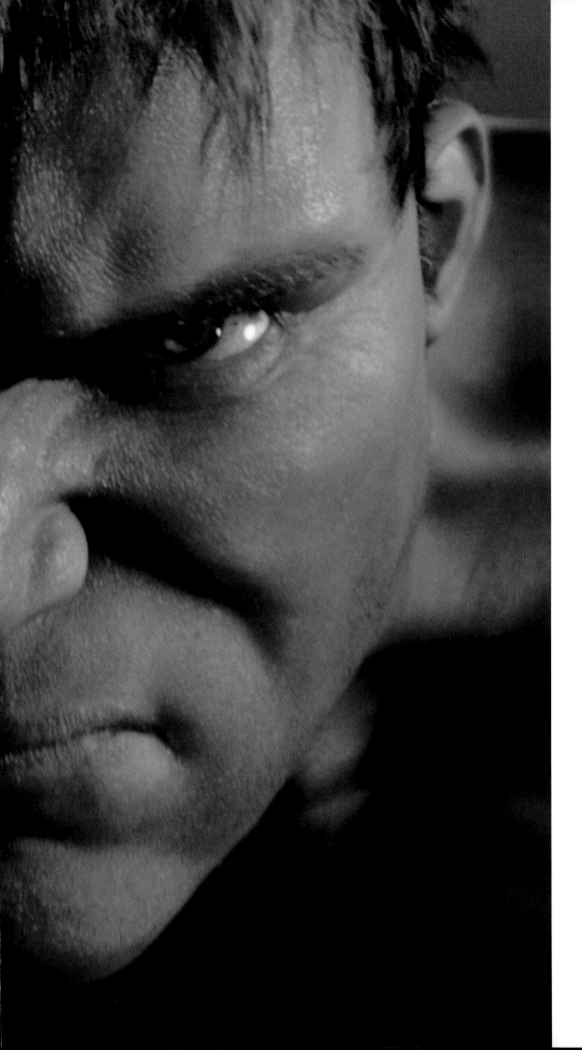

This is not a beefy actor in green make-up. Bruce Banner becomes an all-computer-generated big green ball of id every time he gets really mad. Note the subtlety of the skin texture, hair, and eyes, and the sophisticated musculature that may only be seen at a glance on the big screen but can be fully appreciated in the still image. Courtesy Universal Studios Licensing LLP. © 2003 Universal Pictures.

Kleiser-Walczak

In 1987 Jeff Kleiser and Diana Walczak started a special-effects studio in Hollywood, California, and a few years later moved their headquarters and main production facility to an expansive, twenty-eight-building museum and artist-community complex known as MASS MoCA in western Massachusetts. In this picturesque location the firm has been consistently turning out extraordinary CG special effects for film and location-based entertainment. Its feature film work includes *Stargate* (1994), *Clear and Present Danger* (1994), digital stunt doubles and effects animation for *Judge Dredd* (1995), and the digital morphing and character animation of "Mystique" in *X-Men* and *X-Men 2*. Kleiser-Walczak's impressive location-based work includes the Vegas Luxor Hotel (1990), Disney's *Honey, I Shrunk the Audience* (1995), and Universal Studios' 3D *The Amazing Adventures of Spider-Man* (1999).

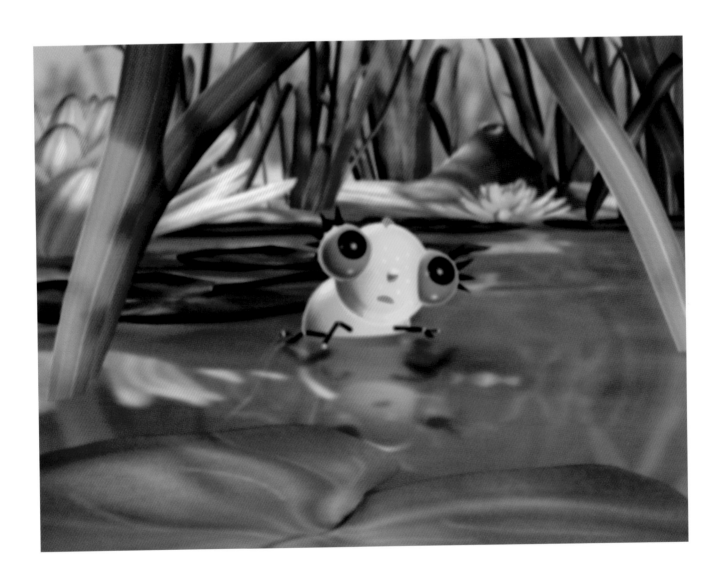

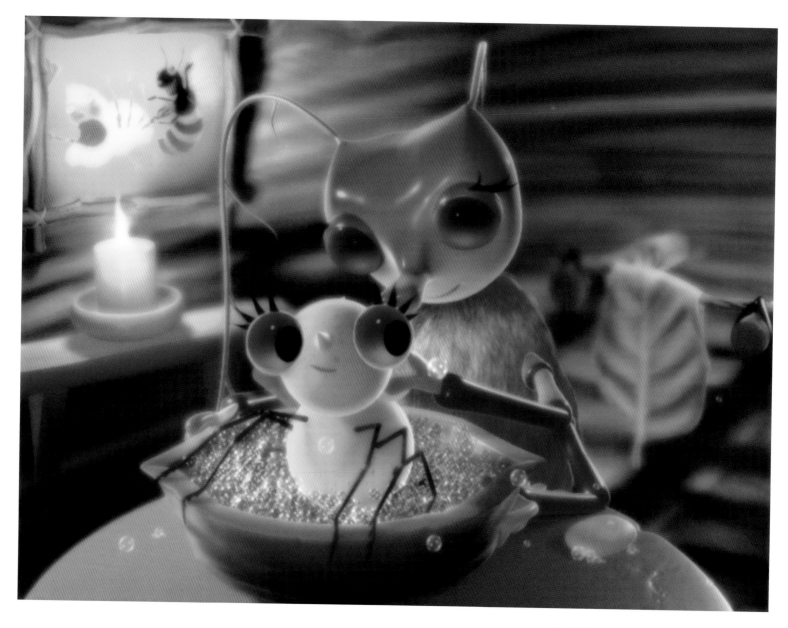

For Little Miss Spider's debut as an animated character, artists at Kleiser-Walczak transformed David Kirk's vibrant 2D oil paintings into a stylized 3D world. The result is a storybook brought to life by warm and inviting 3D computer-generated imagery of Kirk's magical characters. Maya was used for character and scene modeling, animation, and rendering. Little Miss Spider despairs of ever finding her mom (opposite) and is saved by kind Betty Beetle (above) who swoops in to the rescue and adopts her just as she is about to become lunch for some hungry hatchlings. Copyright © 1999 by Callaway & Kirk Co. LLC. All rights reserved. Miss Spider and all related characters are trademarks of Callaway & Kirk Co. LLC.

Lardux Films

French director Jérôme Boulbès was born in 1969 in Casablanca, Morocco. He studied fine arts at St. Etienne, France, and decorative arts (illustration) in Paris. After working as an artist for a Parisian video game company and as a freelancer for various corporate and scientific films, he decided to form Lardux Films and turn to more personal projects. Lardux has released three films, *Le Puits (The Well)*, *La mort de Tau (The Death of Tau)*, and *Rascagne*.

Below and opposite below: Still images from the animated short film *Rascagnes*, directed by Jérôme Boulbès. Copyright Lardux Films/Arte France/Seishin 2003.

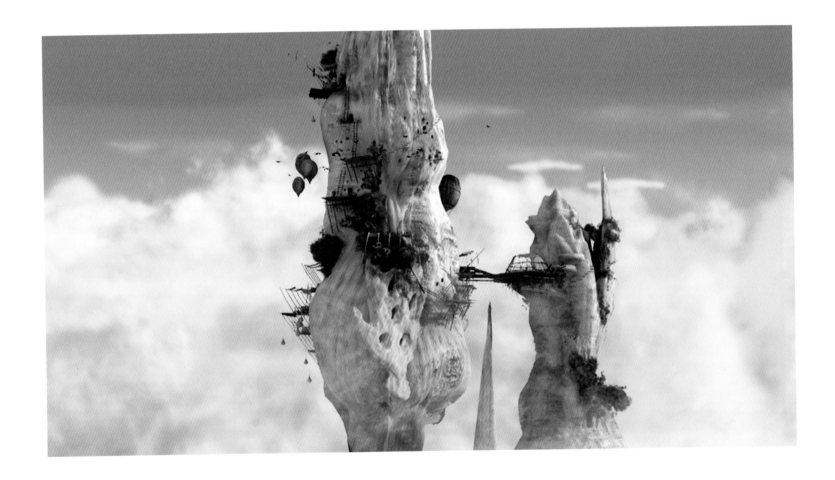

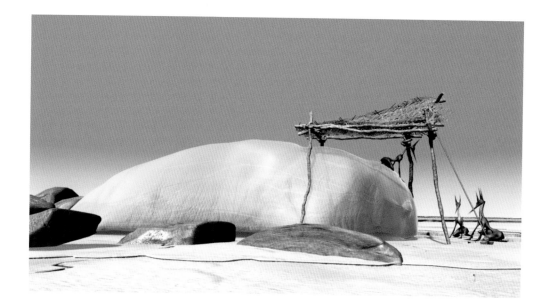

Still image from the short film *La mort de Tau*, directed by Jérôme Boulbès. Copyright Lardux Films/Arte France/Seishin 2001.

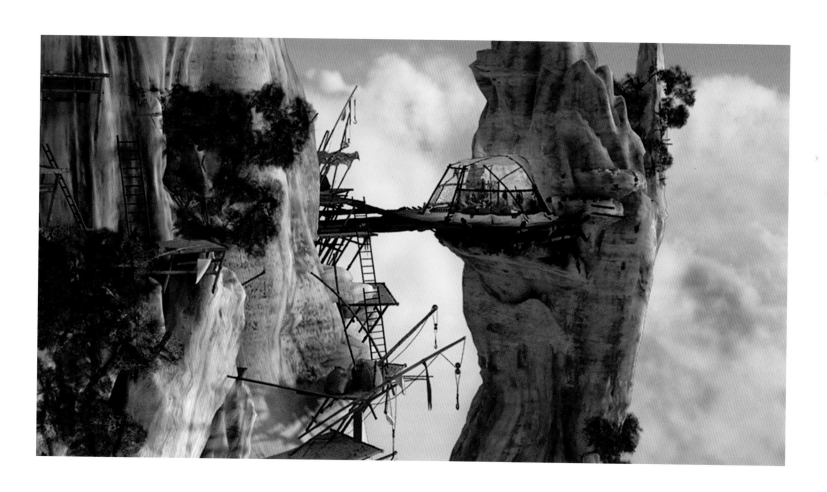

Metacube

Metacube Technology and Entertainment was founded in August 2002, in Guadalajara, Mexico. The company was formed by a dedicated team of professional digital artists whose experience ranged from multimedia, VFX, animation, matte painting, and editing to film and video productions. Metacube specializes in character animation, digital matte painting, and visual effects for TV and film productions. It is quickly developing an impressive international reputation for its work for a multitude of diverse clients.

Studios often create pieces to showcase their talents, such as these 2002 animation and matte painting of imaginary cities.

Bridge Image was made as an experiment for a 2002 compositing test.

An image of Old England was created for a 2002 short film.

The Moving Picture Company

The Moving Picture Company (MPC) is one of the world's leading postproduction facilities.
Based in Soho, London, it creates high-end digital visual effects and computer animation
for the advertising, music, television, and feature film industries. MPC has worked on many
high-profile ad campaigns for firms such as Nike, Levi's, Stella Artois, and Adidas, as well
as on feature films including *Tomb Raider, Troy, Harry Potter and the Prisoner of Azkaban,
Wimbledon,* and *Big Fish*. The firm has also done a great deal of work on landmark drama,
history, and science programs for the BBC, Channel 4, and Discovery Channel.

The Moving Picture Company animated extreme close-ups of organisms in a drop of water and the formation of snowflakes for the BBC television documentary *Wild Weather*. This series explored the whole spectrum of extreme weather around the globe, from avalanches and tornadoes to desert storms and monsoons. It aired in 2002 on BBC 1. Images courtesy of the BBC.

Oddworld Inhabitants

Formed in 1994 by special-effects and computer animation veterans Sherry McKenna and Lorne Lanning, Oddworld Inhabitants is dedicated to creating the next generation of interactive entertainment. Its unique facility in San Luis Obispo, California, has attracted top video game and computer animation talent from all over the world. Oddworld's products — "Oddworld: Abe's Oddysee ®," "Oddworld: Abe's Exoddus ®," and "Oddworld: Munch's Oddysee®," a potent brew of Hollywood artistry and rock-solid gameplay — produce experiences rich in empathy and entertainment value. They have sold more than four million units.

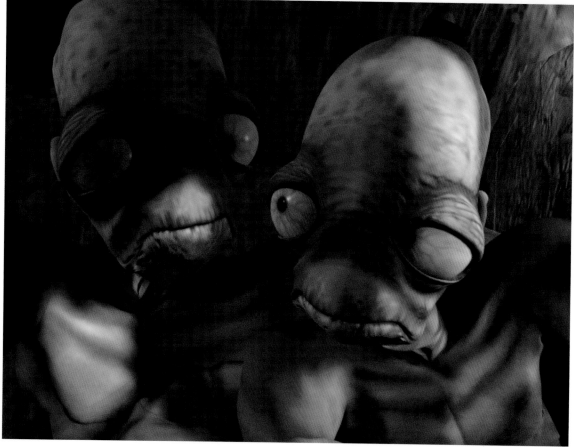

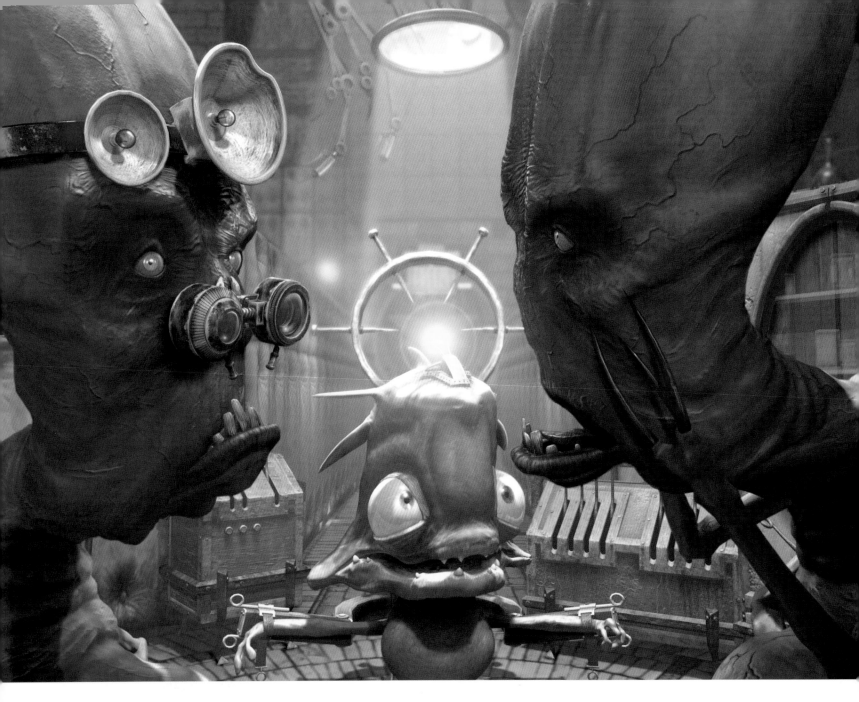

Munch and Vykkers scientists. © 2001
Oddworld Inhabitants Inc. All rights reserved.

Abe reclining. © 1997 Oddworld Inhabitants
Inc. All rights reserved.

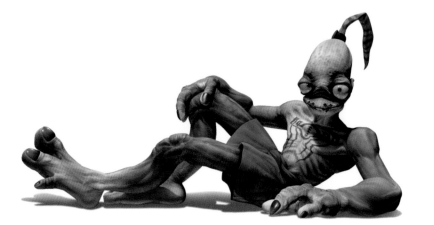

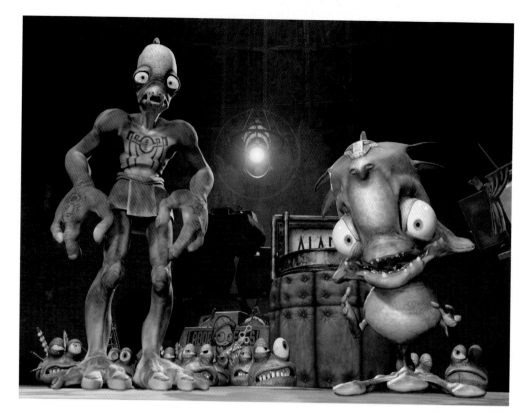

Abe and Munch: the bad ending. If all goes wrong in the game, this is the image the players see when they finish. © 2001 Oddworld Inhabitants Inc. All rights reserved.

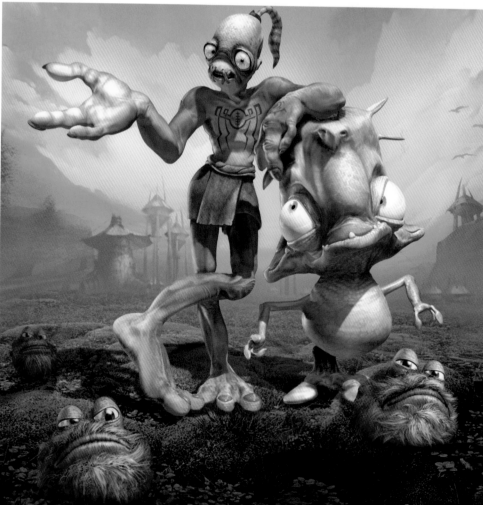

Abe, Munch, and Fuzzles. © 2001 Oddworld Inhabitants Inc. All rights reserved.

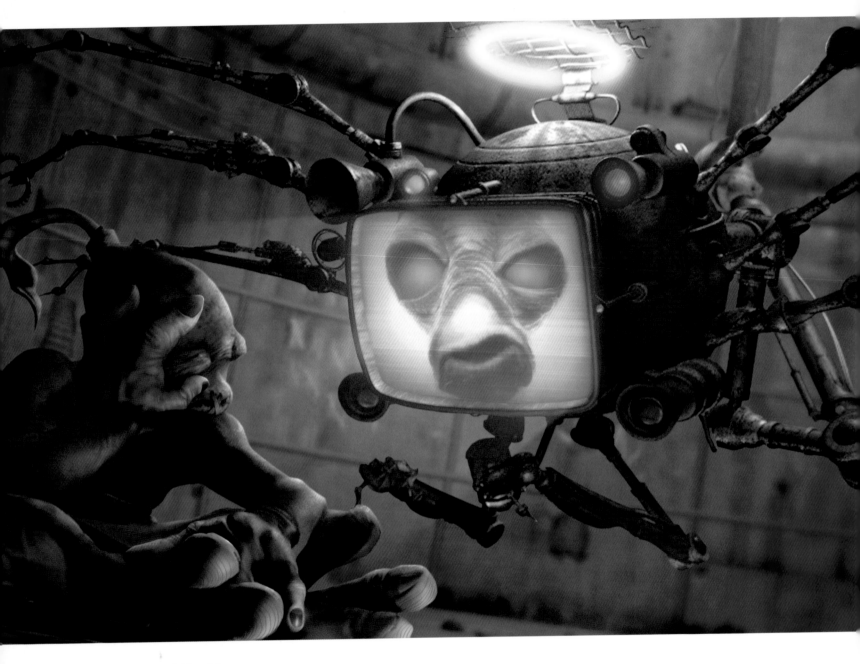

Shrink and Abe. © 1997 Oddworld
Inhabitants Inc. All rights reserved.

Glockstar and his Slig valet at the Auction.
© 2001 Oddworld Inhabitants Inc. All rights
reserved.

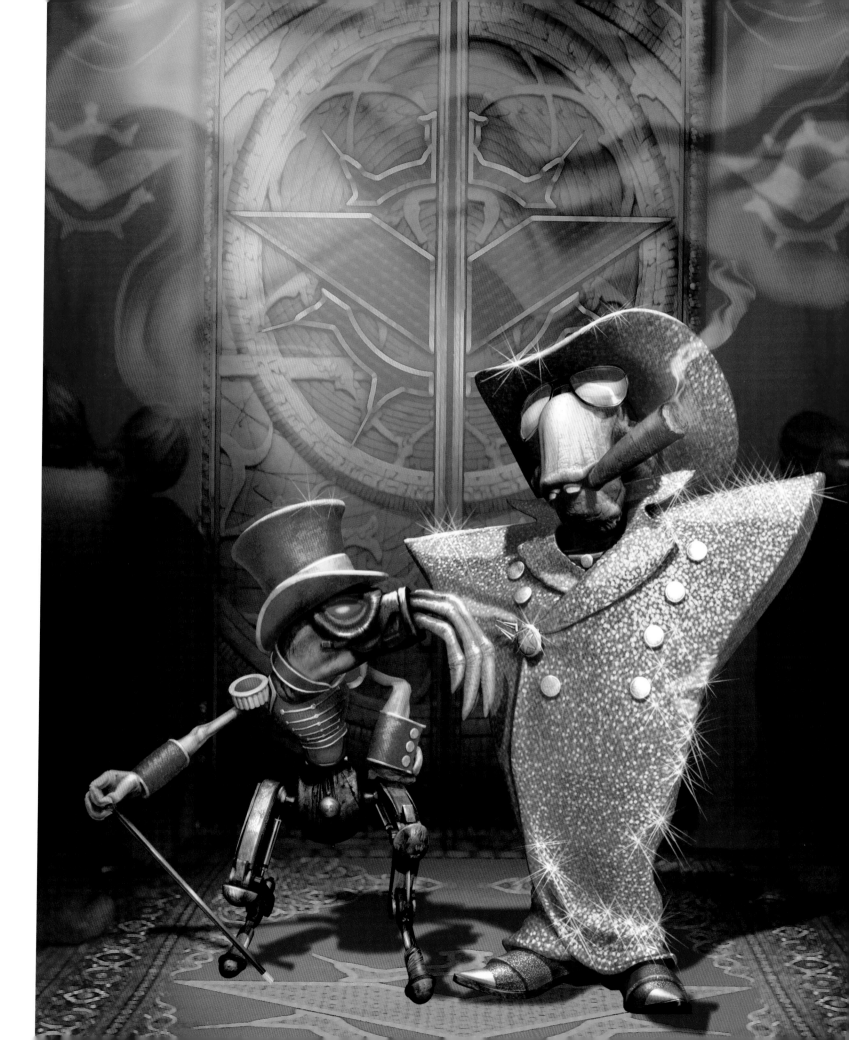

One Plus One

The French production house One Plus One
is associated with Supinfocom, a school
created in 1988 that specializes in computer
graphics and multimedia.

Stills from the 2001 animated short
Recycle Bein'.

PDI/DreamWorks

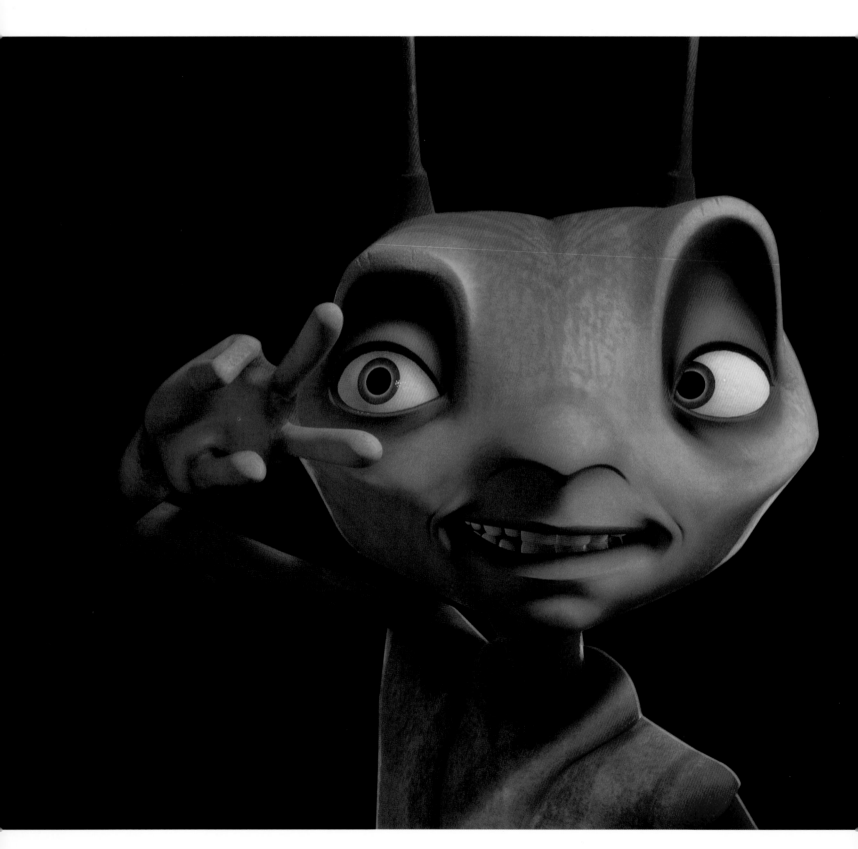

In 1980 Carl Rosendahl, Glenn Entis, and Richard Chuang founded PDI (Pacific Data Imaging), a leading broadcast graphic production house. In 1989 they formed the PDI character group to concentrate on the development of their CG character animation capabilities. Two years later PDI created visual effects for the groundbreaking film *Terminator 2* and then in 1992 stepped back into the limelight with the remarkable morphing effects for Michael Jackson's "Black and White" music video. PDI invented a morphing effect with its custom software that generates smooth transitions between different faces and characters on screen. The studio went on to have a string of successes including the cult favorite 3D segment in "Tree House of Horror," a 1995 episode of *The Simpsons.*

Jeffrey Katzenberg and his team at Dream-Works SKG recognized the incredible potential and creativity of PDI and bought a major stake in the studio. DreamWorks became majority shareholder in 2000. In 1998 it released PDI's first feature-length animated film, *Antz*, which grossed $180 million worldwide. In 2001 they released the blockbuster *Shrek*, which pulled in more than $267 million domestically and won the first Academy Award for Best Animated Feature. *Shrek 2* and the computer-animated film *Madagascar,* which is currently in production, will undoubtedly help PDI maintain its position as a leader in the animation industry.

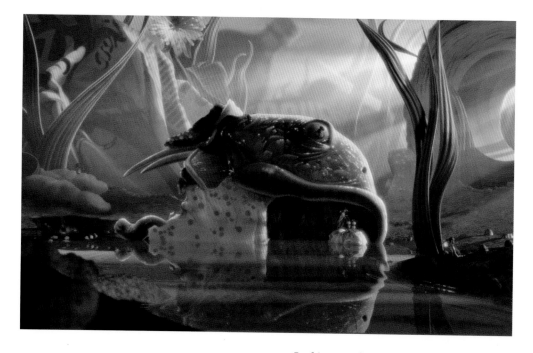

In this scene from *Antz* the artists at PDI effectively used lighting, composition, and modeling to help us see how a bug in love would find floating on a leaf in a dirty puddle near a garbage can to be as romantic as a Venetian gondola ride. Courtesy DreamWorks Pictures.

Opposite: "Z," the ultra-neurotic protagonist of *Antz* (voiced by Woody Allen), cuts the rug *Pulp Fiction*–style in a tour-de-force animated dance scene. The character here is silhouetted from the background plate. Often, studios will render foreground and background separately to reduce computing time and to make corrections easier to accomplish. Courtesy DreamWorks Pictures.

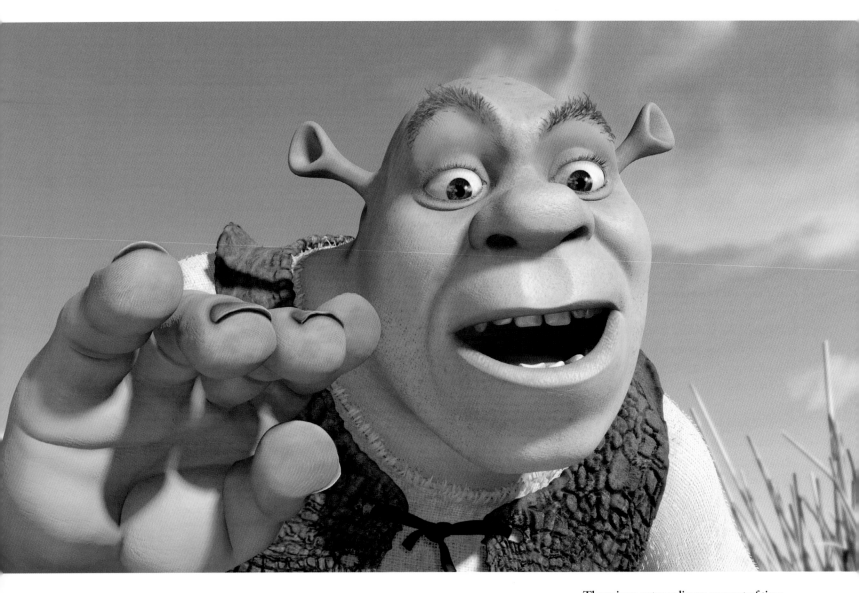

There is an extraordinary amount of time and detail invested in the creation of a character for a feature film. In this still from the irreverent computer-animated comedy *Shrek* (2001), we can see how the texture map artist has even given Shrek his own fingerprints. Courtesy DreamWorks Pictures.

CGI artists work like painters: what they choose to leave out is as important as what they leave in. Here PDI managed to make even an ogre and an outhouse in a swamp look compelling with an extraordinary use of lighting and the creation of lush vegetation. Top: Princess Fiona, Shrek, and Donkey walk through a lush forest. Courtesy DreamWorks Pictures.

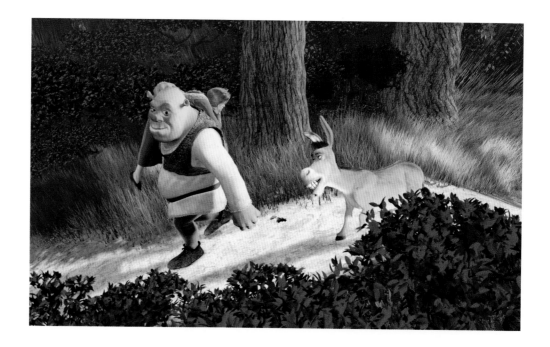

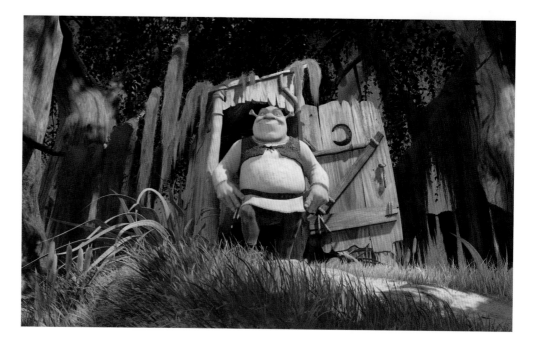

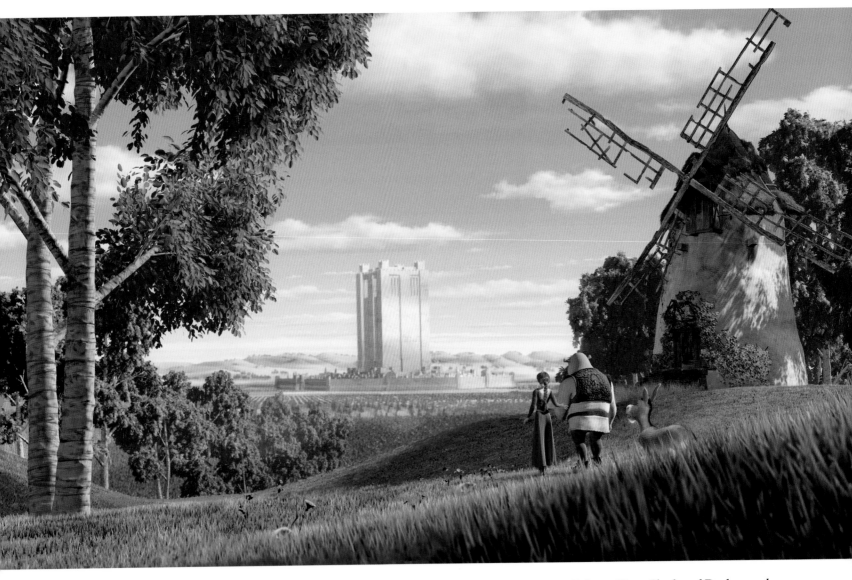

Princess Fiona, Shrek, and Donkey reach the end of their journey to Duloc. PDI broke new ground by showing an audience full fields of CGI grass that waves in the breeze and bends beneath the characters' feet. Courtesy DreamWorks Pictures.

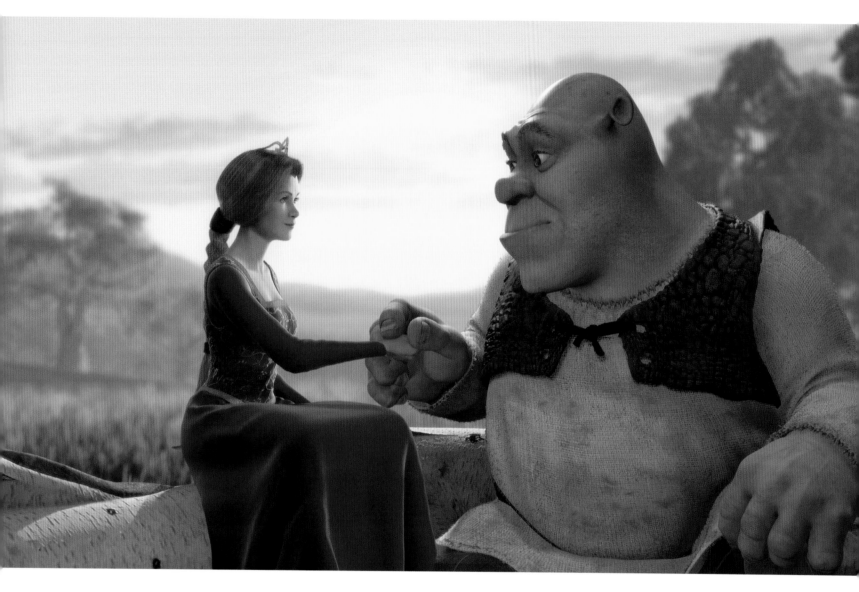

Among the hallmarks of great animation are characters that exhibit subtle movements and have complex and believable facial expressions. The artists at PDI managed to make a believable tender moment between a beautiful princess and an ogre. Courtesy DreamWorks Pictures.

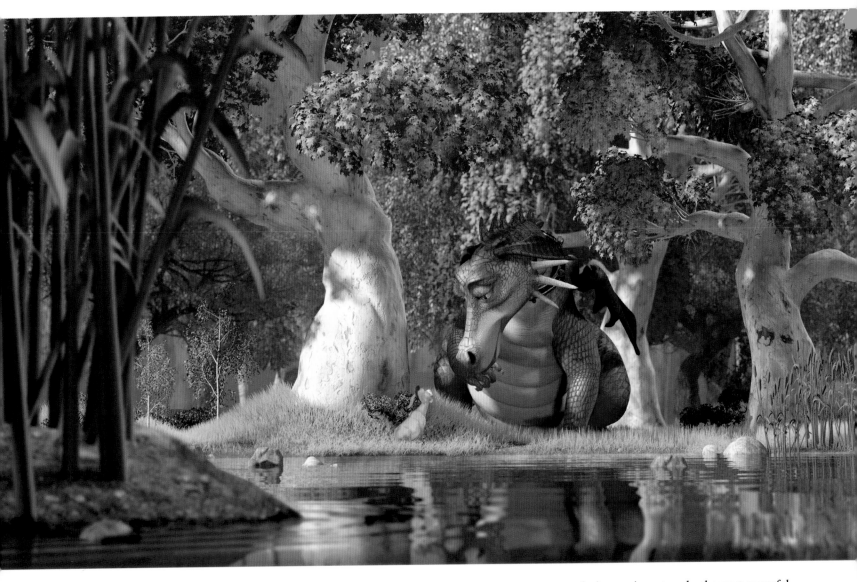

An impressive set can be the most powerful character on screen. The subtle lighting, glasslike water, and lush forest combine to make a sublime setting in which a fairy-tale dragon can feel right at home. Courtesy DreamWorks Pictures.

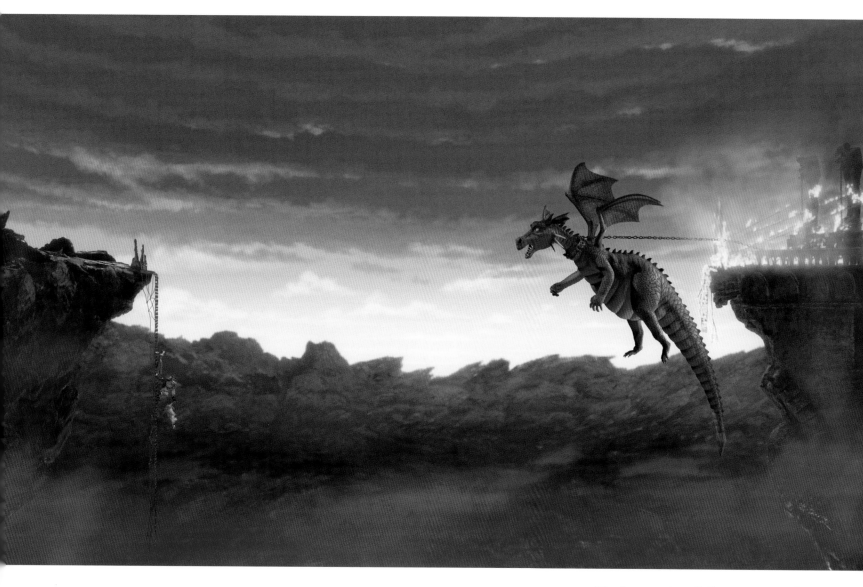

The dragon makes a futile attempt to catch
the escaping Shrek, Donkey, and Princess
Fiona. Courtesy DreamWorks Pictures.

Pixar

Pixar Animation Studios was founded in 1986 when Steve Jobs purchased the computer graphics division of Lucasfilm Ltd. At first Pixar focused visual effects and animation for television commercials. They developed some of the most sophisticated software in the CGI industry, most notably CAPS and RenderMan®, both of which received Academy Awards for Technical Achievement. Then, under the creative leadership of John Lasseter, Pixar created an impressive collection of charming, often groundbreaking, and award-winning short animated films.

Pixar is responsible for many of the seminal events and achievements in computer animation. In 1995 Pixar achieved what was thought to be impossible and made the first fully computer-animated major feature film, *Toy Story*. *Toy Story* was a creative, technical, financial, and popular hit. It ushered in a new genre of filmmaking. As part of a multipicture deal with Walt Disney Pictures, Pixar has continued to raise the bar with a string of critical and financial blockbusters such as *A Bug's Life* (1998), *Toy Story 2* (1999), *Monsters, Inc.* (2001), and *Finding Nemo* (2003). Pixar combines a unique creative vision, an emphasis on wonderful stories and characters, and incredible technical abilities to produce work that will no doubt be an inspiration to CGI artists and animators for years to come.

Woody and Buzz, of *Toy Story* and *Toy Story* 2, have become the icons of the CGI animated feature. Voiced by Tom Hanks and Tim Allen, this venerable pair of friends opened the door for a brand-new genre. Courtesy of Disney/Pixar.

Woody, Bullseye, and Jessie take a turn on the turntable in *Toy Story 2*. Courtesy of Disney/Pixar.

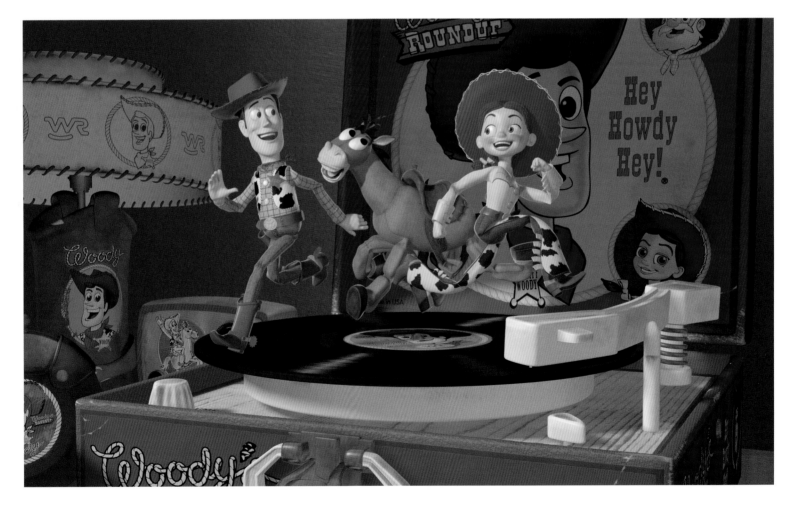

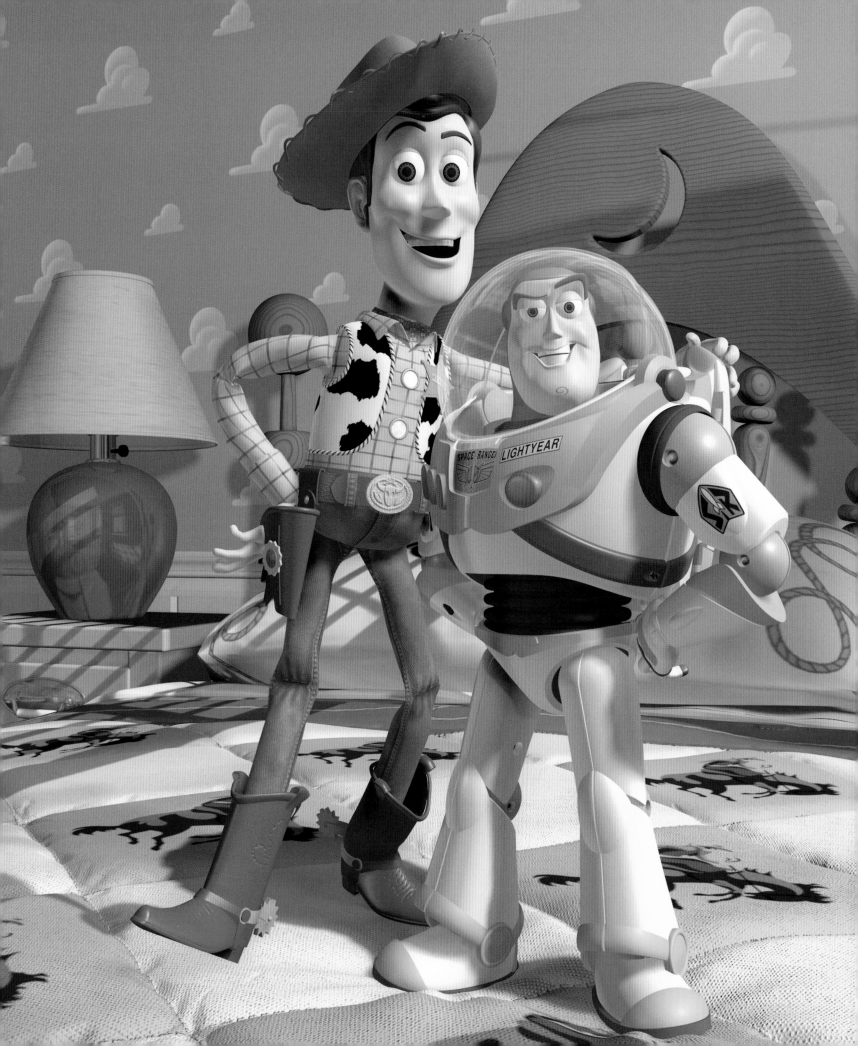

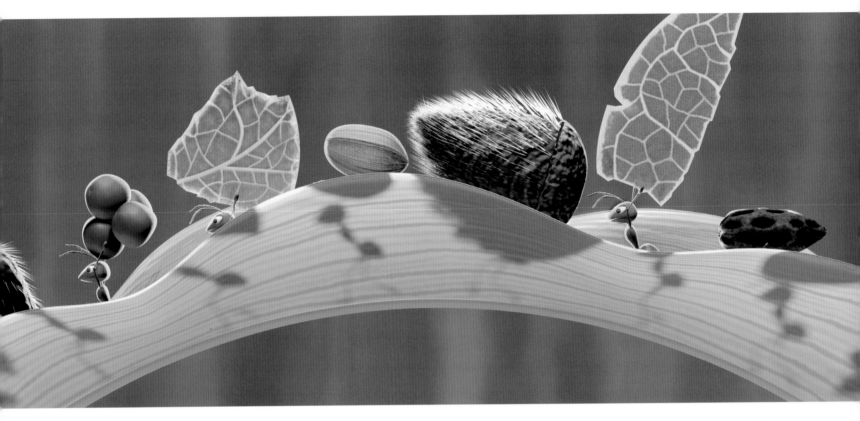

One by one, the ants march across the translucent surface of a new leaf in this shot from *A Bug's Life*. The subtle and beautiful halo of light around the fibers of the seed and the dance of shadows through the leaf are not achieved by accident. The technical directors at Pixar performed miracles with a computer to achieve effects we would take for granted in a live-action shot. Courtesy of Disney/Pixar.

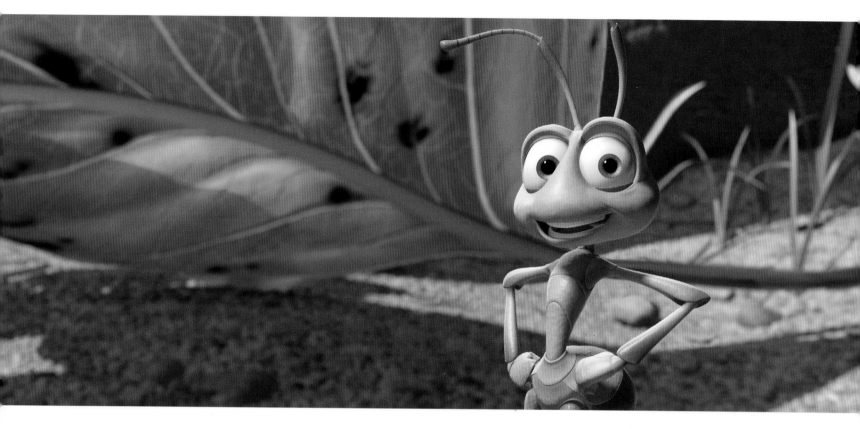

Flik strikes a pose for this publicity still from *A Bug's Life*. For this film Pixar created an entire microworld in which a single leaf or blade of grass could dominate the composition. Courtesy of Disney/Pixar.

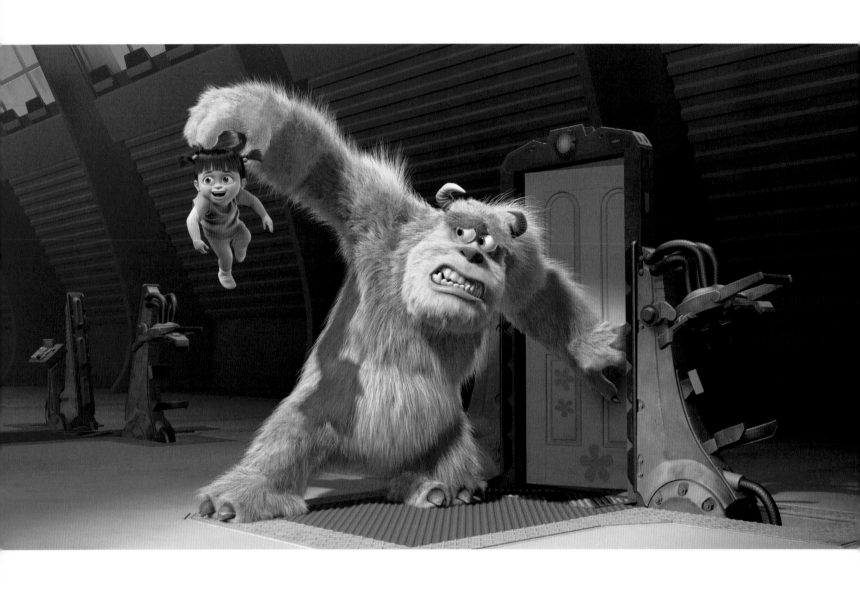

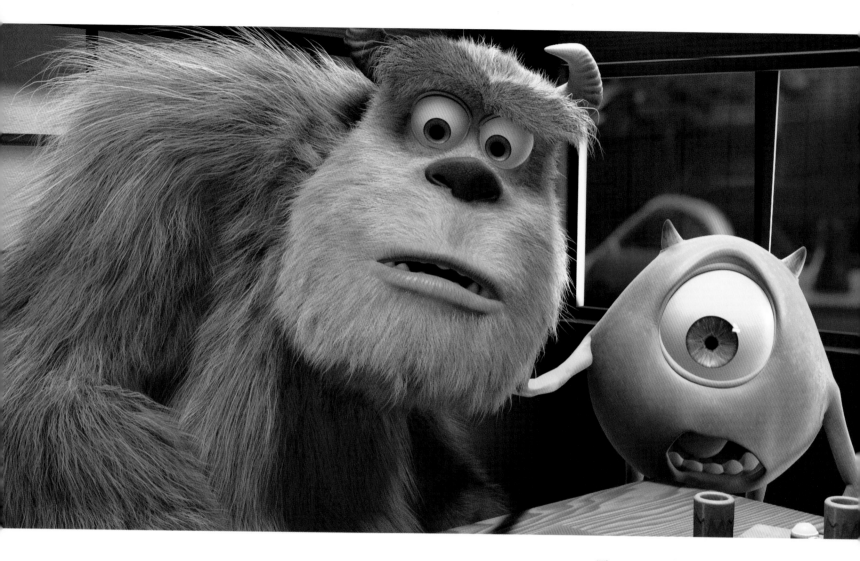

These pages and overleaf: Fur and hair are
some of the most difficult things to make in
CGI. Every strand is a special effect and
every time a character moves, changing the
orientation of his or her surface, there are a
few thousand things that can go wrong.
Pixar not only created a believable fur system
for *Monsters, Inc.* (2001), but then covered
their main character with it. In these stills
we see varying degrees of shadowing, back-
lighting, and close-ups that demonstrate
this technical and artistic marvel. While the
audience might not have picked up the
intricate subtleties of Sully's coiffure, they
would have noticed if he had a particularly
bad fur day. Courtesy of Disney/Pixar.

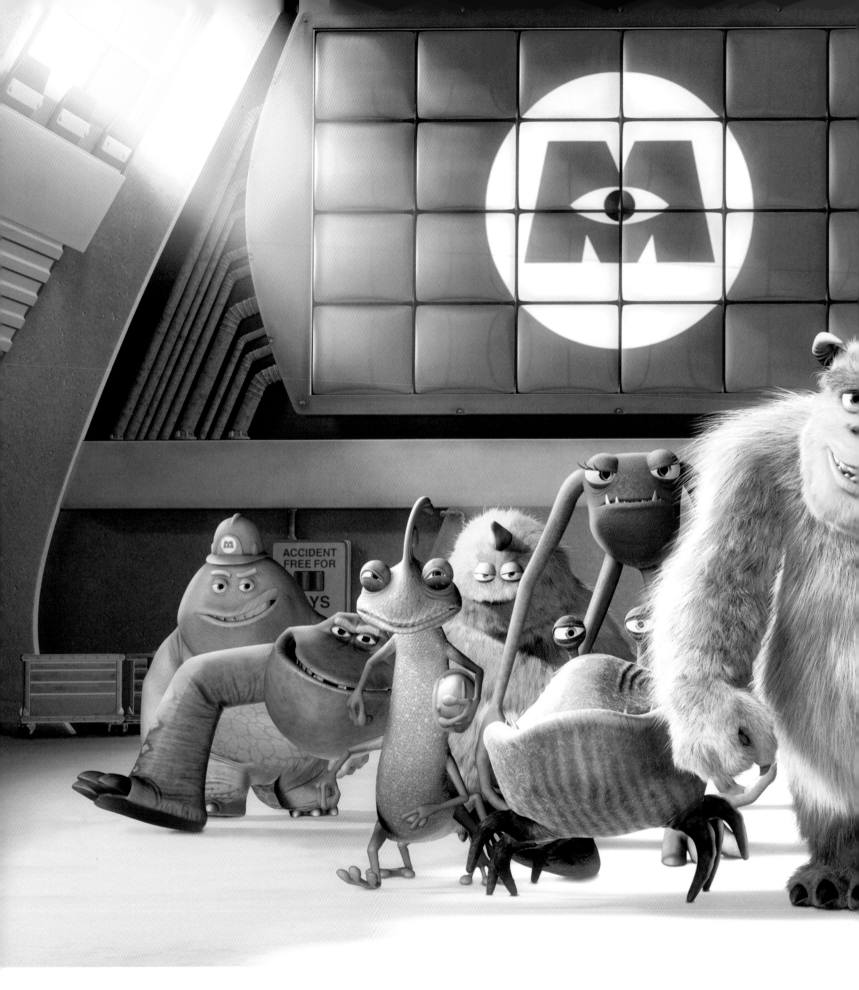

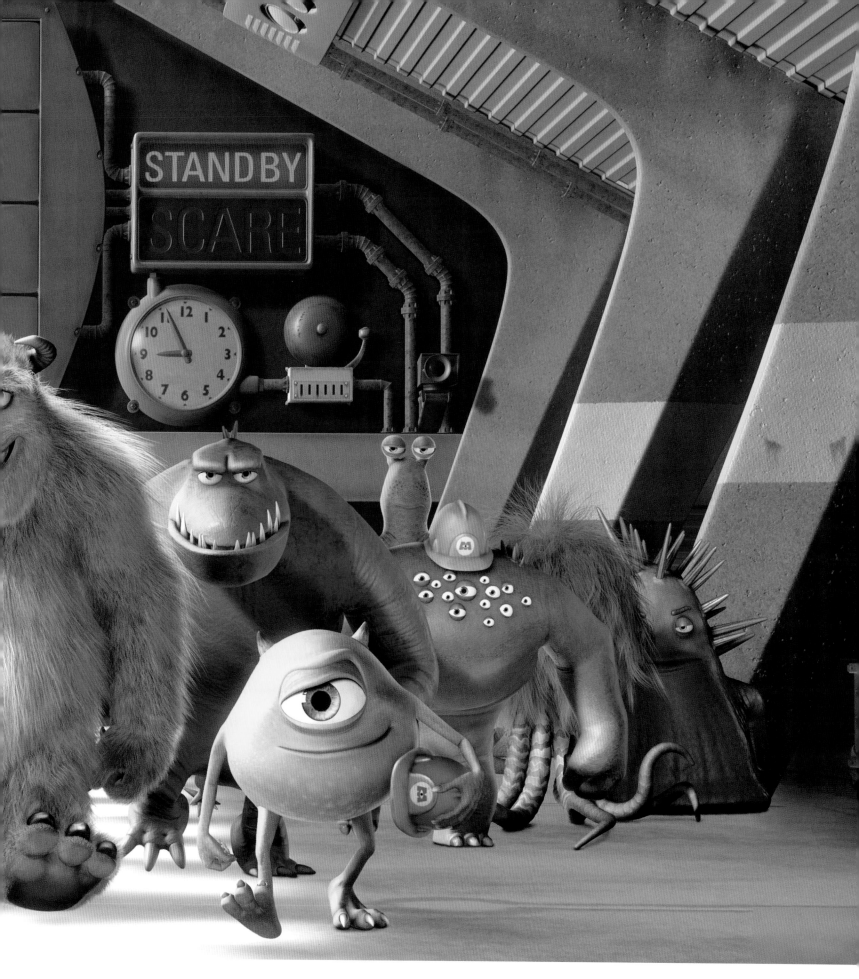

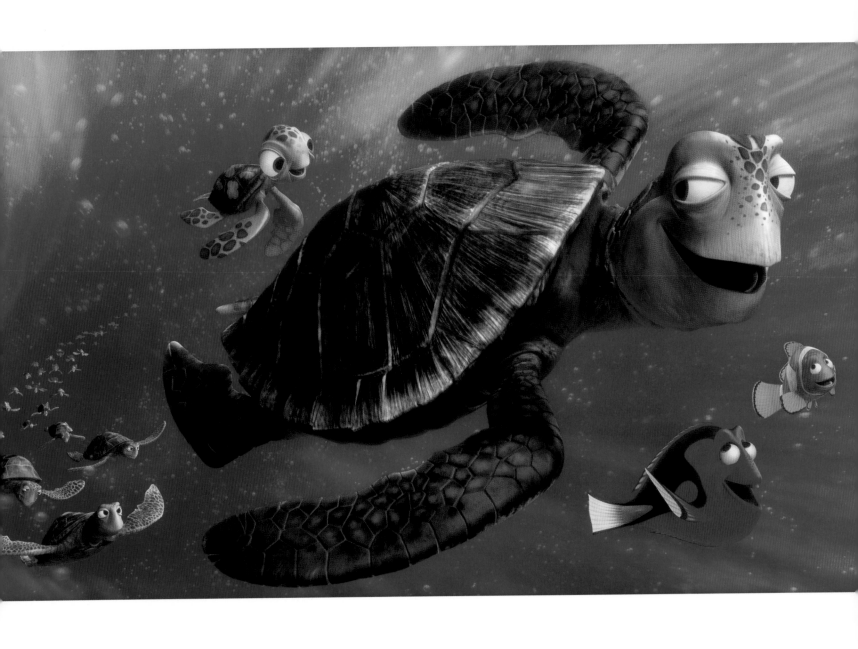

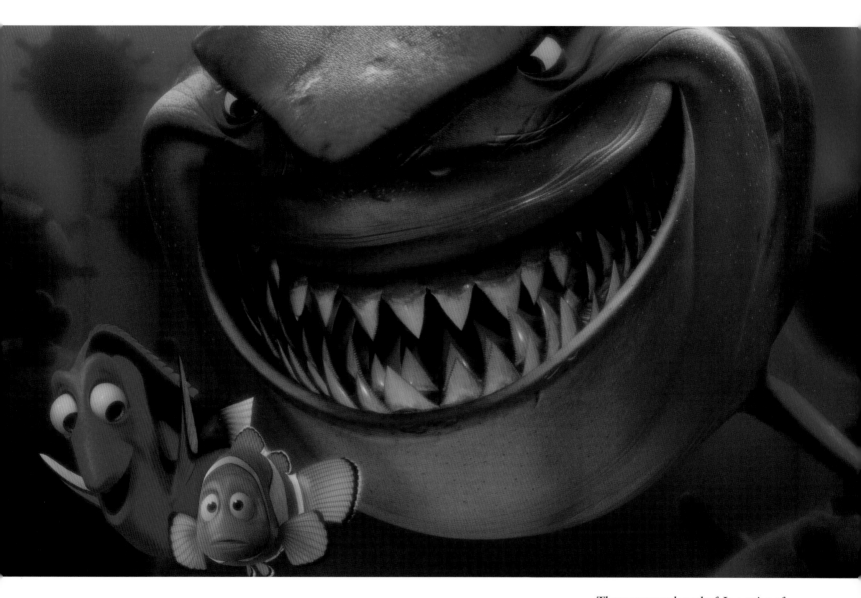

These pages and overleaf: In a string of
unprecedented Pixar successes, *Finding
Nemo* (2003) earned the honor of an
Academy Award and is the most financially
successful animated film to date. The film
also happens to be absolutely gorgeous.
It takes place almost entirely underwater
with its shimmering light, translucent coral,
and iridescent fish. Pixar CGI can help an
artist create a world with extraordinary detail
in which all of the well-thought-out elements
come together to form a believable whole.
Courtesy of Disney/Pixar.

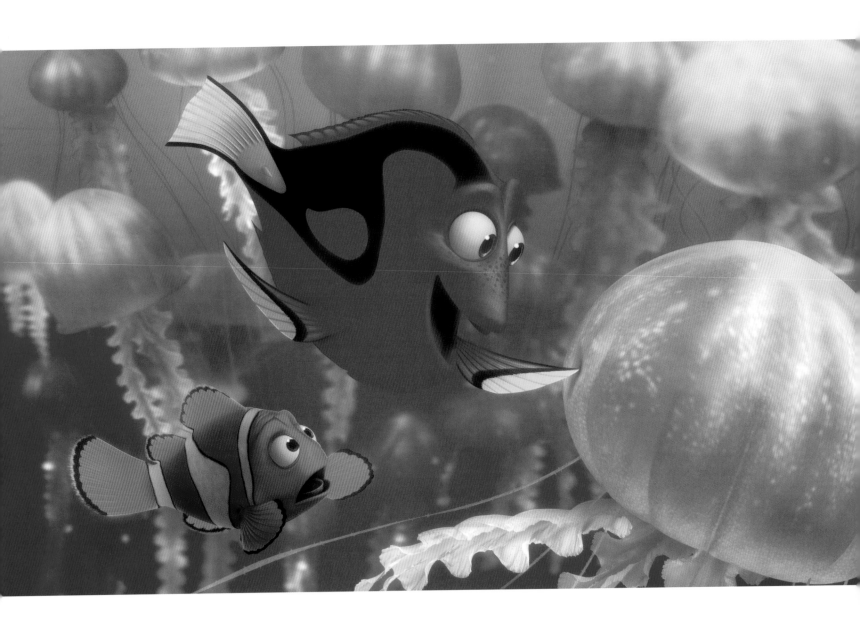

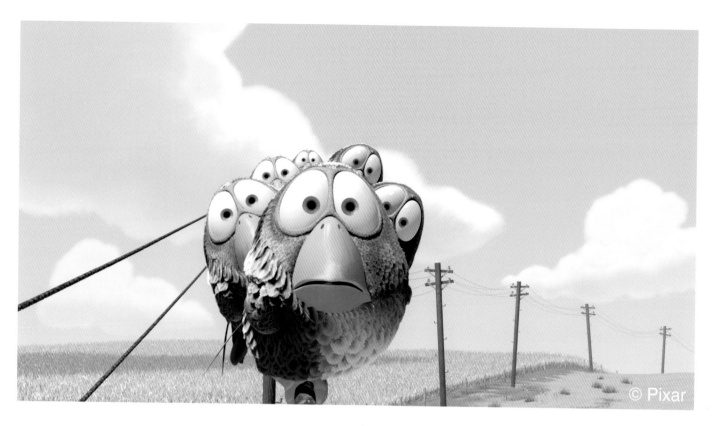

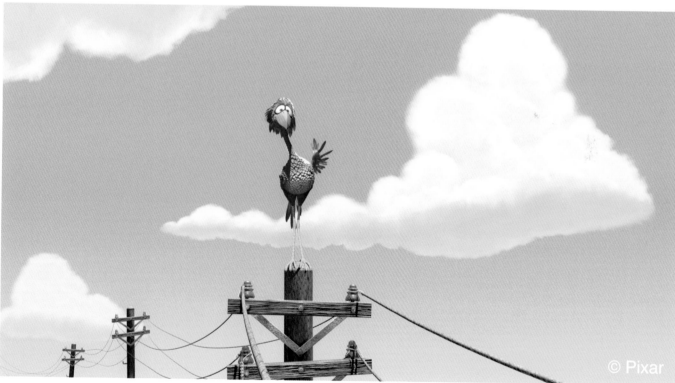

The hilarious Pixar short *For the Birds* (2000) is the story of a particularly clueless large bird who is ostracized by a line of birds on a wire. Pixar's exceptional animation is evident in the individual and recognizable expressions on the simple characters and the wonderful play with the tension on the telephone cable. ©Pixar Animation Studios.

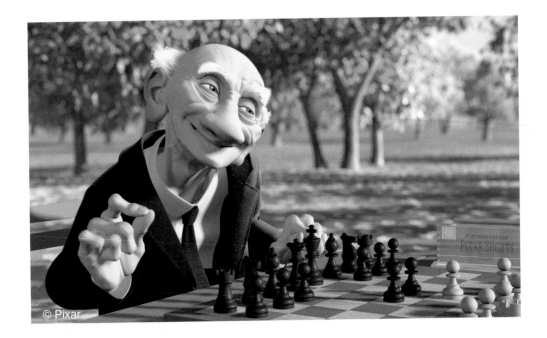

The animated short *Geri's Game* (1997) is about an elderly man who plays chess against himself. The prize: his own false teeth. This short film addressed many of the issues that surrounded human CGI character animation. Geri had a range of expression, believable clothing, and movement that was far more sophisticated than the people in *Toy Story*. After a short dry spell, Geri was brought out of retirement to play "the Cleaner" in *Toy Story 2*. ©Pixar Animation Studios.

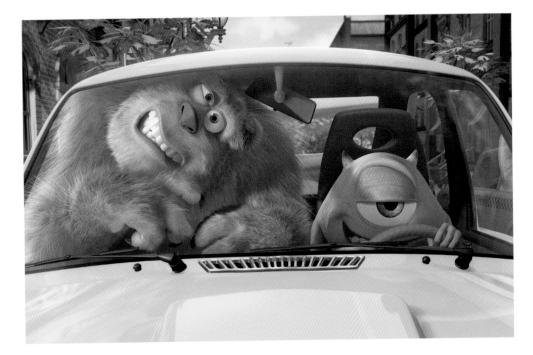

The characters Mike and Sully return to the screen for the short *Mike's New Car*. ©Pixar Animation Studios.

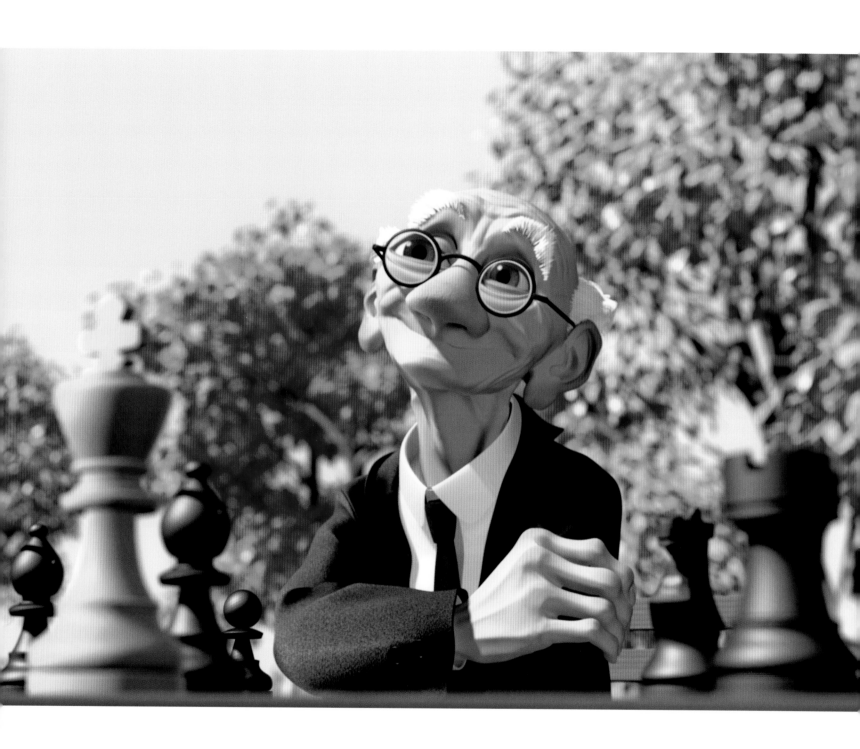

Platige Image

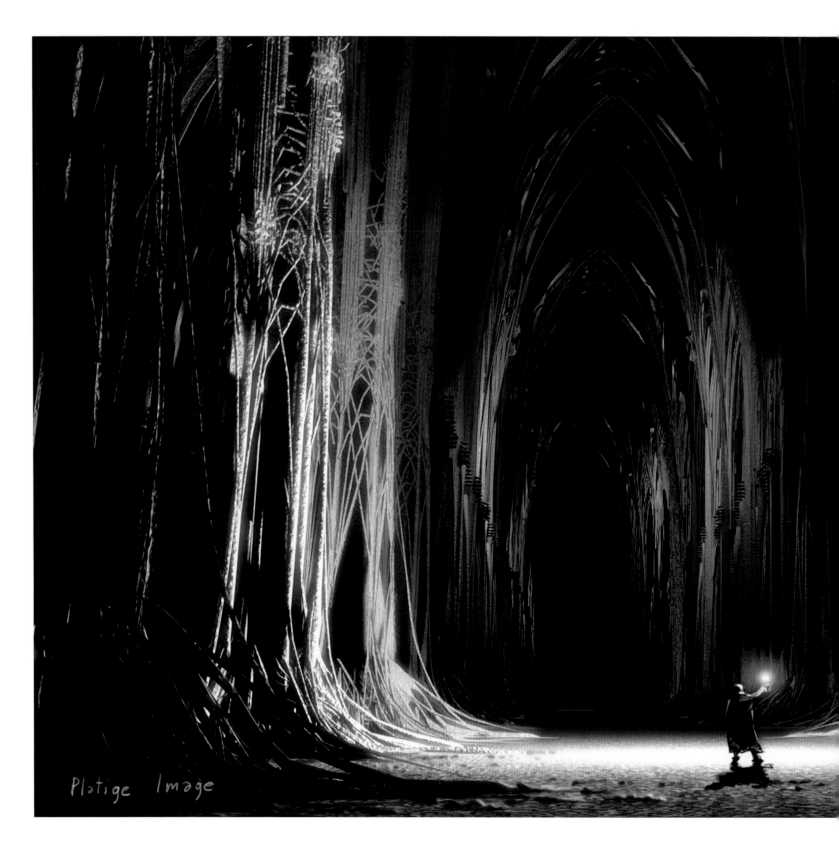

Platige Image

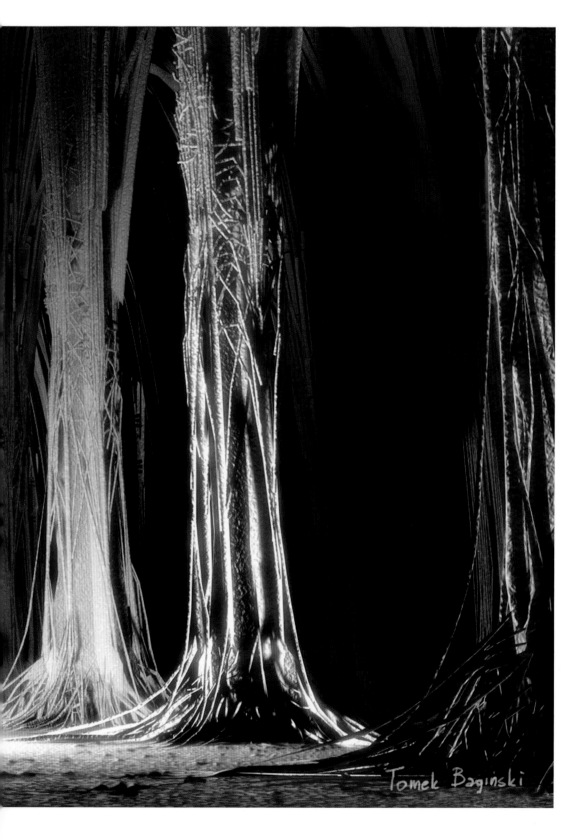

Warsaw, Poland–based Platige Image was started in early 1998 by Jarek Sawko and Piotr Sikora. It has established its presence in the TV industry and is currently one of a limited number of specialized 3D animation studios serving the local and Eastern European market. With about twenty employees, Platige Image has been a prolific producer of commercial work. However, it also encourages the individuality and creativity of employees by supporting the production of in-house non-commercial, artistic projects like the renowned short film *The Cathedral* (2002) by Tomek Baginski.

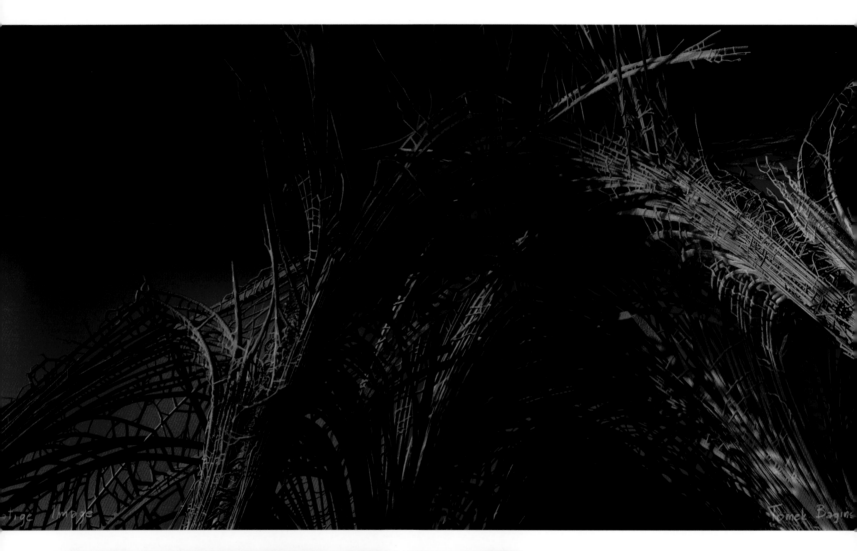

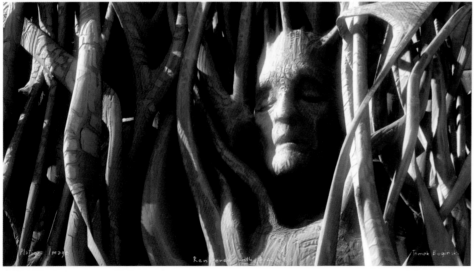

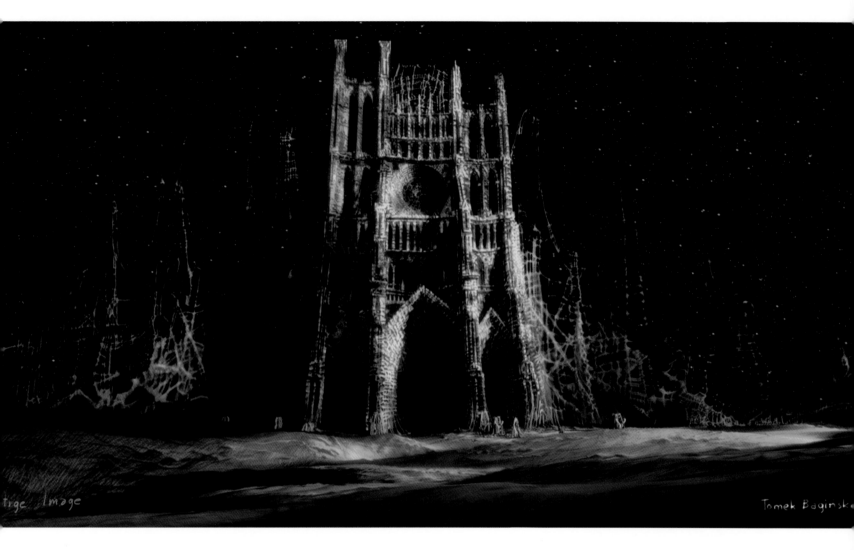

Platige Image

Tomek Baginski

All of these images are from the 2002 animated short *The Cathedral* by Tomek Baginski and Platige Image. *The Cathedral* is a noncommercial film based on Jacek Dukaj's story. Platige Image created a surreal world in which a lone figure walks amid towering, plantlike columns that form a spectacular cathedral in which faces and anthropomorphic elements are interwoven. Finally the sunlight shines on the character, and he "grows" into the majestic structure.

Sideshow Animation

Sideshow Animation is a full-service, award-winning multimedia house based in San Diego. Steve Presser founded the company shortly after completing his MFA in computer animation at the Savannah College of Art and Design. Sideshow Animation is dedicated to creating a presence for companies using the very latest in multimedia technologies.

In this image from an animation for a public service announcement, photo-realistic manatees commiserate over their run-ins with speedboats. 2003, Steve Presser and Randy Ramsey, Sideshow Animation, LLC.

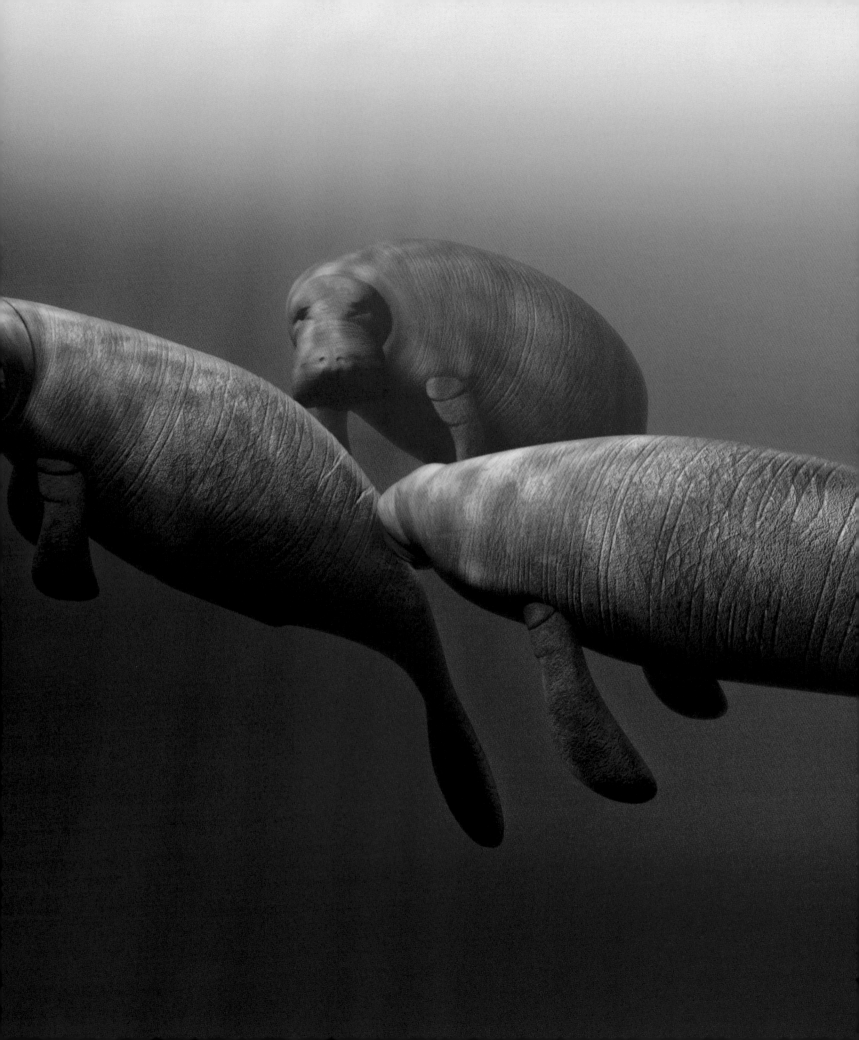

Sony Pictures Imageworks

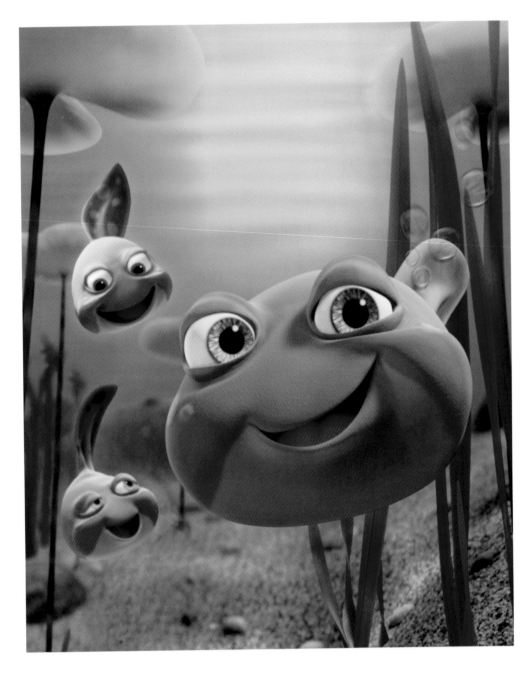

Sony Pictures Imageworks Inc. is an Academy Award–winning, state-of-the-art visual effects and character animation company dedicated to the art and artistry of digital production and character creation. The company has been recognized by the Academy of Motion Picture Arts and Sciences with nominations for its work on *Spider-Man*, *Hollow Man*, *Stuart Little*, and *Starship Troopers* and was awarded an Oscar for the CG animated short film *The ChubbChubbs*. Imageworks is a wholly owned division of Sony Pictures, Inc. Over the past decade they have risen to one of the top production houses in the industry. With an emphasis on CGI character animation, Imageworks' special effects rival, and often exceed, that of their major competitors.

Sony Imageworks made a charming animated short titled *Early Bloomer* in 2003. It is the story of a pond full of tadpoles who are caught by surprise when they start sprouting legs. © 2003 Sony Pictures Imageworks Inc. All rights reserved.

Opposite: These images are from the Academy Award–winning short film *The ChubbChubbs*, in which a little Glorf named Meeper mops the floor at the Ale-E-Inn while daydreaming himself onto center stage. © 2002 Sony Pictures Imageworks Inc. All rights reserved.

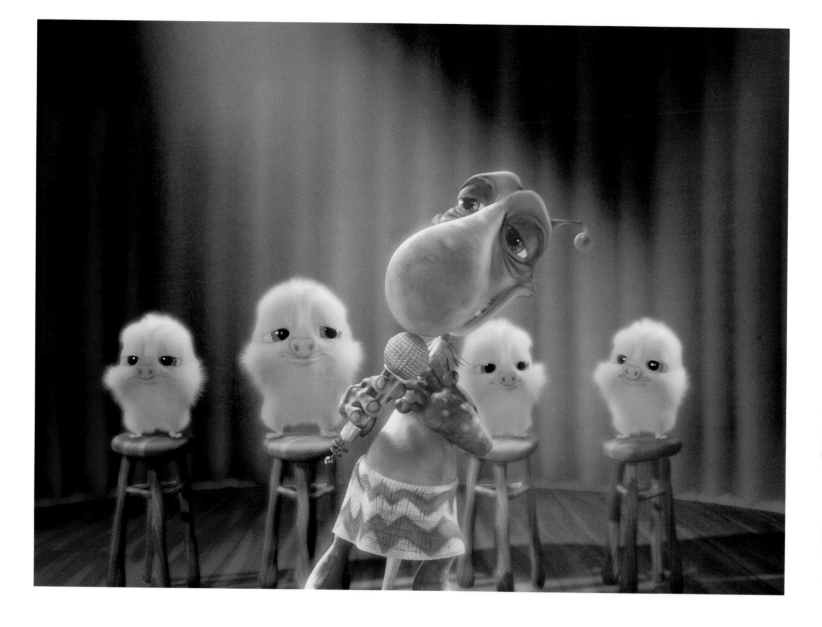

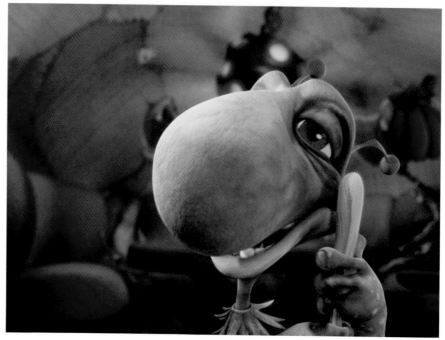

Tippett Studio

In 1983 Phil Tippett left his job as supervisor of ILM's creature shop to start his own studio. From the humble beginnings in his Berkeley, California, garage, Tippett, along with his partners, Craig Hayes and Jules Roman, created a major visual effects studio that now employs 225 artists and engineers. They have been nominated for no less than six Academy Awards. Tippett's incredible work on films like *Robocop*, *Dragonslayer*, and *Willow* helped set the standard for stop-motion animation. In the mid 1990s the innovative studio made the successful transition from stop-motion animation to all-CGI animation. Its special effects and animation work includes feature films such as *Starship Troopers*, *The Matrix Revolutions*, *Evolution*, and *Blade II*. In 2000 Phil Tippett directed his first feature-length film, *Starship Troopers: Hero of the Federation* (2003).

In Blockbuster Entertainment's popular "Carl & Ray Pet Shop" television campaign, guinea pig Ray notes Carl the rabbit's ear imperfection and whispers that a "plastic surgeon could fix that"; from the Clio Award–winning *Prima Donna* commercial (opposite, top). From the gold Clio Award–winning *Kung Fu* commercial, Ray assumes the pose of a martial arts hero from his favorite film genre, kung fu movies (opposite, bottom), and the pet shop "Ninja Mice" prepare to defend Carl, who was involved in an unfortunate accident involving a carrot nunchuck (below). ©2002 Blockbuster Entertainment/ Tippett Studio.

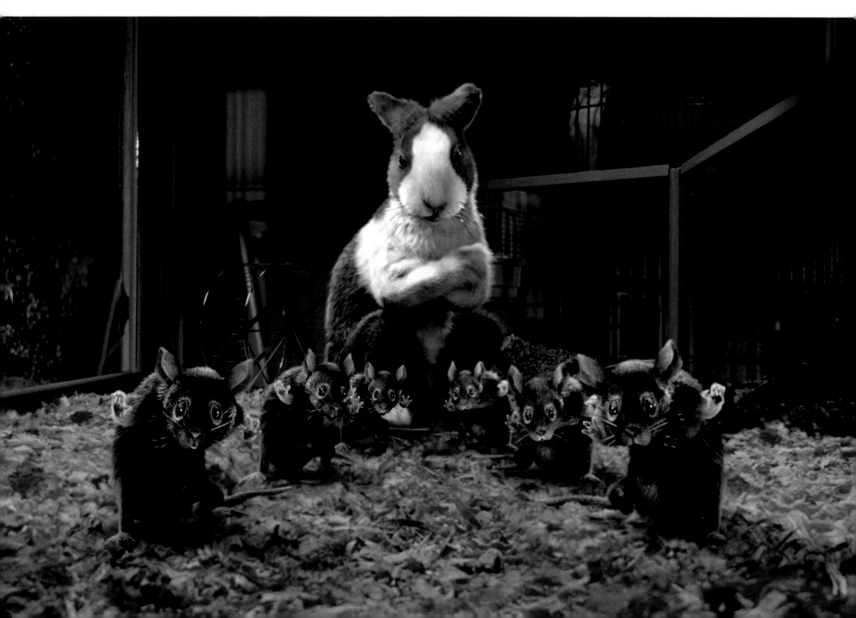

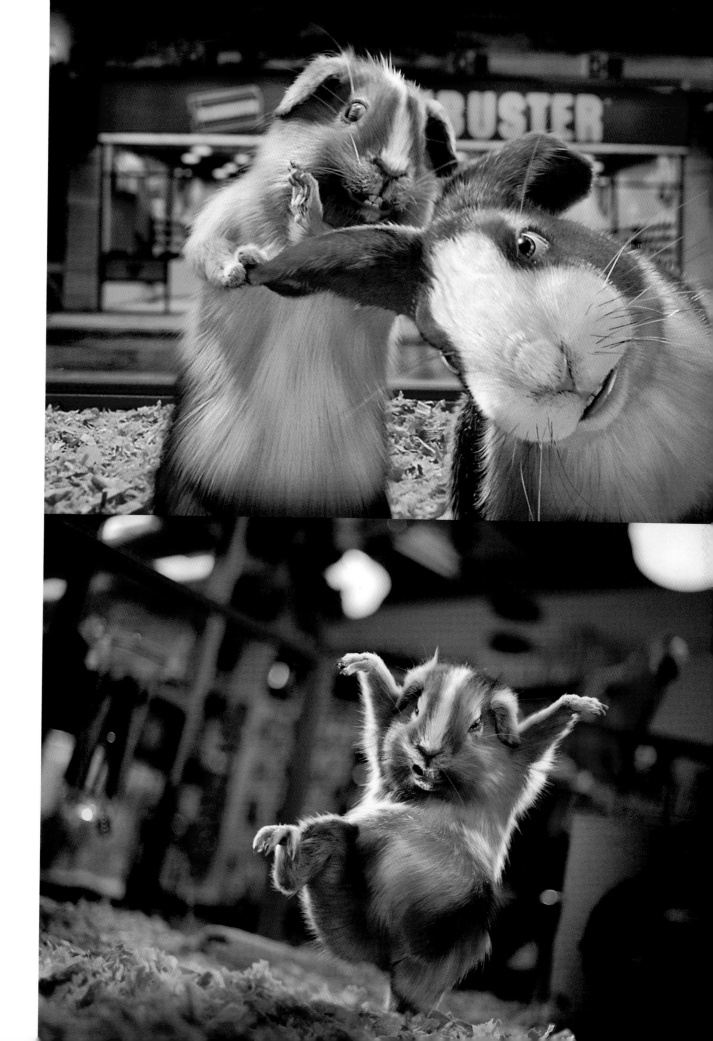

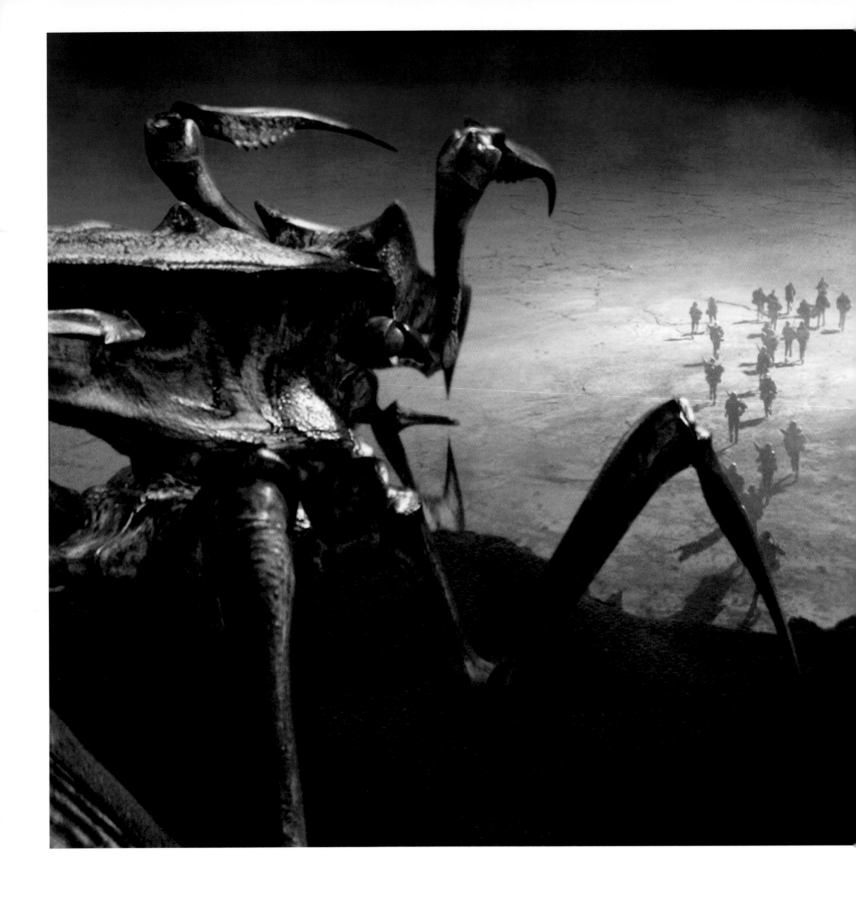

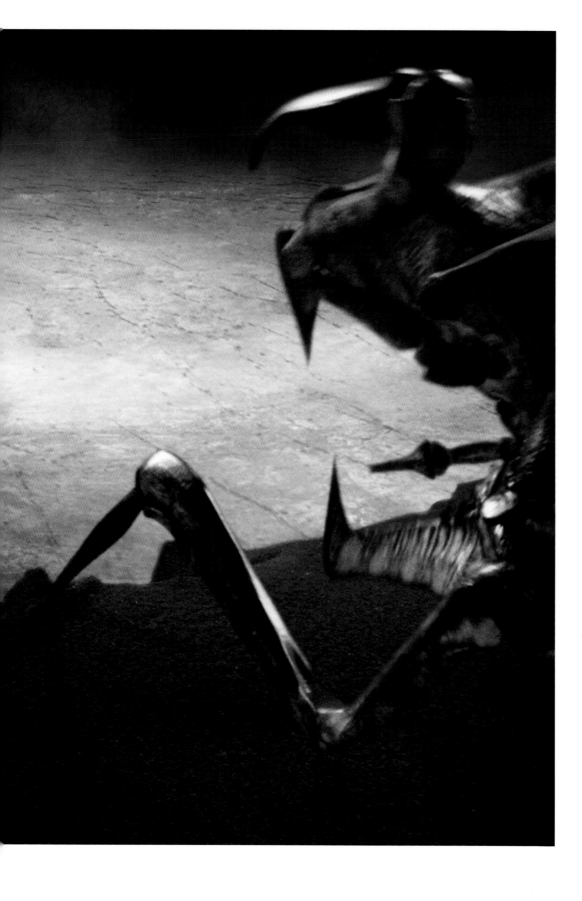

Warrior Bugs stalk the troopers fleeing below in *Starship Troopers 2: Hero of the Federation*. Courtesy Sony Pictures Television.

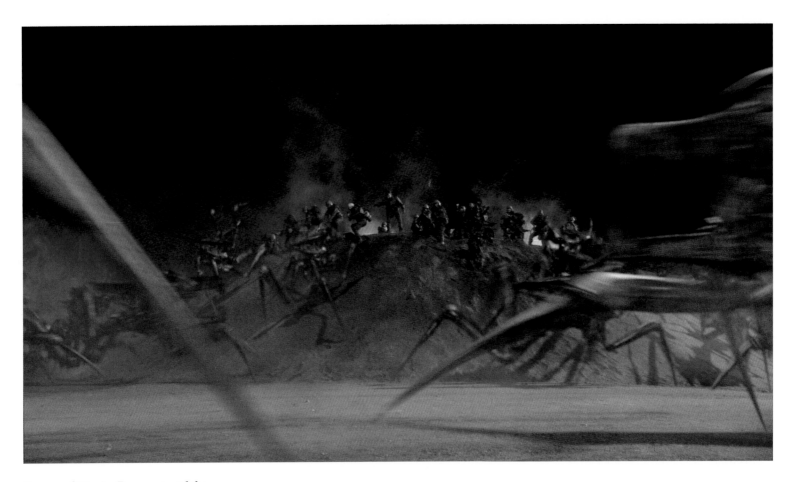

Swarms of Warrior Bugs surround the
Troopers as they search frantically for a
way out in *Starship Troopers 2: Hero of the
Federation*. Courtesy Sony Pictures
Television.

Troopers fight off an attacking Warrior Bug as it penetrates beyond the barricades in *Starship Troopers 2: Hero of the Federation*. Courtesy Sony Pictures Television.

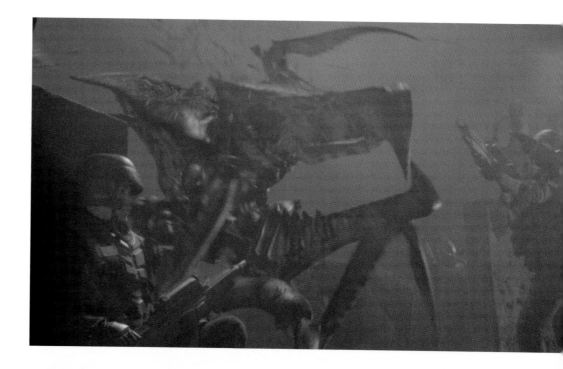

A digital double of Blade (Wesley Snipes) flips through the air, lands on the back of a moving motorcycle, and garrotes the vampire who tried to run him down. From *Blade II*, directed by Guillermo del Toro. ©2002 New Line Cinema/Tippett Studio.

Weta Digital

Wellington, New Zealand, may seem like an unlikely place for one of the world's premier special effects houses, but in fact, Weta Digital has produced some of the most incredible effects and has garnered some of the most prestigious awards in the industry.

Weta was founded in 1993 by a group of filmmakers including Peter Jackson, James Selkirk, Jim Booth, George Port, Tania Roger, and Richard Taylor. Their first project was Jackson's *Heavenly Creatures,* and five more films followed. Then, in 1997 Jackson was given the assignment of directing the three-picture trilogy of the *Lord of the Rings* saga. The majority of the special-effects work went to Weta Digital. The company recruited some of the best talent from around the world and grew to almost two hundred employees. Weta Digital won the Academy Award for Special Effects for both *The Fellowship of the Ring* (2001) and *The Two Towers* (2002) and eleven more Academy Awards for its stunning work for the last installment, *The Return of the King* (2003).

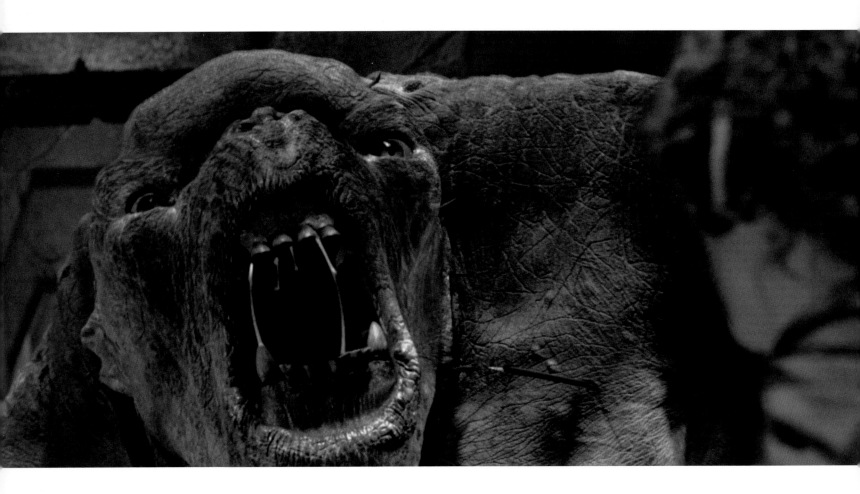

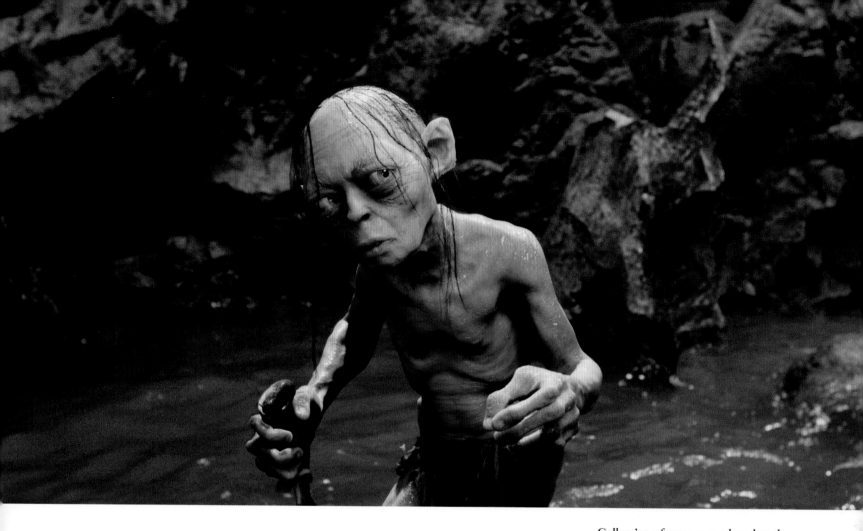

Gollum's performance was based on the motion capture of a live actor. For motion capture an actor wears a suit with a series of markers at the major joints. As the actor moves, the markers are recorded in 3D and fed into the animation software. Literally thousands of hours of work went into the modeling, rigging, texturing, animating, and rendering of the character after the motion capture was complete. Courtesy Weta Digital Ltd and New Line Cinema.

The only thing that is "real" in this shot is the actor playing the hobbit. The set and the troll are both digital. Note how the incredible use of detail, from the wrinkles in the troll's skin to his somewhat off-putting oral hygiene, gives the character a convincing and all-too-real presence. Courtesy Weta Digital Ltd and New Line Cinema.

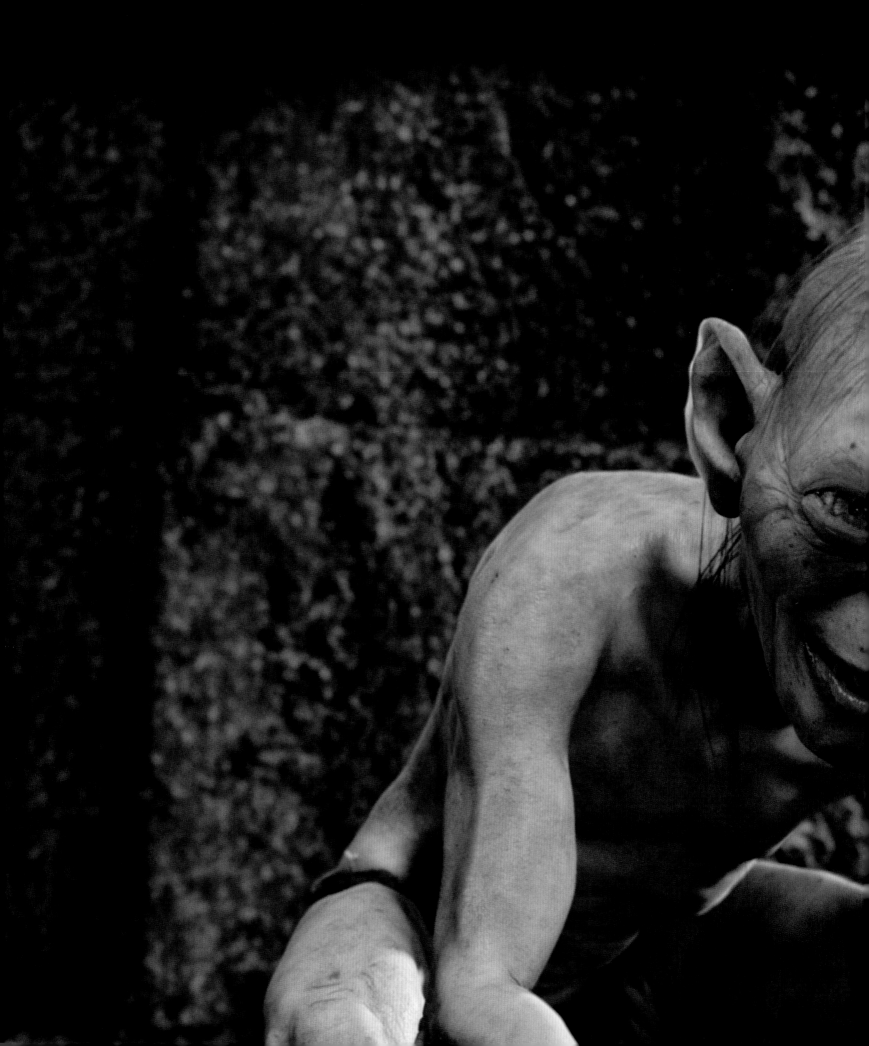

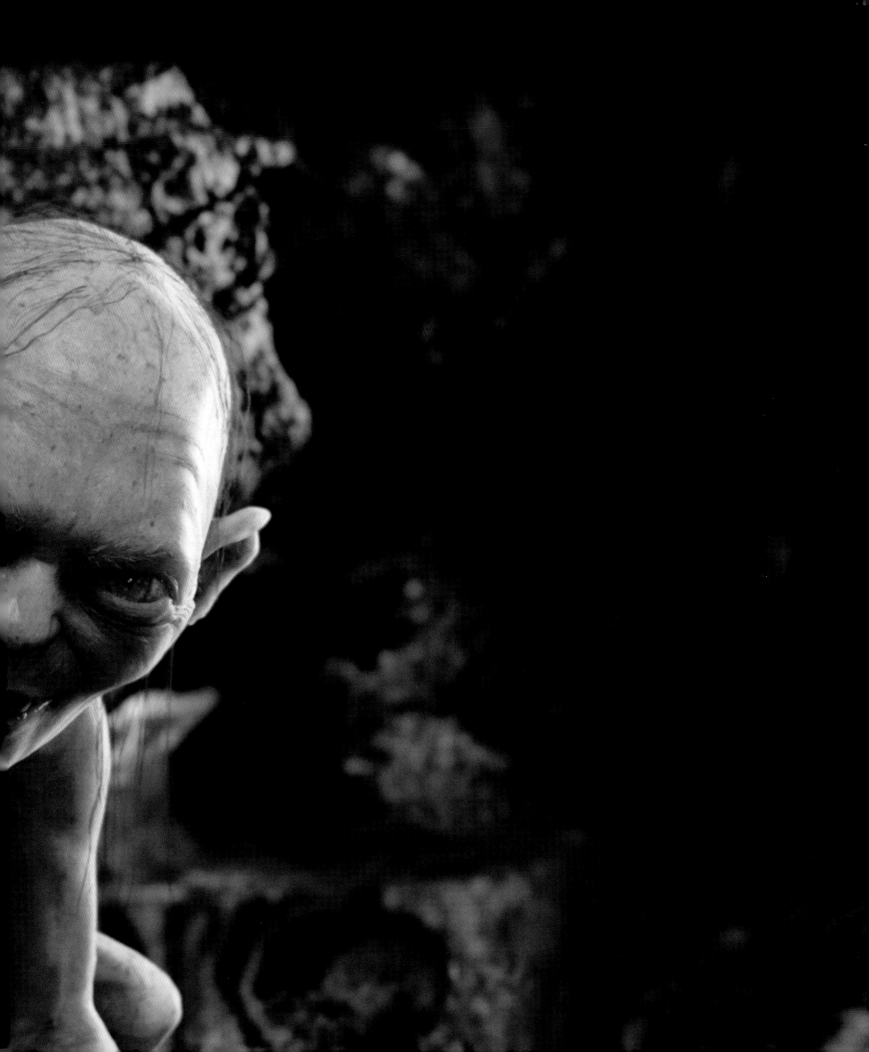

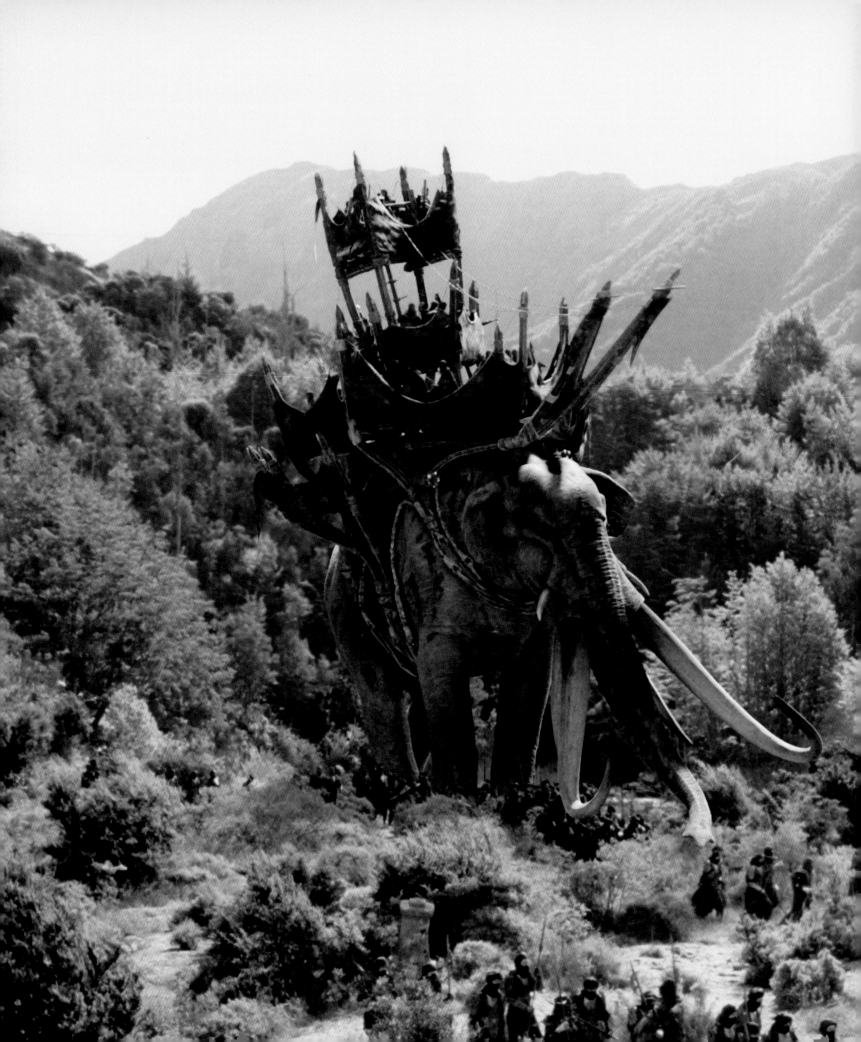

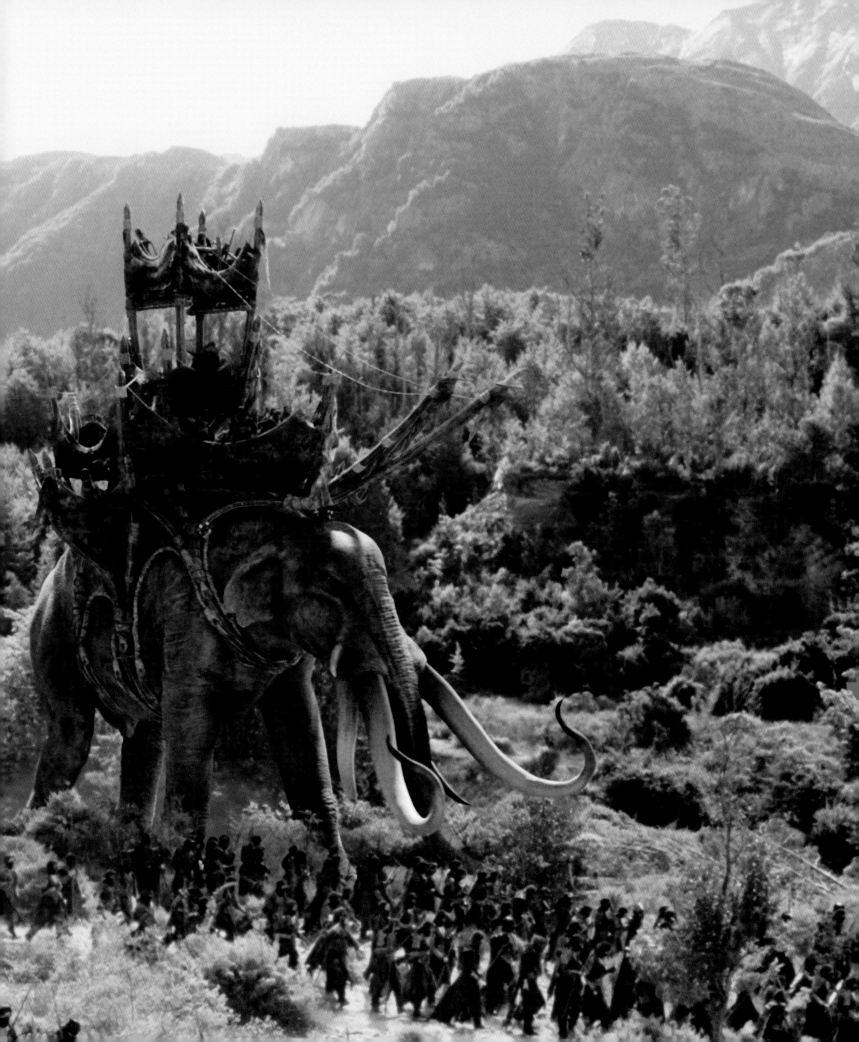

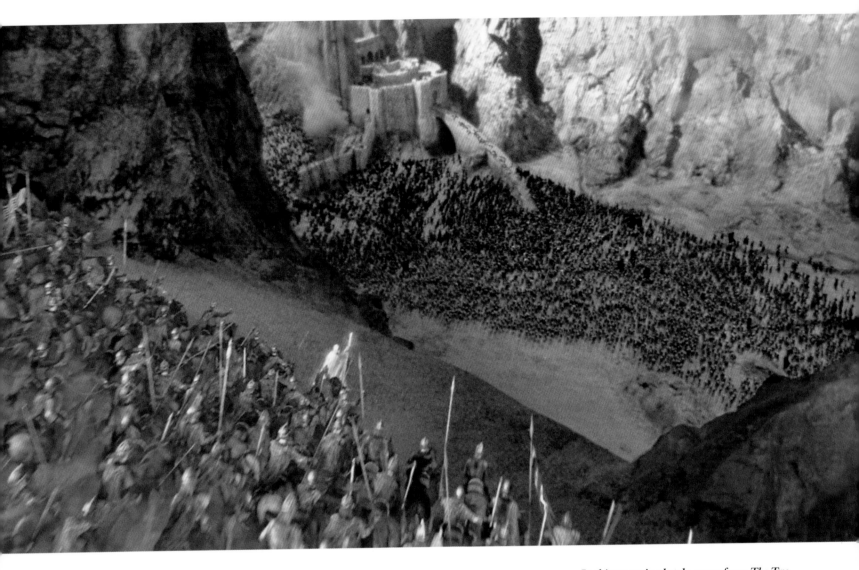

In this sweeping battle scene from *The Two Towers* it is almost impossible to distinguish the real from the digital. Scale models, breathtaking natural scenery, and digital elements along with hundreds of hours of animating and compositing combined to make this climactic battle sequence truly spectacular. Courtesy Weta Digital Ltd and New Line Cinema.

Previous spread: These giant elephant-like creatures were not real pachyderms in movie makeup. They are all-digital creations lumbering through a very real New Zealand countryside. They were composited with real and digital actors to give the illusion of a sizable army on the march through Middle Earth. Courtesy Weta Digital Ltd and New Line Cinema.

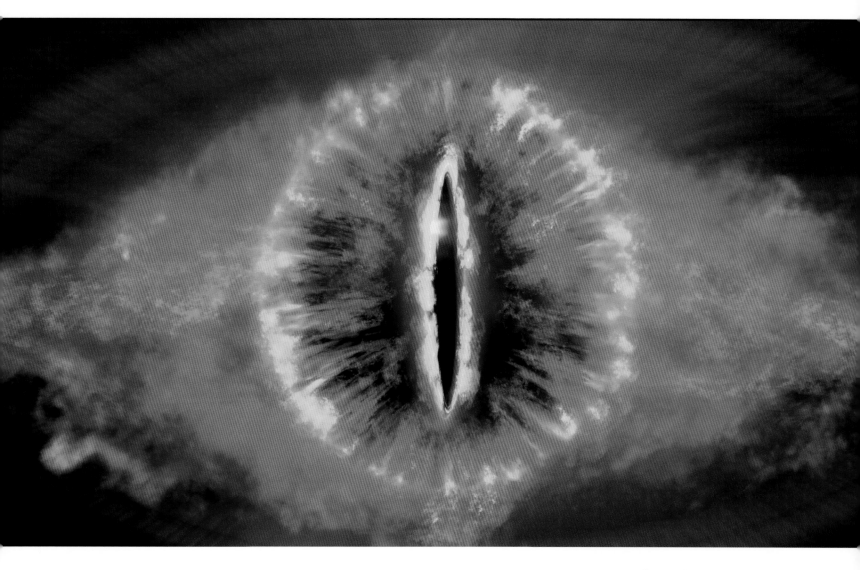

Sauron is the manifestation of pure evil that attempts to conquer Middle Earth in the *Lord of the Rings* trilogy. The eye of Sauron is represented by this flaming iris. Courtesy Weta Digital Ltd and New Line Cinema.

Overleaf: The special-effects wizards at Weta combined live action and CGI fire with a complex digital model to create the Balrog, an ancient and powerful beast that seemed to consist of smoke and fire. Courtesy Weta Digital Ltd and New Line Cinema.

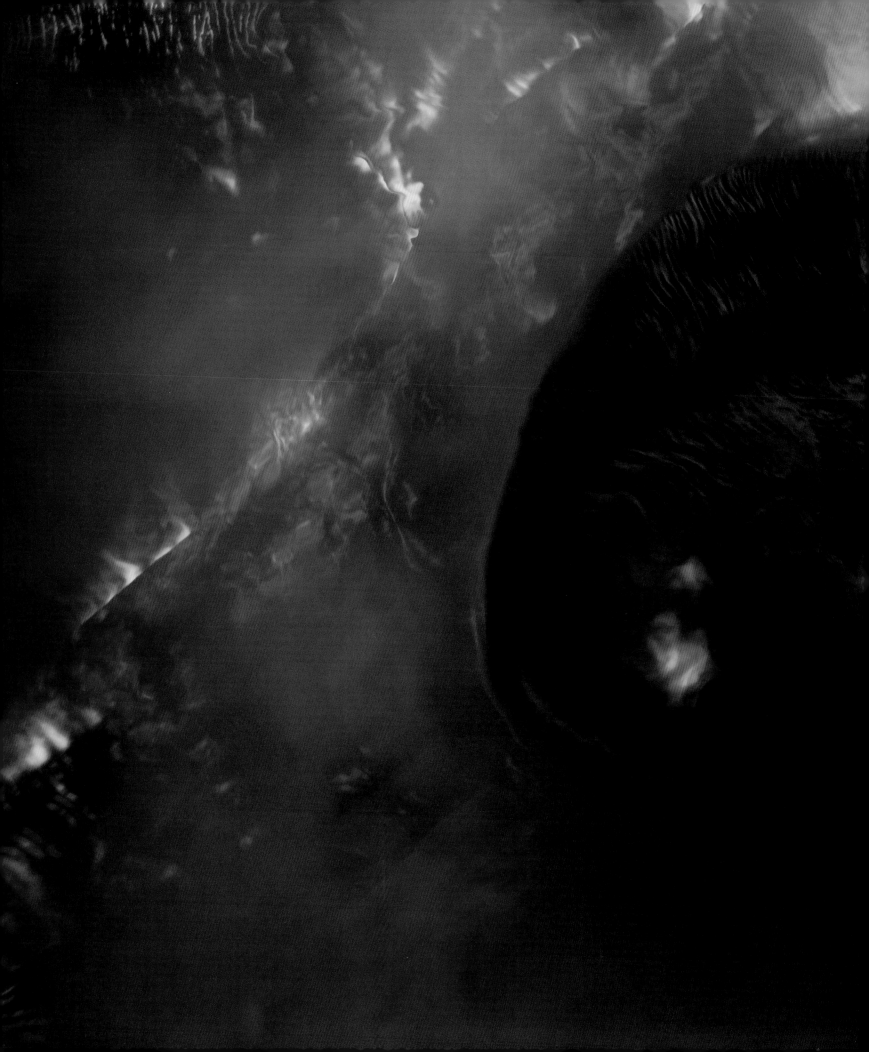

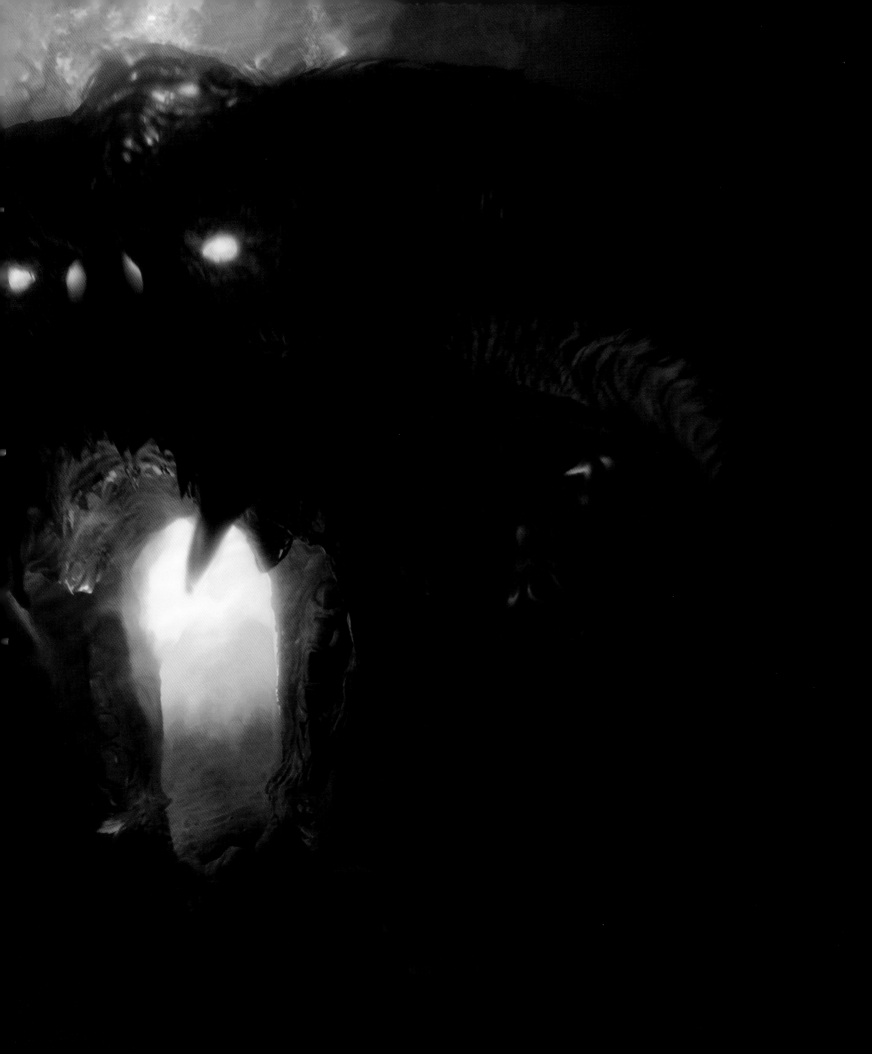

Independent Artists

Richard "Dr." Baily

Richard "Dr." Baily runs his own one-man fine art and production studio, ImageSavant, in Hollywood, California. His primary focus is the production of digital effects and animation using his proprietary software, SPORE, with which he has been able to produce his unique, signature style of imagery. Baily is a CGI veteran with an expansive portfolio of fine artwork and an impressive list of professional credits. Some of his recent feature film projects are *The Cell* (2000), *Solaris* (2002), and *The Core* (2003).

This still frame of a journey inside the mind of a villain is from a one-minute animation from the 2002 feature film *The Cell*. Baily describes this portion as "a sort of sea anemone with sexual overtones." 2003 Courtesy New Line Cinema.

Opposite: An early experiment with the SPORE software was intended to emulate the look of smoke trails confined to the spatial restrictions of a sphere. Some artistic license was taken to produce this colorful and compelling 2002 image.

Much of Baily's work is inspired by the stunning astronomical images made possible by telescopes like the Hubble. The impetus for creating his own software and for producing this kind of work is to represent a fraction of the majesty and sublime beauty of real extraterrestrial images.

Opposite: To Baily's surprise, this ghostly anthropomorphic shape emerged as part of a 2002 experiment to test and expand the parameters of his proprietary software. The image caught the eye of a television producer, and Baily was asked to animate a similar "character" for the television series *A Wrinkle in Time*. With a few more software modifications, he was able to animate the eerie visage.

Terry Calen

Terry Calen has worked in photographic and digital imaging for more than twenty-five years and in 3D computer graphics for more than fifteen. A self-taught artist with a background in biology and chemistry, Calen is also an accomplished fine-art photographer whose work is part of numerous permanent collections and publications. Calen's 3D artwork has been exhibited in trade shows such as SIGGRAPH, Seybold, and Macworld, as well as in galleries around the country. He currently resides in Burien, Washington.

Calen is inspired by the shapes and colors of nature, which very often emerge in his images. His work is an interpretation, as opposed to an illustration, of nature.

Opposite: Calen consistently focuses on a sense of volume and space within an image. By overlapping shapes and diminishing clarity, or atmosphere, the artist was able to produce this illusion.

The artist describes this 2003 work as an exploration into the effects of multiple surfaces. The two major surface with holes acted as templates for the smaller wrapped surfaces.

A common theme in Calen's work is interplay between structural texture and surface texture. Here the combination of fine detailed texture and the repetition of the bold geometric shapes creates its own pattern. The overall effect echoes, but does not copy, the natural world.

The tools of computer graphics allow an artist to visualize completely fictitious structures credibly enough to suggest that they could exist. The idea that one can show the imagined so vividly continues to fascinate Calen and is one of the major motivations for his work.

Chuck Carter

After a stint in the Navy, Chuck Carter started a career as an illustrator and commercial artist. A self-taught artist and entrepreneur, Carter worked on everything from storyboards to novelty portraits. He taught himself 2D and 3D software and then in 1990 went to work for Robyn and Rand Miller of Cyan, where Carter was one of the two artists responsible for the smash-hit game "Myst." Since then, the prolific Carter has worked for many of the top firms in the gaming and television industries including Westwood Studios, Reactor, Inc., and National Geographic. His virtual environment creations have helped define the look of an entire genre of adventure video games.

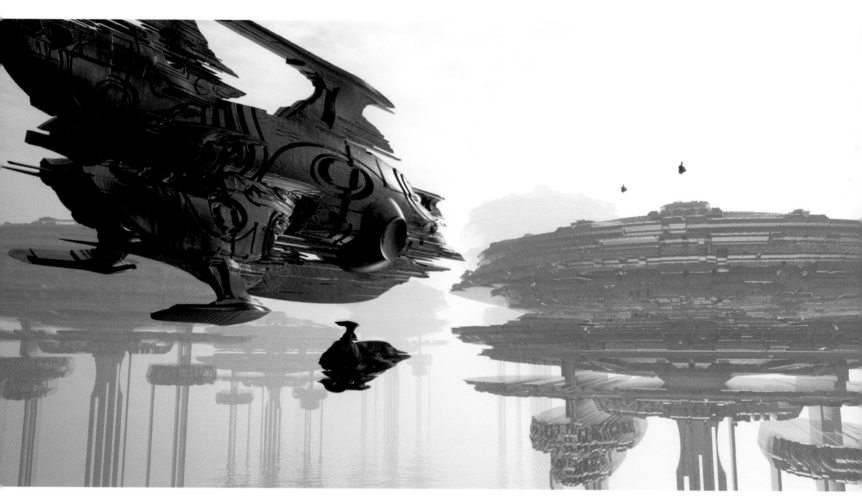

In *Dead City Fly Over* (2001), an experiment into the capabilities of Bryce software, alien spacecraft glide through a mysteriously abandoned world.

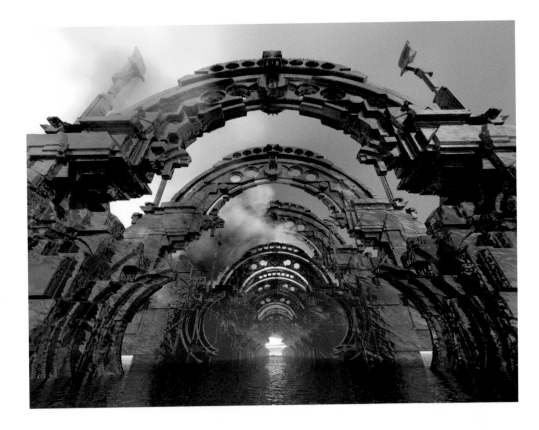

In *Gates to Valhalla* (2001) Carter pushed the limits of the software by letting the displacement map modify the geometry to create a painterly effect.

In his 2001 piece *Murdok's World*, Carter wanted to achieve a painterly look with matte images. "I wanted something that did not look computer generated," he explains. "I feel the image worked, in that people who've seen it could not tell how it was made."

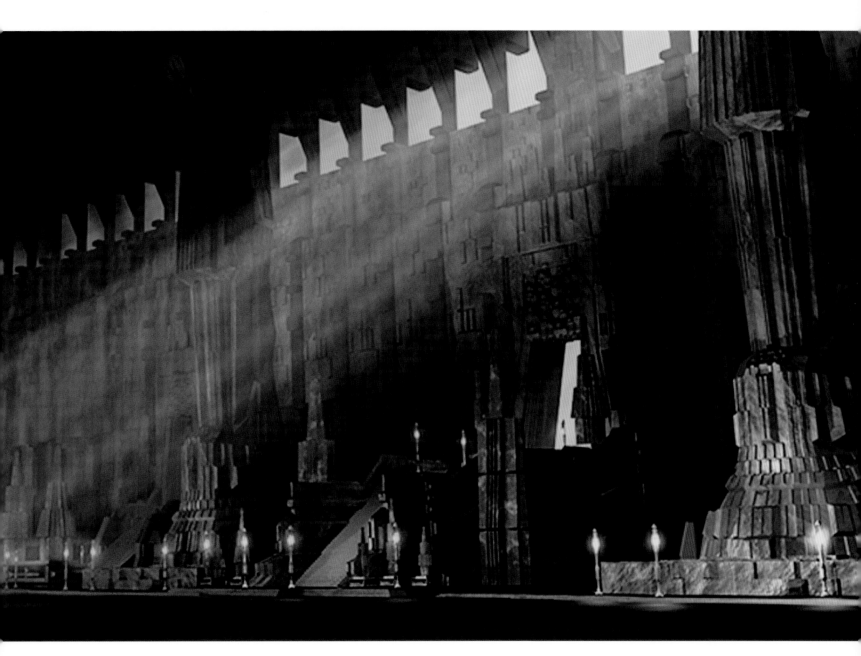

This matte painting for the video game
"Dune: Emperor" was used as a background
for live-action actors. Courtesy Westwood
Studios 2000.

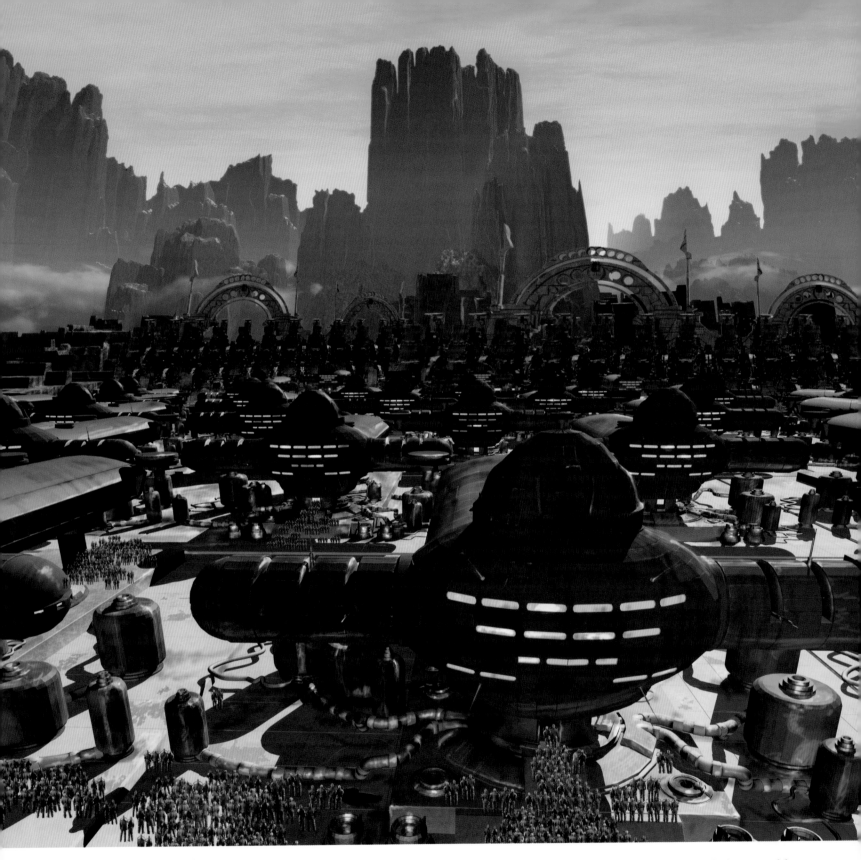

The crowd in this matte painting created for Westwood Studios' video game "Dune: Emperor" was not modeled in 3D. Instead, a small group of actors was shot on video in front of a green screen. They were then duplicated and placed in the digital painting. Courtesy Westwood Studios 2000.

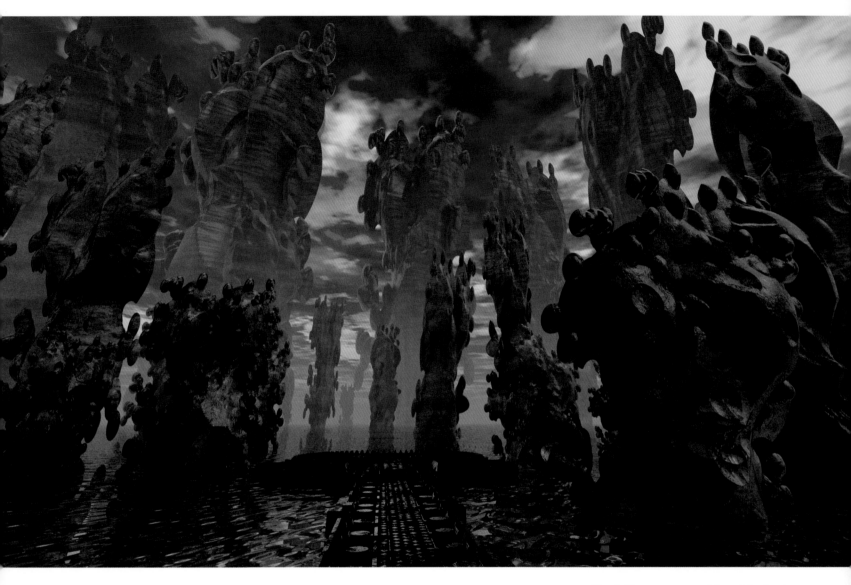

Chuck Carter was one of the original artists for the "Myst" CD-ROM game. Carter explains that this 2001 image is part of an ongoing project "that is sort of an update on what I would do if I was making 'Myst' today, with today's technology and with what I've learned these ten years since I worked on 'Myst.' This is the Stone Forest."

Clara Chan

Clara Chan graduated from Texas A&M University with a master of
science in visualization sciences. She is currently working as a technical

**The 3D computer-animated film *Autumn
Bamboo*, from which this image comes, was**

Vishal Dar

Vishal Dar is an architect and new media
artist. He conceptualizes, designs, and builds
works that inform and overlap with the fields
of architecture, design, film/animation, and
interactive art.

These digital sculptures from *Project: Snake*
were produced with the animation software
Maya. The data was processed through
SURFCAM and then translated through the
CNC Milling process into physical sculptures
in wood. A large-scale sculpture was pro-
duced in high-density foam and converted
into an acrylic mold through the process of
vacuum forming.

Gary Day

Gary Day trained to be a traditional printmaker. In the mid 1980s he began making computer-generated images that were printed using lithographic and intaglio techniques. After about a decade, he began to use CAD programs to design installations. Eventually, Day began to concentrate exclusively on animations and the creation of virtual objects and environments.

Day's image is from an animation called *La Caixa*, which is based on a curiosity cabinet.

Jim Ellis

Jim Ellis is a graduate of CalArts experimental animation and film programs. He has created more than fifteen short films. His work has appeared in music videos, *MTV's Amp*, Kinetica 4, SIGGRAPH, ACM1, and group shows at: the Los Angeles County Museum of Art, Los Angeles Contemporary Exhibitions, Postartum, and numerous film festivals. In 2002 he performed live real-time touch animation for the world tour of the Canadian rock band Rush.

Seeds of Notion (overleaf, top), *Memory Fragments* (overleaf, bottom), and *Lore* (above) were created as a backdrop for a piece Ellis created for a song called "Believer" by musician/performance artist Mimi Goese's band, Mimi.

David Em

David Em began producing digital art in 1975 in research institutes such as the Xerox Palo Alto Research Center and NASA's Jet Propulsion Laboratory. "My early computer art was done in big labs with hardware that was Scotch-taped together and required a team of system operators, programmers, and managers to run," Em says. "The software was all one of a kind, completely undocumented, and definitely not designed for artists. The whole process was a nightmare."

Since then, Em's images have been exhibited in museums in the United States, Europe, and Japan. Today he creates his work on a network of PCs in his studio in Sierra Madre, California.

Glacier **is one of a series of digital prints Em created in 1997. The final version is a 3' x 6' digital print.**

Annika Erixån

Annika Erixån lives in Gävle, Sweden. She is a graduate of the University of Gävle with a degree in creative programming. Much of her work is inspired by the 1986 Chernobyl nuclear meltdown, which rained radiation down upon her hometown, contaminating much of the local wildlife and environment. Since that time Erixån has used a combination of X-ray images and 2D and 3D CGI to produce her artwork.

This 1998–2001 image is from a large project titled *X-rays*. The original was modeled in 3D and then printed out at a very large scale.

Richard Green

design & artwork by
Richard Green
www.artbot.com
© copyright 2003

Richard Green has been a 3D artist and designer in the video game industry for over a decade. He graduated from the Art Center College of Design in Pasadena, California. A self-taught 3D artist, Richard Green has worked as a freelance artist for LucasArts Entertainment Company and Totally Games.

Green first designed the Uniracer vehicle on paper and then created the 3D model as a personal piece. The Uniracer image won First Place in the TAACCL Digital Arts Competition and has appeared in *Scientific American* and *Focus* magazines. The piece has been so popular that a real physical life-size model was built for display at the Houston Space Center Museum.

Jen "Zen" Grey

Jen Grey (JEN ZEN) is internationally recognized as a visual artist and published author in the creative technology movement. Her current work combines innovative experiments in human-computer interaction with hyperrealistic old master painting techniques. Grey is professor of drawing and painting at California State University, Long Beach, and has a prestigious history of professional activities from 1975 that includes numerous national and international exhibitions, awards, commissions, and publications.

Final Spin (1999). **JEN ZEN creates her art with nontraditional real-time input devices and a combination of off-the-shelf and custom software. The red figures in the image are "cyber-touch" shells created in virtual reality by petting actual human beings from head to toe. The kinetic images were placed in a background of Devil's Racetrack in Death Valley. "Inspired by classical painters Eugène Delacroix and Peter Paul Rubens, who used mathematical formulae to portray pictorial movement," says the artist, "I was obsessed with creating 2D still animations while retaining the integrity of the original 3D motion capture data created with Steven Schkolne's proprietary Surface Drawing software."**

Eric Heller

Eric Heller, a professor of physics and of chemistry at Harvard University, has been interested in scientific illustration for many years. Also a landscape painter and photographer, early on Heller occasionally transformed his scientific work into art. These works remained on his computer's drive until a few years ago, when digital printing technology made large, high-resolution prints possible. Since then he has produced new images with the new technology in mind. Exhibitions of his work include "Approaching Chaos," a traveling exhibit of thirty-five large-format images.

In a simulation of electron flow in a semiconductor device, electrons are launched from the lower left corner, and their tracks are recorded. Dark lines show the paths of single electrons; where many traveled, the paths are lighter. The electrons are heading uphill against an electric potential, and they meet with bumps caused by nearby positively charged donor atoms (atoms that donated the electrons). Several such bumps are visible as holes in the upper third of the picture. The electrons slow down as they approach the top of the image, and eventually turn and head toward the bottom again.

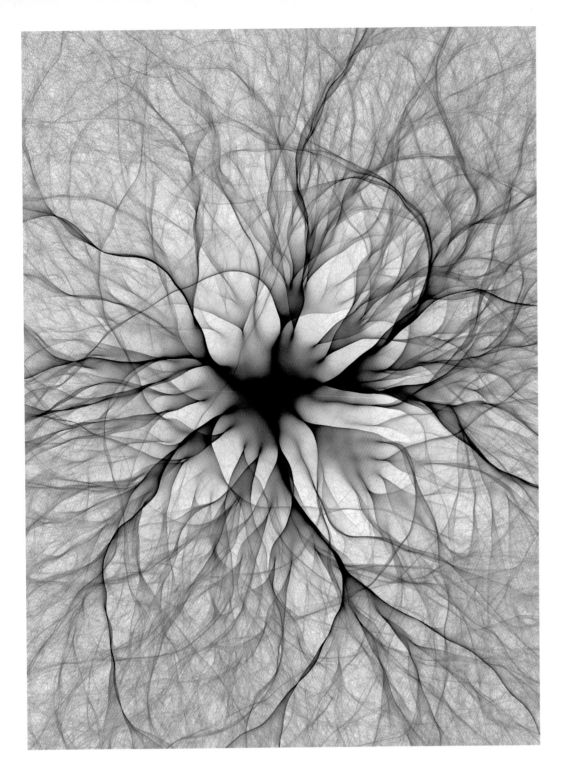

These images from Heller's "Transport" series render electron flow paths in a two-dimensional electron gas, a thin sheet in which electrons can flow almost freely. Inspired by the experiments of Mark Topinka, Brian Leroy, and Prof. Robert Westervelt at Harvard University, this is a theorist's classical simulation of the flow by Prof. Eric Heller. What is seen is the result of propagating (generating under certain parameters) hundreds of thousands of electrons on a computer. In *Transport II* (this page), darker regions show where more electrons passed by. The electrons are all launched from a point on the image uniformly over a range of directions. They ride over a lumpy landscape of hills and dales caused by attraction to the irregularly placed positively charged atoms nearby. The electrons have more than enough energy to ride over the highest of these hills (which are not seen), but they are still deflected by them, forming the intricate patterns seen in the image. These patterns, or "branches," have been seen experimentally, too, in the imaging experiments at Harvard. The images are of an area that spans about 6 microns.

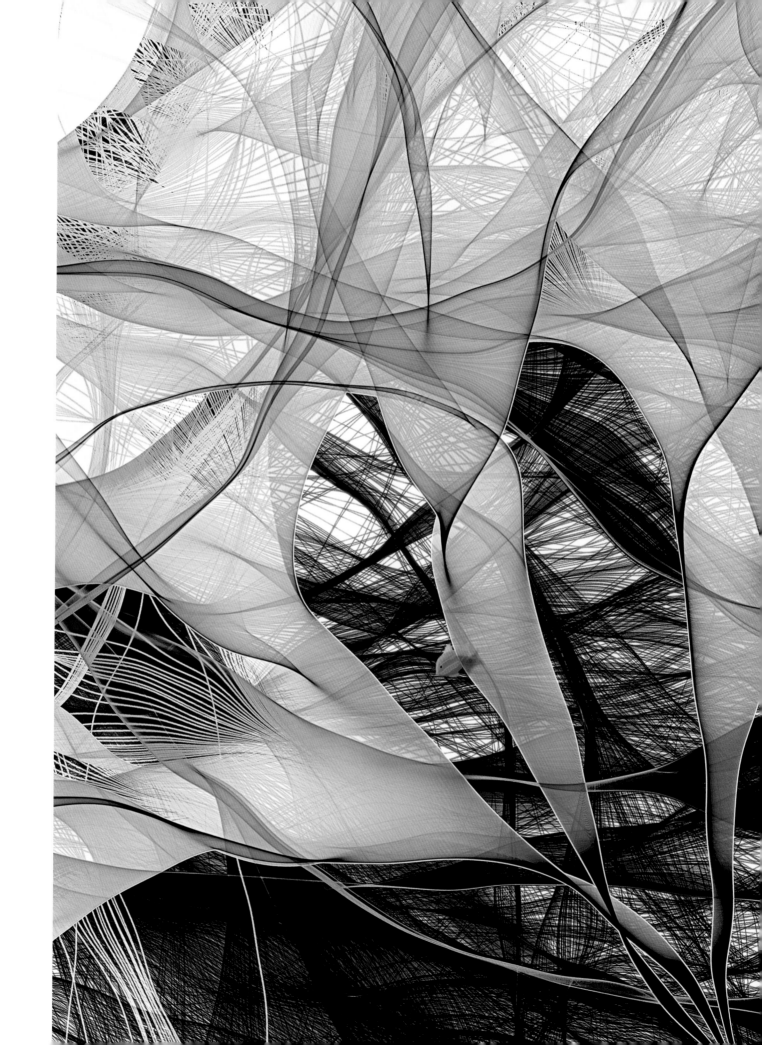

Kenneth Huff

Ken Huff is a self-educated, independent fine artist who began creating images with his current technique almost ten years ago and started exhibiting his work in October 1997. He is a world-renowned artist whose work is held in numerous public, private, and corporate collections. He has received more than 100 awards. Huff's work was shown in the SIGGRAPH 2003 Art Gallery, in the sixth consecutive inclusion of his work in this annual exhibition. Born in Bismarck, North Dakota, in 1969, Huff now lives in Tampa, Florida.

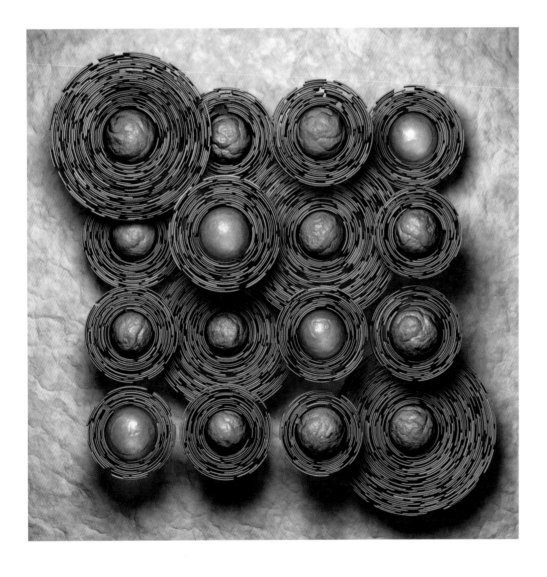

The whorls, arches, and loops of the concentric lines of a fingerprint served as the inspiration for the patterns in this 2001 image. The thousands of unique, small copper forms were constructed using the artist's surfacePlater tool. There is only one glass sphere in each row, column, and the two four-sphere diagonal groups. This type of deliberate, structured variation is a hallmark of Huff's work.

Opposite: An aperiodic (irregular) structure built from a periodic pattern is the basis for this 2000 image. The tubular forms are based on a 3D grid of a simple base unit, a cube with its six sides connected by three quarter-circles. The image is part of the artist's "Truchet" series, based on 2D tiling patterns documented in a paper written in 1704 by a Dominican monk, Sebastian Truchet. Each of the no-longer-visible cubes was randomly rotated (in 90-degree increments) and the resulting adjoining quarter-circle sections were merged to form the red tubes.

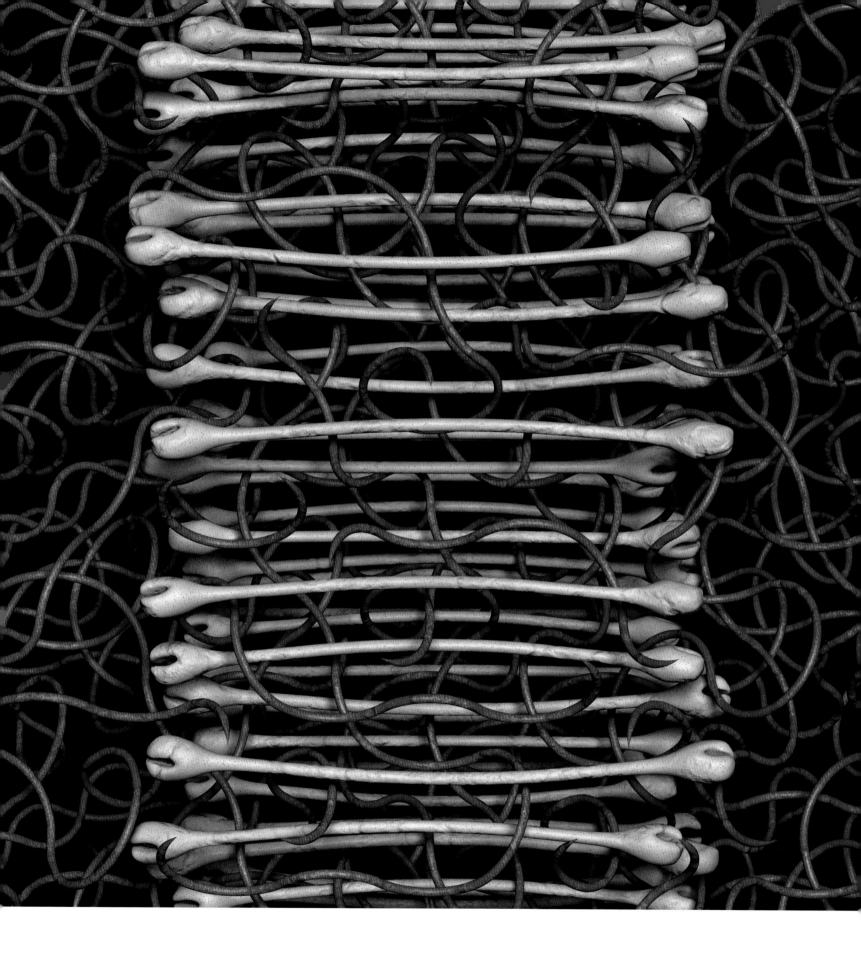

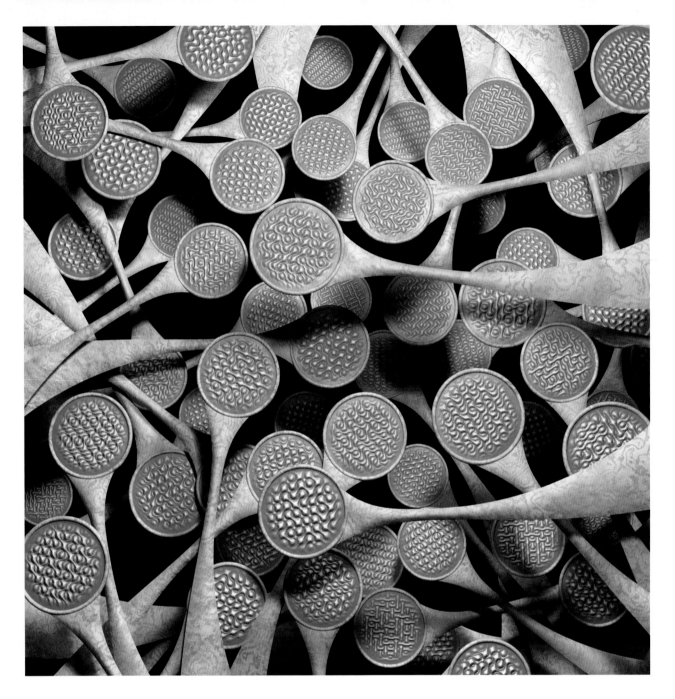

The surface of each blue disk has its own textural pattern. While the patterns are unique, they also are obviously related. This type of repetition with variation mimics the subtleties of natural patterns. The complex patterning in this 1999 work is based on interference between two simple 2D grid-based patterns and is related to the tubular "Truchet" pattern.

In this and the following images, Huff has created patterns and structures using multitudes of similar, yet unique, forms. In each case, the exact number of objects involved was not significant. The image opposite, from 2000, is an example of a recent theme in which the number of objects involved does have particular significance. The numbers of bulbous arms extending from each of the four sides of the image represent the set {1, 2, 3, 5, 7, 11, 13, 17} (the identity and the first seven prime numbers). The first four numbers appear in the background, behind an icelike plate.

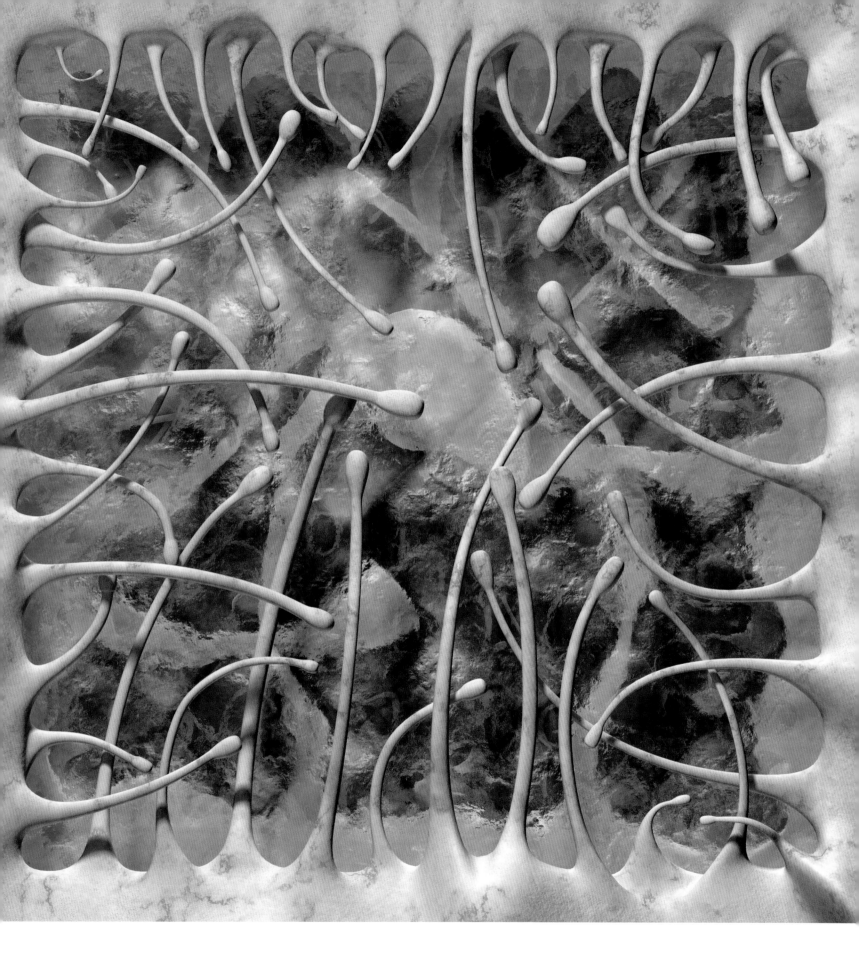

This 1999 image also makes use of multitudes of unique but related forms. The relative scale of each of the two component parts of each object is unique, as are the surface texture and patterns of coloring of each object.

Instead of re-creating a particular object from the natural world, Huff distills the essential elements of various references and combines those elements in unique ways. A cross-section of a fossilized mollusk shell, the cellular structure of a leaf, and the ornament of Victorian scientific instruments are some of the inspirations for this image. Again contrasting periodic and more random elements, each chamber is unique in its structure.

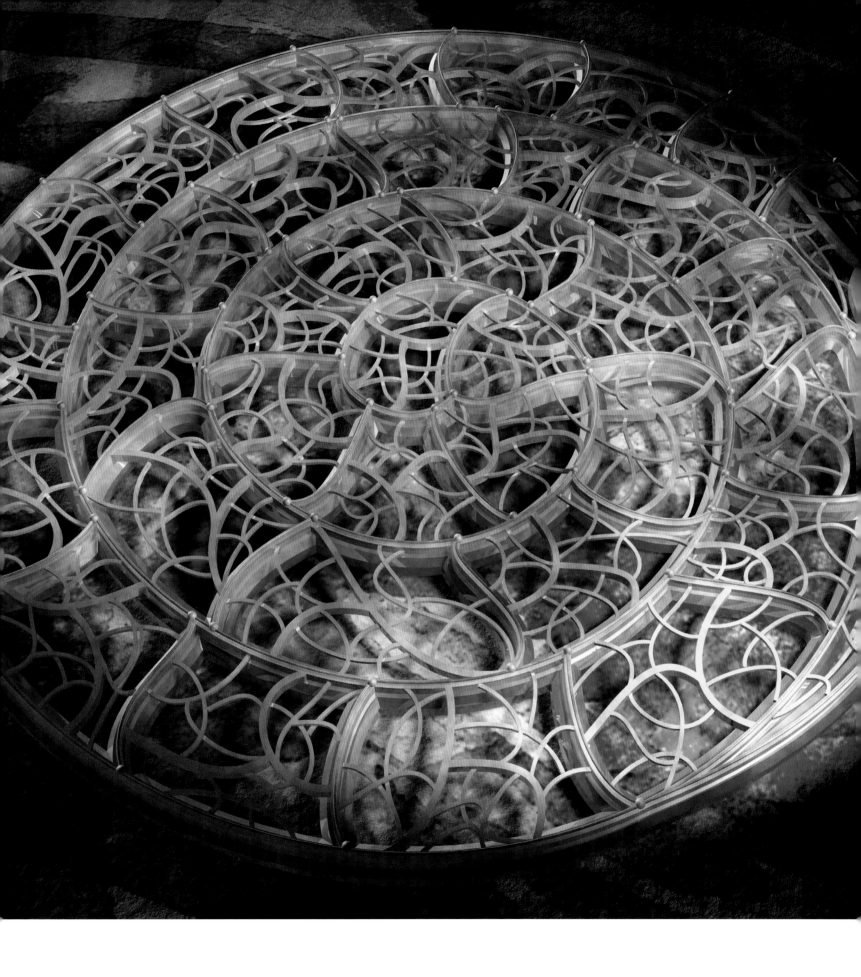

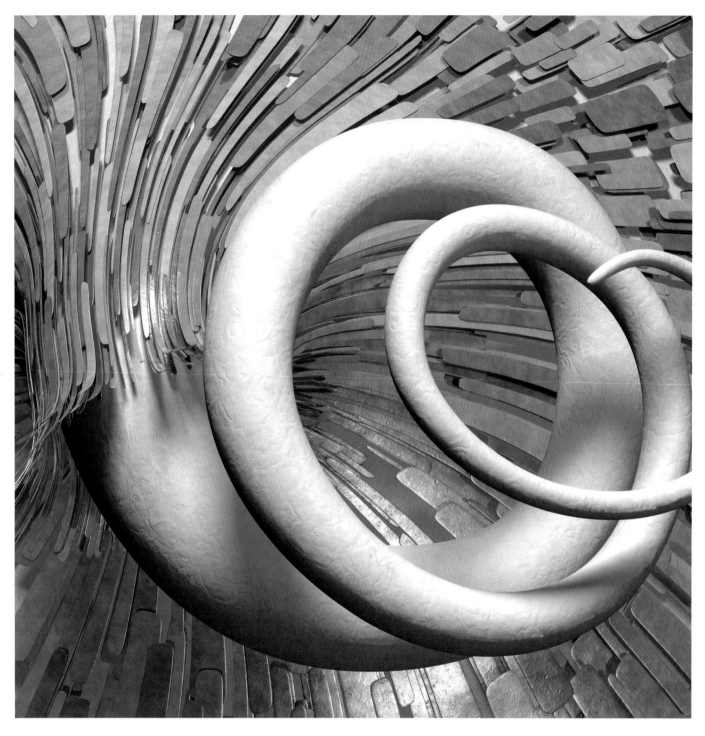

Spiral forms and patterns occur throughout the natural world, from the twisted double helix of DNA to the formation of galaxies, and is an important motif in Huff's work. The spiral in this 2002 piece was initially inspired by a tiny portion of dried grapevine. The blue forms, "plates" in the artist's lexicon, were constructed using a software tool he developed. Development of these custom tools is a fundamental part of Huff's creative process, allowing him to implement ideas which otherwise would be extremely difficult or impossible to create.

Masa Inakage

Masa Inakage is a professor of environmental information at Keio University. He is also the chair of the Media Design Program, School of Media and Governance, and the director of the Digital Cinema Laboratory at Keio University. As artist and producer and president of The Media Studio, Inakage has won numerous awards and competitions. His work has been exhibited at SIGGRAPH six times and at the Cannes Film Festival in 2002.

Utopian Paradise, 2002. This work depicts tranquility in the forest of a utopian paradise, a place to find a very peaceful and silent moment, where we can isolate ourselves from the overloaded information society and stressful human relationships. Inakage refers to his work as abstract realism, an integration of surrealism and abstract expression. The surrealistic component in the work provides the viewer with hints and guides, while the abstract component gives the viewer freedom to imagine. In this work, color and composition hint at peaceful nature, and the reflective surfaces refer to the mirror of one's state of mind.

Tangled, 1999. Masa Inakage is interested in using the digital medium to express his emotions. "My recent works have been focusing on our technology-driven civilization that is causing many problems and distortions within our society," he says. "My visual style is to integrate surrealism and abstract imagery. This work depicts the complexity of one's memory, how one memory relates to another memory. These memories are referenced to make decisions in our daily life."

Henrik Wann Jensen

Henrik Wann Jensen is an assistant professor in computer science and engineering at the University of California, San Diego, where he is establishing a computer graphics lab with a research focus on realistic image synthesis, global illumination, rendering of natural phenomena, and appearance modeling. Jensen invented the photon mapping algorithm for simulating lighting in complex 3D models and developed the first precise techniques for simulating light scattering by translucent materials such as snow and human skin. His inventions are widely used in films, architectural visualizations, design, and lighting engineering. Jensen's *Realistic Image Synthesis Using Photon Mapping* was published by AK Peters in 2001. He lectures extensively on his groundbreaking work in computer science and rendering technology.

These images demonstrate how a rendering technique known as photon mapping can be used in an architectural model to accurately simulate lighting as the sun moves over the sky during a day. The images simulate 8 am, 10 am, 3 pm, and 6 pm in the unbuilt "Courtyard House with Curved Elements" by Ludwig Mies van der Rohe. A more traditional rendering technique such as ray tracing would have created an image that is very dark without indirect illumimation. In contrast, the photon mapping algorithm is capable of simulating the indirect illumination efficiently. This model was created by Stephen Duck and rendered by Henrik Wann Jensen.

Yoichiro Kawaguchi

Yoichiro Kawaguchi is one of the most influential and respected fine artists working in CGI. He has been creating computer graphics since 1975. Kawaguchi was a pioneer in the use of seemingly organic mathematical algorithms as an essential component in artistic expression and achieved a unique style using his "GROWTH Model," based on a growth algorithm. Since SIGGRAPH '82, he has consistently presented work in the United States. Kawaguchi is a professor at Tokyo University/Graduate School of International and Interdisciplinary Studies, Research Center for Advanced Science and Technology (RACE).

The structure of a hard-sided cell as it is dividing is the subject of *Xenion* (2003).

***Eggy* (1990) is the artist's depiction of the churning motion of a planet's birth.**

Lise-Hélène Larin

Lise-Hélène Larin teaches painting and drawing at Concordia University in Montreal. Her 3D work has been exhibited at SIGGRAPH twice and is part of a European traveling exhibition. Larin is a multidisciplinary artist whose tactile sculptures have turned virtual. She creates nonfigurative 3D animated films that question sculpture and painting as well as 3D animation itself. The films, which are shown on multiple transparent screens, investigate interactivity using anamorphosis, a play on perception in which the viewer must move around the piece to find the best point of view and read the moving image in a meaningful way. Earlier Larin made 2D animation for the National Film Board of Canada and the French Canadian Broadcasting Corporation, for which she received many prizes.

Bondir (2002) is a series of nonfigurative 3D animations. Larin strives to rearrange the elements of traditional languages of sculpture and painting while exploring uncharted visual realms in film. "I want to create new emotional conditions in viewing 3D animated film," she says. "I show my digiscapes in installations using anamorphosis to further heighten the sense of loss and to stimulate the imagination."

Stephan Larson

Stephan Larson has been creating images with computers since an Atari 400 computer showed up in his home. While technology has changed a bit since then, he continues to use computers as his primary production tool, taking periodic forays into drawing using more classical media. He has been producing animations since 1990; his first notable computer-generated animation, *Mondrian, a Revisitation*, was completed in 1992. His work has been shown in more than 100 exhibitions throughout the world including the ACM SIGGRAPH Animation Theater (1995 and 1996), Anima Mundi (2000), and the ACM SIGGRAPH Art Gallery (2003). Larson has been teaching computer graphics and animation since 1996. He lives and works in the small city of Marquette, Michigan, on the beautiful shores of Lake Superior.

Exploration, Tension, 2003. Original print size: 18" x 10"

Overleaf: *Exploration, Fluid*, 2003. Original print size: 18" x 12"

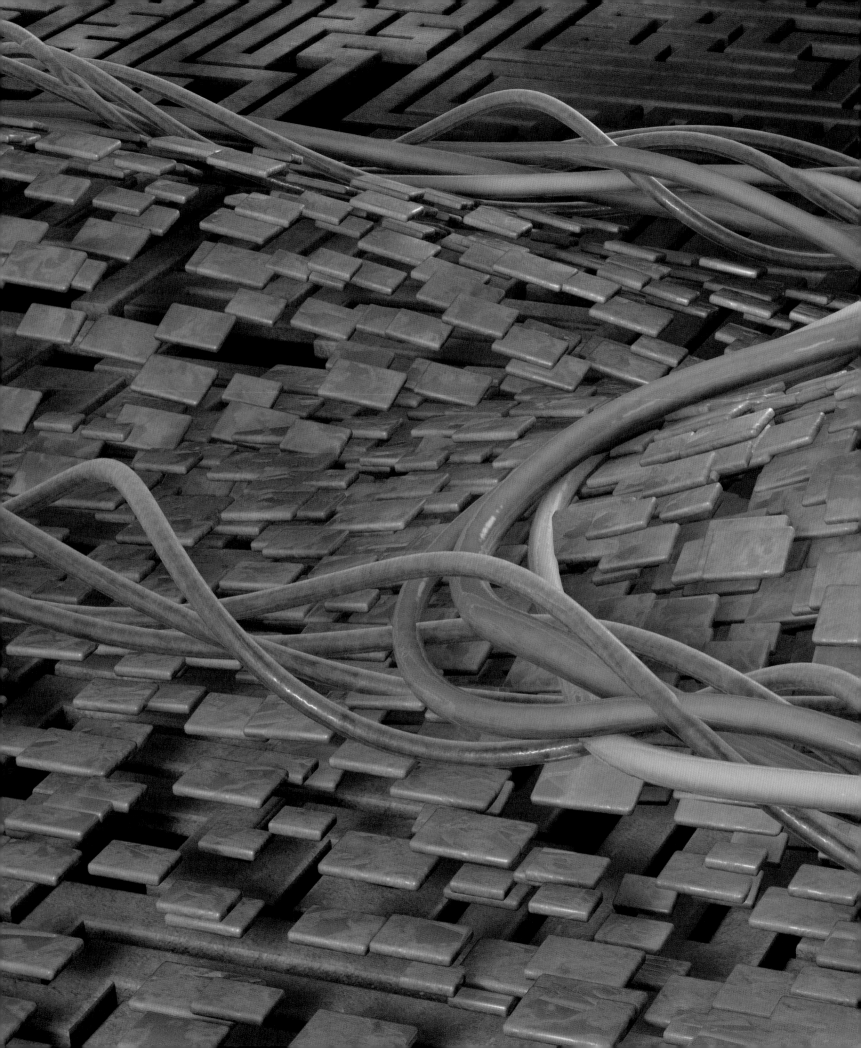

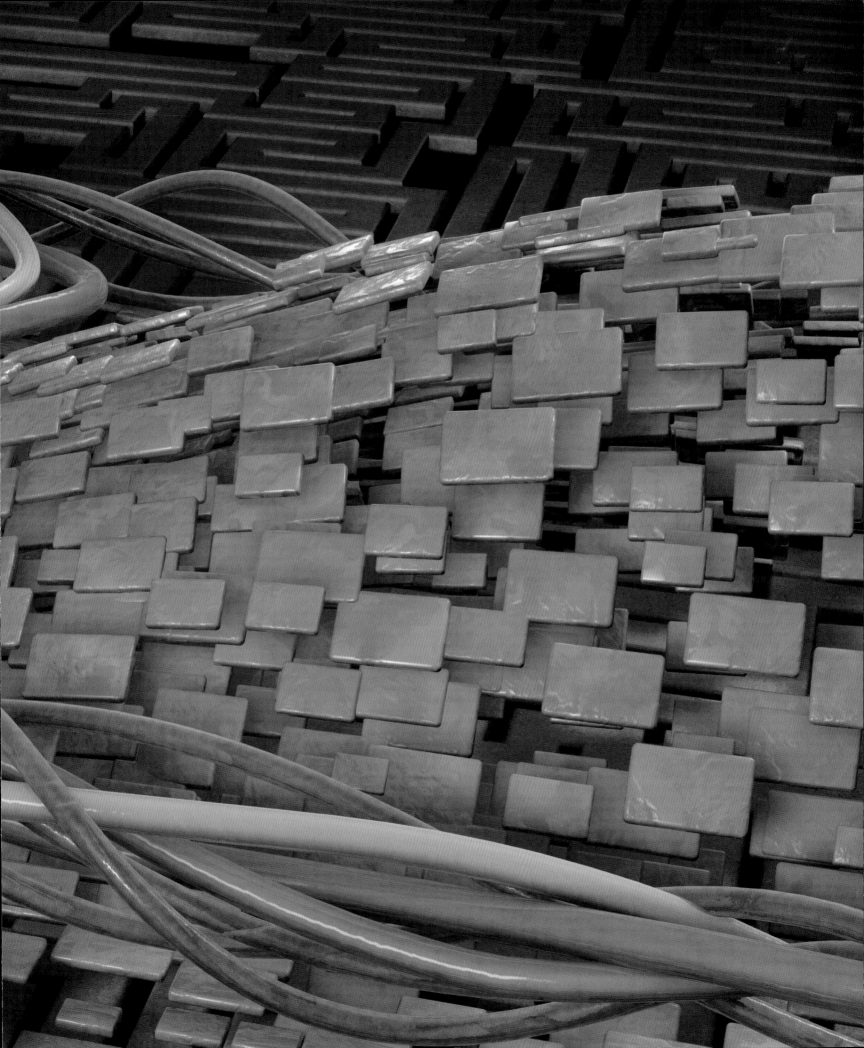

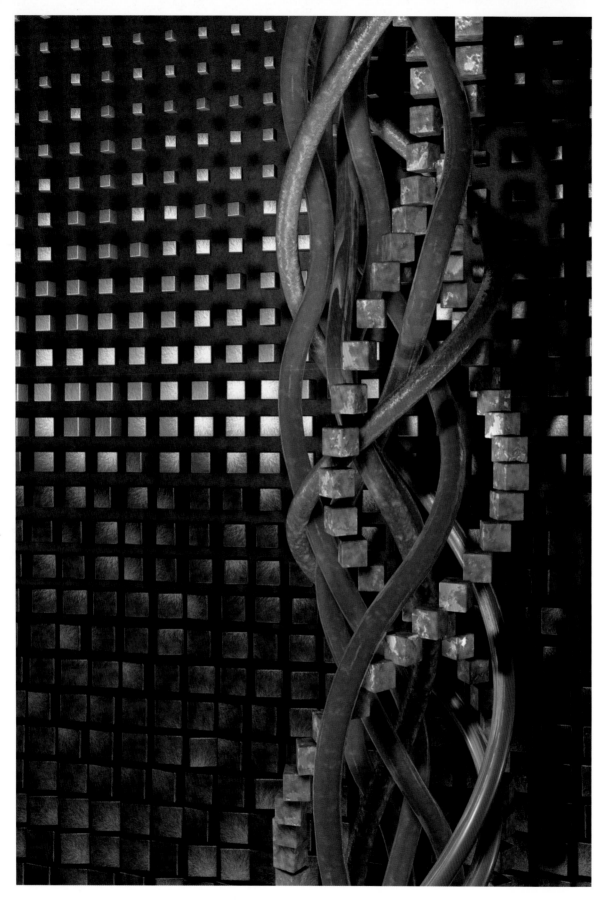

Exploration, Structure, 2003. Original print
size: 13" x 18"

Jim "Meats" Meier

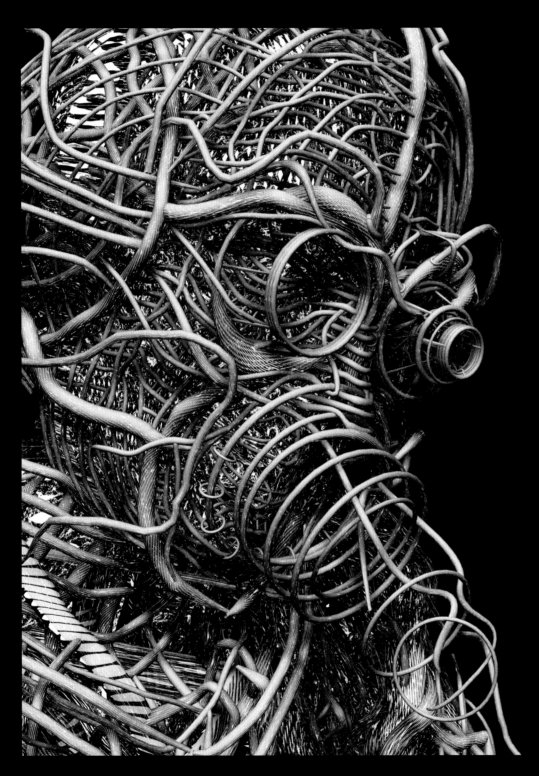

Meats Meier has extensive experience working in the video game industry producing pre-rendered animations and visualizations. He currently runs SketchOvision, a one-man studio dedicated to creating fine art CG prints and animations. He has been honored with numerous festival and show awards. He has also been featured in various television shows and print articles. Meier lives in Salt Lake City, Utah.

This page and overleaf: The "Etcher" series (2001) is comprised of a collection of intricate interwoven tubes that were rendered with a piece of custom code written by Richard Greenspan. CG artists and technical directors often write their own software rendering a set of parameters that describes the surface of a 3D object (known as shaders). A custom shader can often produce effects such as those seen in these examples, which would be very difficult or downright impossible with a standard software package.

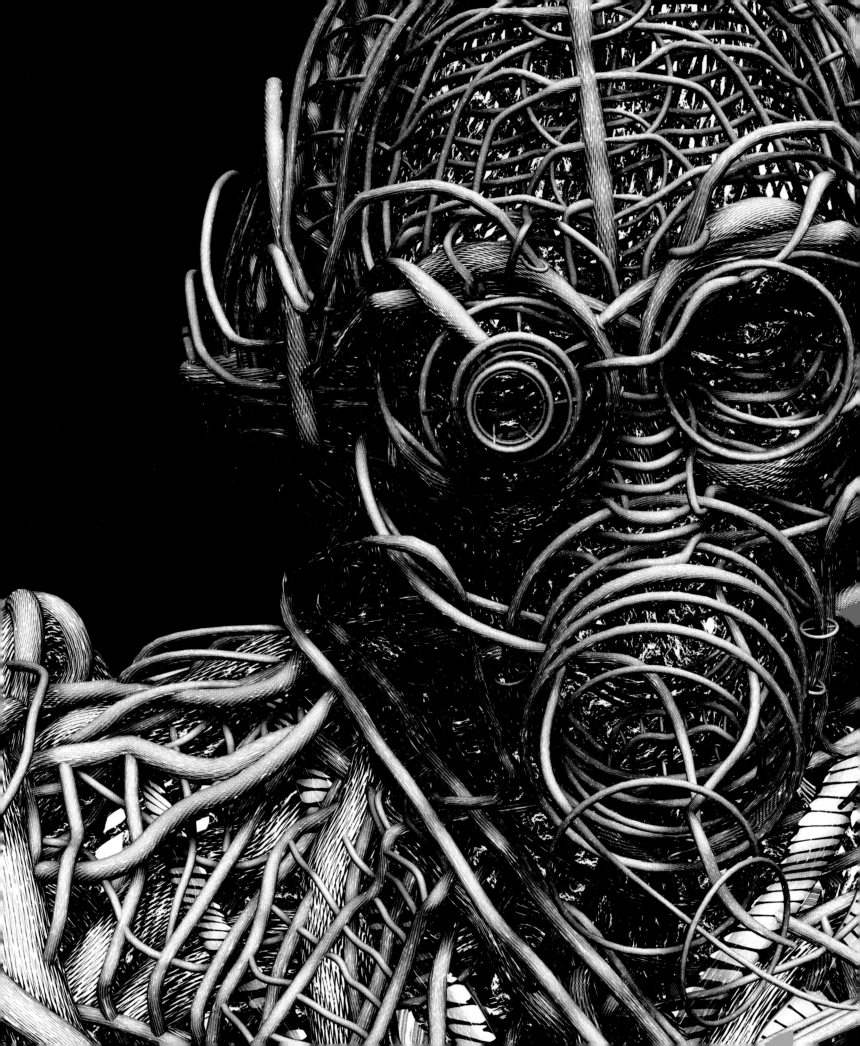

Meats Meier created the "Mother Nature" series in 2003 as a birthday present for his wife, Susan, who is an avid gardener. Mother Nature is represented as half woman and half plant. Most of her form is modeled in the traditional CGI manner of working with curves and surfaces, but her hair and flowing greenery were generated with a 3D fractal paint module of Alias Maya software called Paint Effects, which allows the artist to interactively paint in virtual space, with each stroke manifesting itself as a solid object.

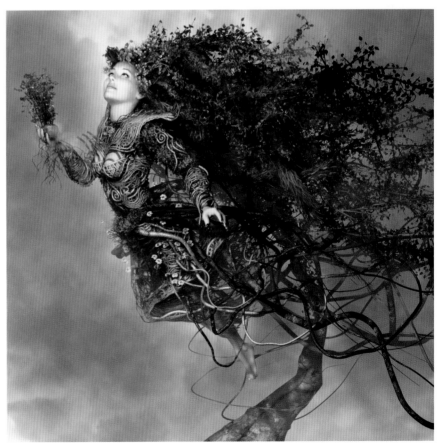

Kent Oberheu

Kent Oberheu has successfully combined the elements of 3D modeling and graphic design to create his own unique style of CGI artwork. He graduated from the University of Kansas, Lawrence, where he studied graphic design and illustration. Oberheu moved on to work as a designer and eventually taught visual communications at his alma mater. In 1999 Oberheu relocated to Berkeley, California, to pursue motion graphics with the San Francisco office of Attik and soon after joined Pandromeda as design director. He has been working steadily as a freelance commercial artist and fine artist ever since.

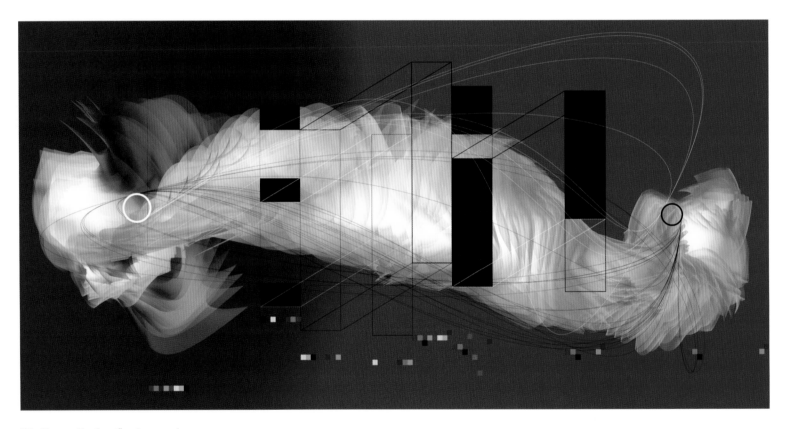

The Frozen Etude, a flowing continuum of transparent cells, suggests the form and structure of a musical composition.

The Running Dress, 2000. This image is a 4D virtual sculpture of the fractal algorithm known as the Julia Set. The process involved creating a 300-frame animation in which sine waves of various frequencies drove the parameters. After the final position and angle were chosen, the final version took just over 149 hours. The sculpture was then composited to include a graded background and a shadow.

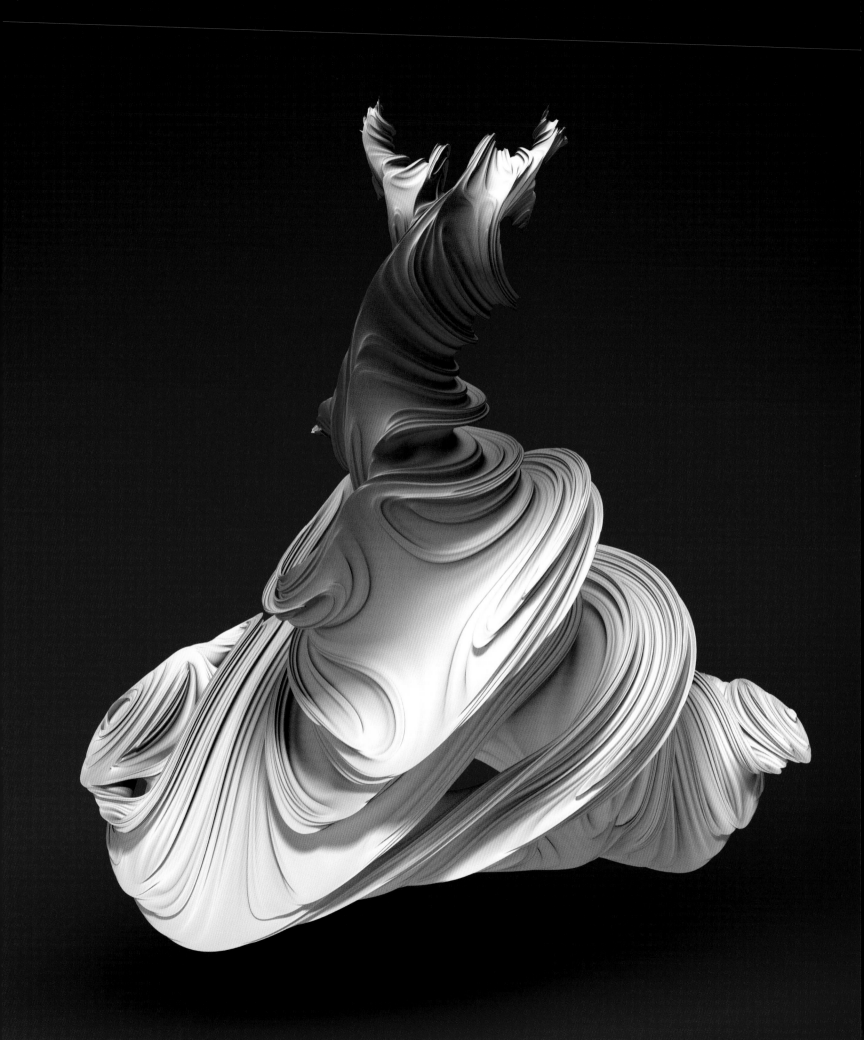

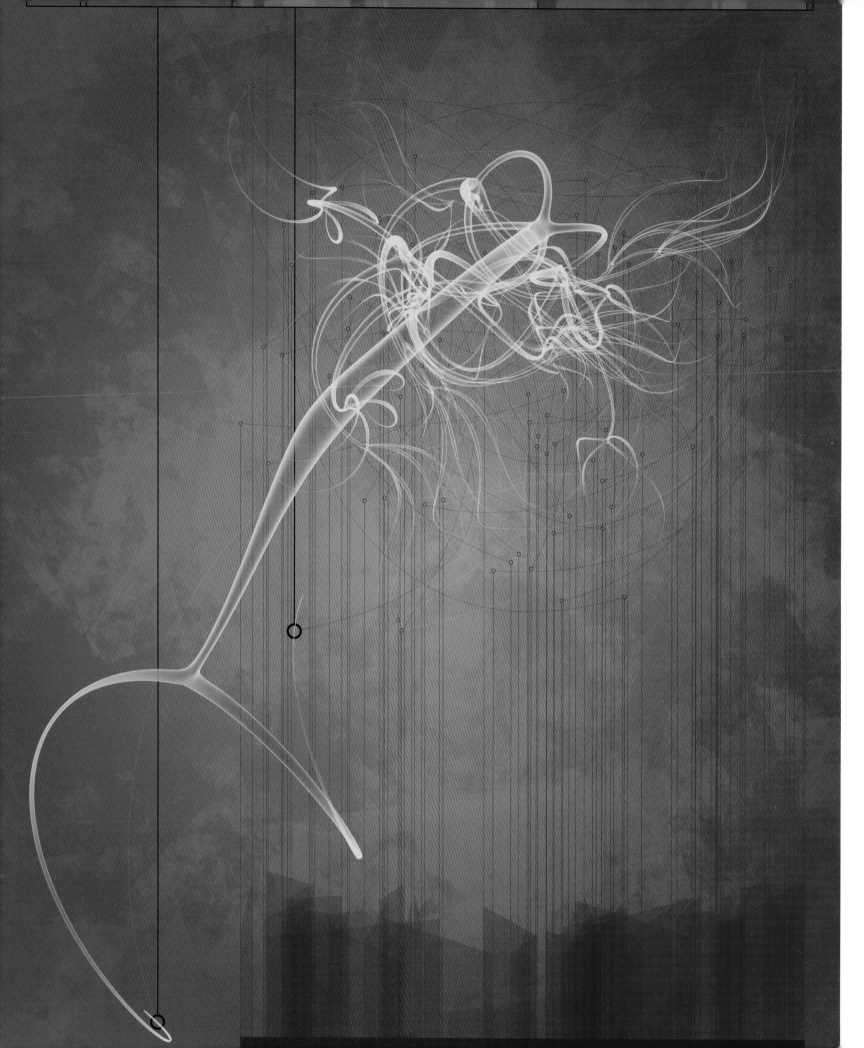

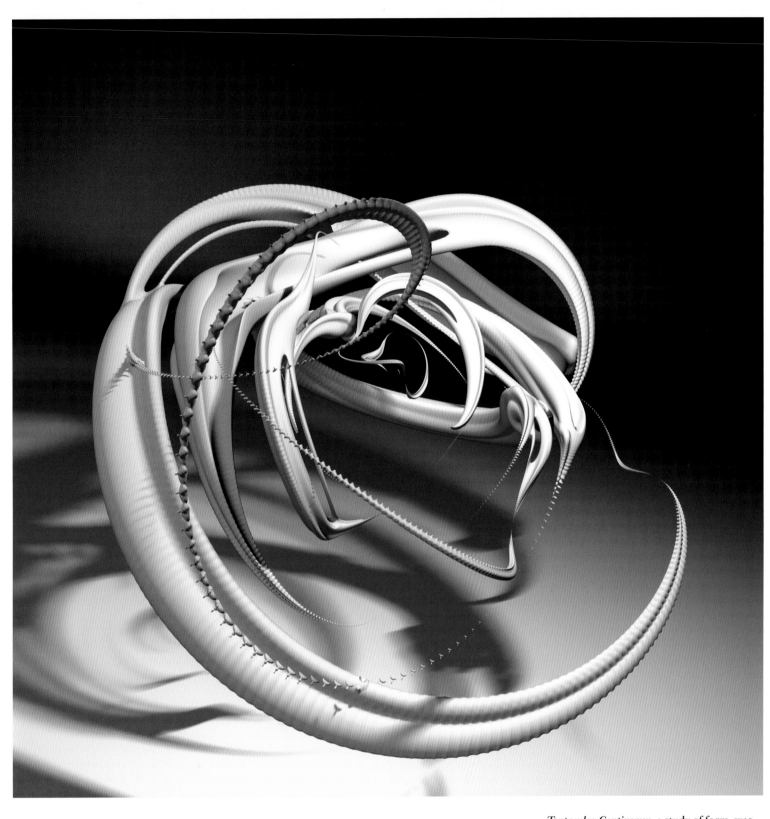

Intractable Sentience arose as a study of branching form and the relationship among extruded tips. The resulting shape implies an interrelationship of living entities.

Tentacular Continuum, a study of form, was created using more than 16,000 so-called "blobby" spheres. In CGI blobby particles act kind of like mercury in that they meld together when within a certain distance. Oberheu used oscillating sine and cosine functions with various translation and scale parameters to create the variation in form.

François Rimasson

François Rimasson lives in Paris and has worked as a designer and CG artist at the French video game company Kalisto, where he developed graphics for CG movies in the PC adventure game "Dark Earth." Since 2001, Rimasson has worked as a freelance artist on films, animated features, and video games. His most recent credits include the video game "Terminator 3: Rise of the Machines."

Eve: A Nude Study, 2000. **The polygonal modeling and rendering for this image was all done within a 3D program. The simple white gives the figure the illusion of a sculpted object or a black-and-white photograph.**

Provence (2001) was made using Photoshop for the textures and Maya 3.0 for the polygonal modeling and rendering. This picture is featured in *Maya 4.5 Fundamentals* (New Riders Publishing).

Umesh Shukla

Umesh Shukla is an award-winning animator/director. He has been involved with the computer animation and special effects industry for more than fifteen years and has worked with major Hollywood special effects and animation studios such as Disney Feature Animation, DreamWorks Feature Animation, and Digital Domain. He is currently involved with exploring various approaches to experimental computer animation.

The animated short *Still I Rise* (2002) was inspired by the coincidental suicides in 1890 of Elephant Man Joseph Merrick and Impressionist painter Vincent van Gogh. The piece presents the final dreams of Joseph Merrick in an impressionist style.

Kevin Suffern

Kevin Suffern has taught computer graphics at the University of Technology, Sydney, since 1982, and is currently a senior lecturer in the Faculty of Information Technology. His interests include ray tracing, computer art, and fractals. His computer art has been exhibited at SIGGRAPH and Prix Ars Electronica, and he has won a number of international awards. Suffern uses his own ray-tracing software to produce his artwork.

Impact (above) and *Nebula* (overleaf) are the results of trying to create a complex fractal image by ray tracing a simple scene. They consist entirely of the reflections of colored lights on the mirrored inner surface of a hollow black sphere with a number of colored lights inside. The rays have been allowed to bounce eight times inside the sphere. *Nebula* was exhibited at SIGGRAPH 2003 and was selected for the SIGGRAPH Traveling Art Show.

Ying Tan

Originally a Chinese landscape painter, Ying Tan is currently interested in the use of digital media for nonobjective motion graphic work that is highly aesthetic, sensual, and spirit lifting. Professor Tan has won numerous awards and has had many gallery and festival showings of her digital artwork. She currently teaches 3D computer animation and communication design at the University of Oregon.

Images from 2001 short film *like a swarm of angry bees....*

Brian Taylor

Early on, Brian Taylor focused primarily on traditional illustration for the graphic design and advertising industry, but in recent years the computer has played an increasing role in his work. He has branched out into other areas including multimedia, computer game design, part-time teaching at an art college, and concept work for a television production company. Brian works from home in Dundee, Scotland, and his most ambitious undertaking to date is undoubtedly the *Rustboy* project, a 25-minute animated film and book, with several possible tie-ins.

Rustboy looks over the balcony while exploring his new surroundings, discovers that rain is not good when you are made of metal (opposite), and sleeps beneath a wooden arch in this landscape environment test (overleaf).

Richard Taylor

Richard Taylor has been wowing audiences since the '60s when he worked on multimedia light shows for The Grateful Dead, Crosby, Stills and Nash, Santana, and Jethro Tull. He was a founder of the art department at Robert Abel Associates, which made groundbreaking CGI effects for commercial television. Taylor has also worked for such prestigious firms as Rhythm & Hues, Disney, and Microsoft. With an extensive background in live-action direction, production design, animation, special effects, and computer-generated imaging for theatrical films and television visuals, he may be best known as the special effects director for the 1982 feature film *Tron*.

In *Tunlz 2* (2000), multiple gyros pass through the walls of a mirrored tunnel. A stone wall at the end of the tunnel is created from a black-and-white photograph of an old rusted clock part.

Gyroflix (2000) is part of a larger series. The artist writes: "As I worked on various gyro images I began to see the gyro as a three-dimensional geometric symbol of man. Its order and its up, down, left, and right angles are shapes that are created only by mankind. The gyro represents an artifact of consciousness. If you view the earth from the air you see what I call the geometric blight of consciousness. The geometric shapes created by man cover an astonishing percentage of the earth's surface and what makes these patterns even more fascinating is that at night they transform into a dazzling sea of luminescence. In nature the most perfect structure is the sphere. Be it a star, a planet, or a bubble, a sphere is the absolute truth of gravity and the forces that shape the universe. In my work I try to play out in some small way the battle of man against nature."

Overleaf: *Klox Stop 8* (2001) depicts an alien monument constructed in a high desert lake. The monument was built in reverence to time, the elements, and gravity.

Eugene Tulchin

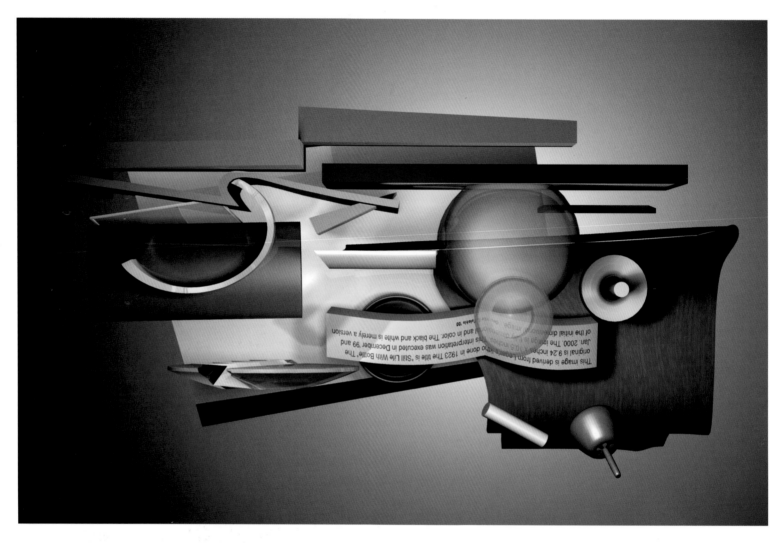

Eugene Tulchin was born in 1934 in New York City and was a photography professor at Cooper Union for more than twenty-five years. His work has been exhibited in dozens of well-known galleries in Europe and the United States. Tulchin's in-depth understanding of the art world coupled with his sense of composition, technical abilities, and experience as a photographer has yielded witty, surrealistic pieces that often play with a mixture of conventional and anarchist subject matter.

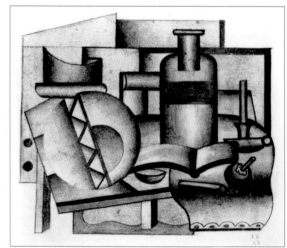

Tulchin asks the question "Can we now have our cake and eat it too?" Computer graphics and three-dimensional imaging suggest that it might be so. To that end he decided to explore the possibility of looking at the other side(s) of a painting. "I have long been sympathetic to the Cubist movement and particularly to the work of Fernand Leger," he says. "Central to the idea of Cubism is the notion of multiple views changing over time and condensed into a single image. I was quite curious as to what would happen to a 'decompressed' and then 'reconstructed' cubist work. What would it lead to? Would it still be cubist? Would it still hold together? And finally would it validate the rather abstract ideas of Cubism and yet be a substantive and independent work of art? What you see is my attempt to answer those questions. The work I 'processed' was a 1923 pencil drawing by Léger, *Still Life With Bottle* [opposite]."

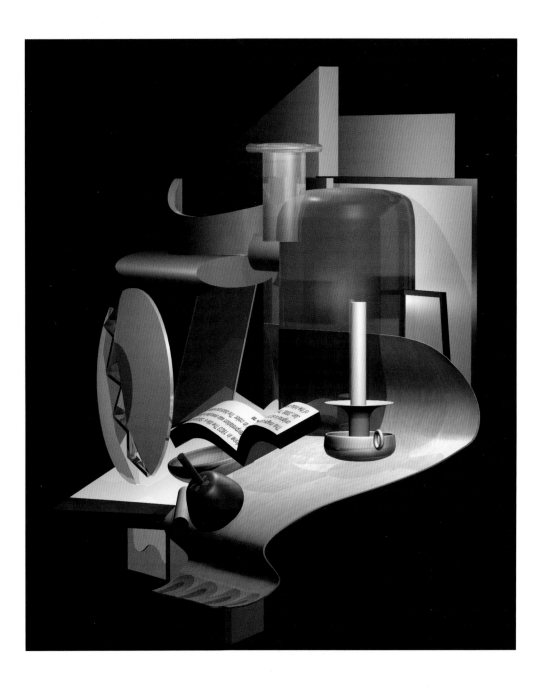

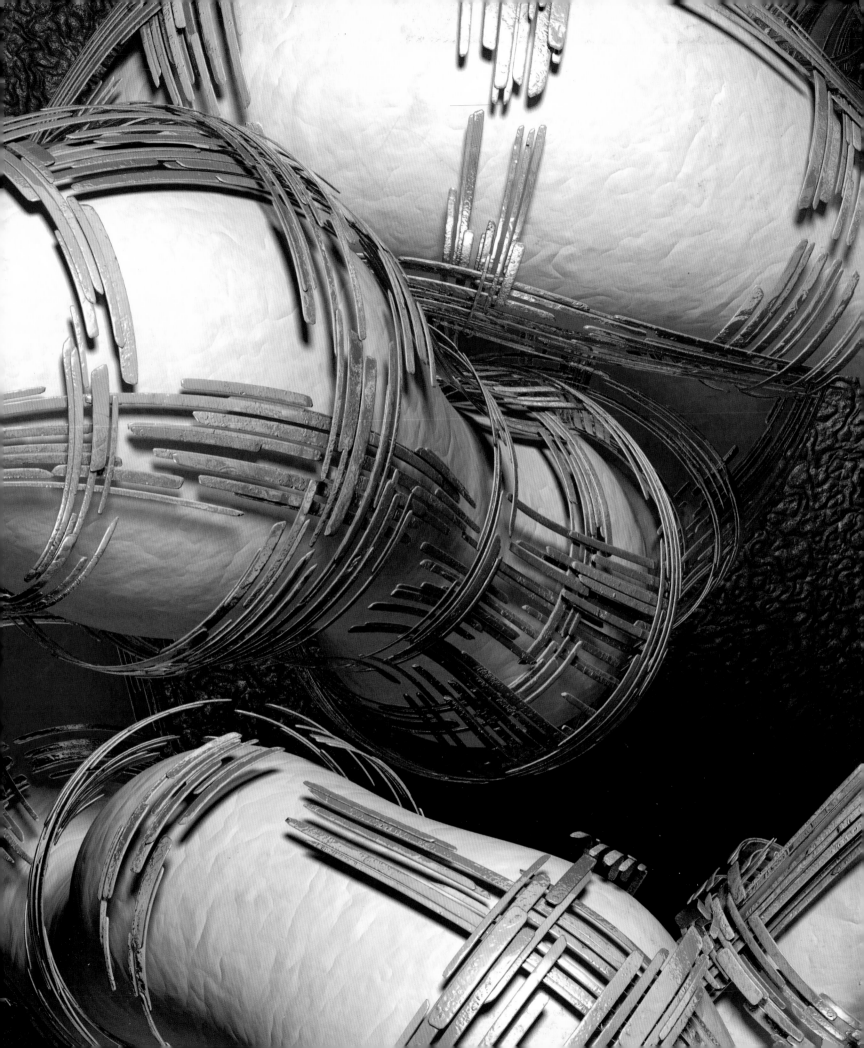